UNIVERSITY OF
The person charging this material is responsible for its
renewal or return to the library on or before the
The minimum fee for a lost item

Post— Photography

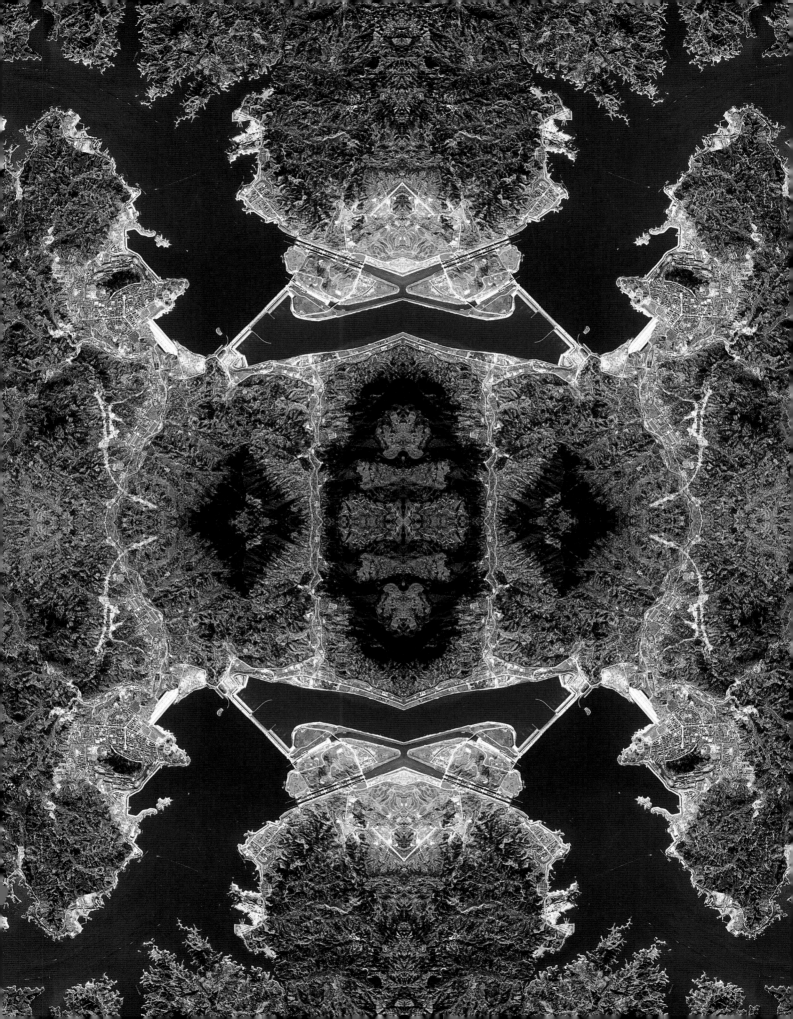

Post-Photography

The Artist with a Camera

Robert Shore

David Thomas Smith
Three Gorges Dam, Sandouping, Yiling,
Hubei, People's Republic of China, 2010–11
from *Anthropocene*

UNIVERSITY H.S. LIBRARY

1

2

Post-Photography Is...

Something Borrowed, Something New 12

Layers of Reality 72

779
Sh78p
cop. 2

3

All the World Is Staged 104

4

Hand and Eye 176

5

Post-Photojournalism 224

advantage of a 'manner of being', a socio-moral status ◆ Photography is therefore above all the acknowledgment of something deep and irrationally co-extensive with politics ◆ Photography is a synthesis of the technical and the creative ◆ Photography is a visual language still in its infancy ◆ Photography is allowed where possible ◆ Photography is allowed after 4 pm ◆ Photography is the real thing for me ◆ Photography is raised in three of Kracauer's crucial publications ◆ Photography is presented as a subjectless technical instrument that is merely capable of capturing a spatial configuration of a temporal instant that is incommensurable with history, and which can only be brought back by a memory-image ◆ Photography is attributed with a formative capability that enables the medium to express the subjective creative aspirations of the photographer ◆ Photography is bound to time in precisely the same way as *fashion* ◆ Photography is unable to resurrect the dead because even the recent past appears totally outdated ◆ Photography is given a role in the study of history ◆ Photography is a passion and you are simply happy each time a picture comes out right ◆ Photography is confined within the Clubhouse only up to the waterfront ◆ Photography is $350 and any additional time is charged at an agreed rate of $350 per hour ◆ Photography is seen not only as a linguistic device, but also as a vehicle for analysing and learning ◆ Photography is the first "official" pictures of the engaged couple ◆ Photography is embedded in the paintings of Alex Katz ◆ Photography is an extremely competitive field in which we must maintain very high standards ◆ Photography is one of the

most powerful tools of expression that we have in this culture, and therefore is useful in this recovery process ◆ Photography is becoming a reality ◆ Photography is offered by Joshua Chuang on Thursdays, October 30, and November 13 and 20, at 5:30 pm ◆ Photography is identified as the central medium which can carry on a discussion about European identity, it is interesting to question the reasons why the photography itself has been chosen to build a discourse about Europe ◆ Photography is meant as an opportunity to negotiate cultures, to negotiate the meaning of Europe through photographs ◆ Photography is put into the core of signification, exposed to the semiotics analysis as semiotics faces up to common objects insofar as they participate to the semiosis ◆ Photography is meant as a common object participating to the observation and interpretation of Europe ◆ Photography is based on a cultural strategy which gives the images the role to guide a reflection on European arrangement of identities ◆ Photography is an event intentionally arranged that aims to be an interpretive mediator through photography, shaping an idea of Europe and setting Reggio Emilia within Europe ◆ Photography is connected to realism and objectivity, a convention attributed by society ◆ Photography is a sense of suspension, of indeterminacy that comes out from the theme of the border ◆ Photography is a core component of the program ◆ Photography is aware of the Rule of Thirds - sometimes called the golden mean ◆ Photography is about self discovery on a technical level as well as a personal level ◆ Photography is only a young art form anyway so you have to embrace the changes ◆ Pho-

moment and atmosphere of the occasion, as a naturalistic setting and in a non-intrusive way, producing creative and powerful images ◆ Photography is a fascinating field ◆ Photography is nothing - it's life that interests me ◆ Photography is one of the most difficult to price ◆ Photography is an abundant medium ◆ Photography is a skill; a skill is KNOWLEDGE reinforced with EXPERIENCE ◆ Photography is like the question, "how do you get to Carnegie Hall? Practice, Practice, Practice" ◆ Photography is a language for Benjamin; second, that it is a language which is initially mixed up in the image; and third, given Benjamin's retrospective, allegorical glance, that language as such exists within and beyond any meaningful horizon that the photographic image brings into representation ◆ Photography is through a retrospective glance ◆ Photography is restricted to the use of the photographic process to depict observations from all branches of natural history, except anthropology and archeology, in such a fashion that a well informed person will be able to identify the subject material and to certify as to its honest presentation ◆ Photography is a simple research method that provides great results ◆ Photography is a world of fantasy ◆ Photography is used to determine how long these construction sites affect the watershed ◆ Photography is the best research method to provide answers on this subject ◆ Photography is used by amateurs to preserve memories of favorite times, to capture special moments, to tell stories, to send messages, and as a source of entertainment ◆ Photography is the result of combining several technical discoveries ◆ Photography is that chemical photography

resists manipulation because it involves film and photographic paper, while digital imaging is a highly manipulative medium ◆ Photography is often pre-eminent in photographic subjects which have little prospect of commercial use or reward ◆ Photography is probably best defined as any photography for which the photographer is paid for images rather than works of art ◆ Photography is a matter that continues to be discussed regularly, especially in artistic circles ◆ Photography is authentically art, and photography in the context of art needs redefinition, such as determining what component of a photograph makes it beautiful to the viewer ◆ Photography is one of the new media forms that changes perception and changes the structure of society ◆ Photography is both restricted and protected by the law in many jurisdictions ◆ Photography is like a mistress whom one cherishes and hides, about whom one speaks with joy but does not want others to mention ◆ Photography is not an art because it is produced with a mechanical device and by chemical and physical phenomenon not by hand and inspiration ◆ Photography is so similar to lithography and etching then it would be beneficial to the arts as well as culture ◆ Photography is an art or a new form of documentation seen by the eye instead of the mind ◆ Photography is an expression of the photographer's fantasy (or a combination of the fantasies of the creative team) ◆ Photography is regarded as one of six visual domains (the others being film, television, arts and crafts, the built environment and performance) which constitute a culturally conditioned visual communication system amenable to ethnographic

Introduction:
Post-Photography Is...

Post-photography is a moment, not a movement. The photographers featured in this book – or, more precisely, since some don't actually use a camera to produce their work, the artists-working-with-photography featured in this book – do not subscribe to a common philosophy of image-making. But their works, despite originating from all points of the twenty-first-century globe, do visibly share a social and technological context.

In 2012, the National Gallery in London hosted the exhibition *Seduced by Art*, which gave equal weight to photographs and Old Master paintings, and showed one of the grander art institutions gradually embracing the eternally arriviste medium of photography as it approaches its 200th birthday. But if photography is receiving increased recognition from the art establishment, it is also coming under ever greater pressure from the wider culture. After all, not only *can* everyone take photos; in the digital era more or less everyone *does*. The real world is full of cameras; the virtual world is full of photographic images. Citizen-photographers click away constantly with their smartphones, immediately uploading the results to Flickr and other sharing sites. Type 'sunsets' into Google Images and you'll get literally millions of matches in under a second of searching. CCTV surveillance cameras blindly add to this profusion, capturing the image of the average city-dweller up to 300 times a day.

The mythical excesses of the analogue masters of the past – W. Eugene Smith going overboard in Pittsburgh, Garry Winogrand shooting himself silly in LA – now seem positively modest compared to the snap-and-show behaviour of the average amateur today armed with a smartphone, a Tumblr or Instagram account, and a desire to make a photographic record of his or her every second on Earth. We have moved on from 'I think therefore I am' to 'I document therefore I exist'. Simply 'being in the moment' now involves documenting being in it – though without any commitment to reviewing the photographic evidence afterwards: after all, who has the time to look at old photos when there are new ones to be taken? Photography is such an overwhelmingly populist business these days that it generated the Oxford Dictionaries Word of the Year 2013 – 'selfie'.

If you're a photographer you might be tempted to conclude that the world-out-there is now so hyper-documented there's no point in taking your own pictures any more. Understandably, in this context, found imagery has become increasingly important in post-photographic practice, with the Internet serving as a laboratory for major experimentation in image-making. Sharing is a keyword of the digital age, and appropriation – or 'stealing' as some prefer to call it – is a leading post-photographic strategy. The online environment is a key hunting-ground for acts of creative, transformative borrowing.

'The stupendous proliferation of images across the Web makes it relatively easy to find images to match a concept,' says Jonathan Lewis, a member of the Artists' Books Cooperative (ABC). 'I have recently been making increasing use of that ubiquitous low-resolution phenomenon, the thumbnail. I think of them almost as Duchampian readymades, just waiting for me to point my digital finger and click!'

Looking at, and creatively incorporating, other people's images has never been more central to the practice of many photographers – sorry, artists-working-with-photography. 'Notable artists in ABC such as Andreas Schmidt, Mishka Henner and Hermann Zschiegner make extensive use of search engines and online archives to "steal" other people's photographs,' continues Lewis. 'Our work was recently included in an exhibition entitled 'From Here On' at the Arles photography festival. The manifesto for this show begins: "Now, we're a species of editors. We all recycle, clip and cut, remix and upload. We can make images do anything. All we need is an eye, a brain, a camera, a phone, a laptop, a scanner, a point of view. And when we are not editing we're making. We're making more than ever because our resources are limitless and the possibilities endless. We have an Internet full of inspiration: the profound, the beautiful, the disturbing, the ridiculous, the trivial, the vernacular and the intimate." It's a philosophy to which

Mishka Henner
from *Photography Is*, 2010

7

I increasingly subscribe, and I use my camera less and less these days.' Mishka Henner elaborates: 'The clue is in the phrase "taking photographs". Even with the traditional meaning of the term, there's an almost implicit assumption that the images are already out there ready to be taken by the photographer. So I don't make much of a distinction.'

The photojournalist-turned-art-photographer Michael Wolf controversially won an honourable mention at the 2011 World Press Photo awards for his *A Series of Unfortunate Events* project, which involved him taking photos of Google Street View images from his computer screen. As Wolf told the *British Journal of Photography*: 'Our world is full of images. It's part of the future of our imagery. We have to deal with this – curate them or incorporate them into our work.... I think a large part of our future will be the curating of all these images. Can you imagine the number of images stored in our world today? It's unlimited. In 100 years, there will be professions such as "hard-drive miners", whose mission will be finding hard-drives in electronic junkyards and developing software to sort these images. And then there will be art projects and sociological projects created using images mined from electronic storages. The whole idea of curating this incredible mass of images that has been created has tremendous potential.'

In keeping with this fresh context for image-making, numerous works and series in *Post-Photography* reveal the photographer cast in the role of editor–curator. This is the defining theme of the opening chapter, 'Something Borrowed, Something New', which runs the gamut from Joachim Schmid's heroic acts of analogue looking to Clement Valla's avant-garde digital explorations in *Postcards from Google Earth*. But there are projects throughout the book that draw on the themes of creative borrowing – for instance, Martina Bacigalupo's use of found imagery in the service of the photojournalistic tradition in her *Gulu Real Art Studio* – and the uses and abuses of digital technology – such as David Birkin's glitch-rich series *Embedded*.

The idea persists that photography is above all else a medium of witness, a self-effacing window on to the world which is primarily concerned with recording that thing to which we breezily refer as 'reality'. In the intellectual and technological environment of the third millennium, the notion of objective truth – the bread-and-butter of an earlier generation of photographers – is constantly being tested; the fact/fiction dividing line is continually blurred in post-photographic work. In general, the last thing you should expect from photography these days is objective truth. But it has always been false to say that the camera sees the world more objectively than humans. Rather, it sees *differently*. And that's how most of the photographic greats like it. As Garry Winogrand said: 'If I saw something in my viewfinder that looked familiar to me, I would do something to shake it up.' The camera's distinctive way of seeing differently is the subject of the second chapter, 'Layers of Reality', which focuses on some of the most cutting-edge technology – from Olivo Barbieri's use of tilt-shift lenses and helicopters to Jae Yong Rhee's exploitation of the potential of digital superimposition – deployed with a view to shaking up our ideas of the real.

'You don't take a photograph, you make it.' So, famously, opined the great US landscape photographer Ansel Adams. This notion has been taken up with ever-increasing vigour in the past couple of decades, though in a manner not explicitly envisaged or practised by Adams. No doubt the pressure created by the teeming omnipresence of amateur image-makers' work in the digital realm has further encouraged the growth of the 'directorial mode' in contemporary art photography. If you're frustrated with the degree to which the everyday world is now hyper-documented, why not construct your own world and document that instead? That's what the artists in chapter three, 'All the World Is Staged', do, and what Julia Borissova did in her project *DOM (Document Object Model)*, shown opposite.

Where artists do still wield cameras, then, there's a sense that *merely* taking photographs is no longer enough. Some construct their own realities to shoot; others

Julia Borissova
from *DOM (Document Object Model)*, 2013

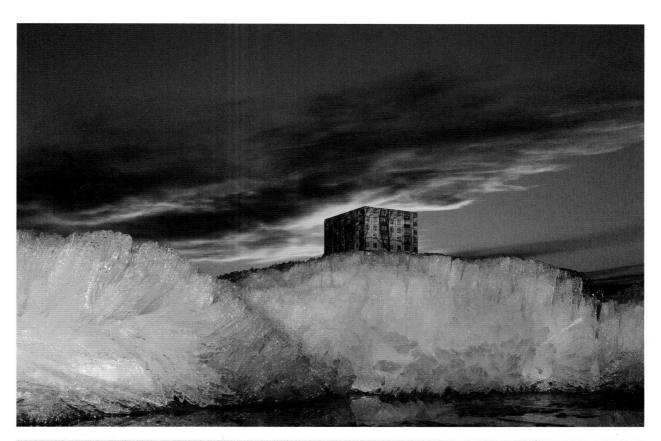

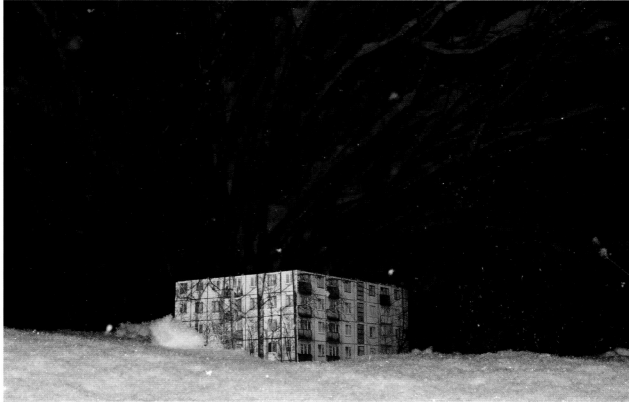

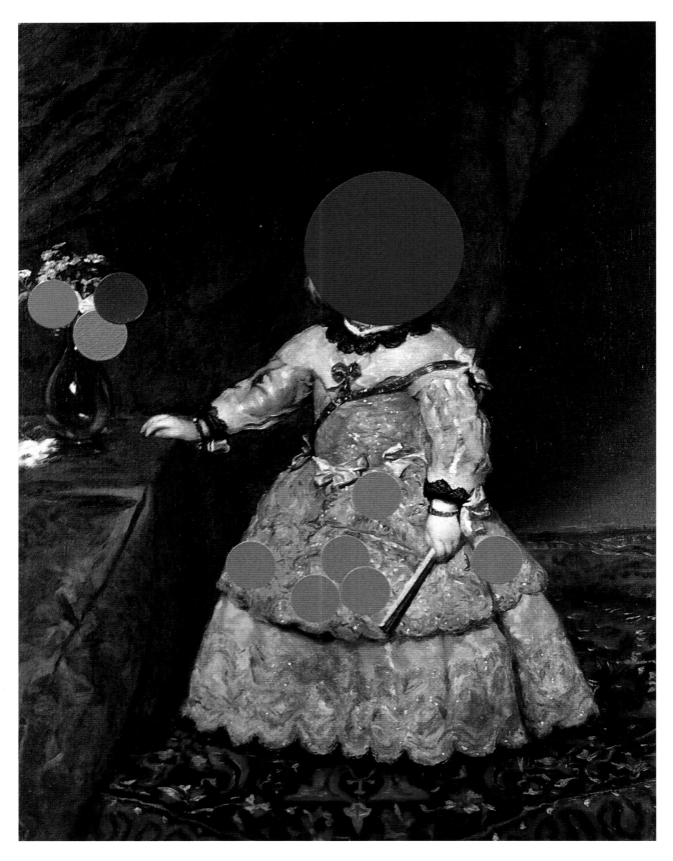

turn their images into objects, the artist's hand intervening physically. 'Photography is at the same point that painting was with Abstract Expressionism in the 1940s: we see a material photograph, we don't just see an image,' says Aliki Braine, an artist to whom the hole punch is as important a tool as any camera. 'It's because we're so saturated with photographic images that we're able to look at a photograph's material, not just the image it carries.' This 'materiality' tendency in contemporary photographic practice is the subject of the fourth chapter, 'Hand and Eye'.

Braine's work draws on different tendencies in contemporary art photography examined in this book. The work shown opposite, for instance, involves a significant act of visual borrowing, although the artist points to a subtler form of influence that this kind of engaged looking at others' work has on her other, more obviously 'original' creations (shown on pages 179–83). *Masterpiece in 10 Coloured Dots (after Velázquez)* is not so much about appropriation of images as about investing time and thought in Old Master composition and form,' she explains. 'The works I have been reworking are by artists whose paintings explored painterliness and the materiality of paint. The coloured sticker dots highlight the surface of the image along with its illusionism. This is in the same manner that the impasto brushmarks highlight the presence of the artist and the abstract nature of all images. The dots also remind me of the tiny dots of pigment that make up all mechanically reproduced images. While we are more familiar with digital pixels, photographs are tiny coloured dots of coloured pigment trapped in paper and revealed by light.'

The date 12 November 2012 is a significant one in photojournalistic circles: the august magazine *Time* put an iPhone shot – not taken by a common-or-garden citizen–journalist, admittedly, but by the acclaimed 'conflict photographer' Benjamin Lowy – on the front cover of its print edition, thereby acknowledging an important shift in photographic means and modes. In recent years, newspapers and magazines have been laying off their photographic departments and training their reporters in iPhone photography (in response to the growth of the revenue-sapping digital domain), putting traditional photojournalism under tremendous strain. Some have experienced this change as a tragedy, others as a liberation; many image-makers trained in the documentary tradition are actively seeking out new ways to communicate important news stories or ideas. In the case of Cristina De Middel, this involved openly (and controversially) 'faking' her visual documentation of the 1960s Zambian space mission. This and similarly imaginative, mould-breaking projects are the subject of the final chapter of this book, 'Post-Photojournalism'.

As the eminent teacher and theorist Fred Ritchin suggested recently, in an interview with *Mother Jones*: 'Photojournalism has become a hybrid enterprise of amateurs and professionals, along with surveillance cameras, Google Street View, and other sources. What is underrepresented are those "metaphotographers" who can make sense of the billions of images being made and can provide context and authenticate them. We need curators to filter this overabundance more than we need new legions of photographers.'

It's a sentiment that could be extended beyond photojournalism to the whole of professional photographic practice. Welcome to the era of post-photography.

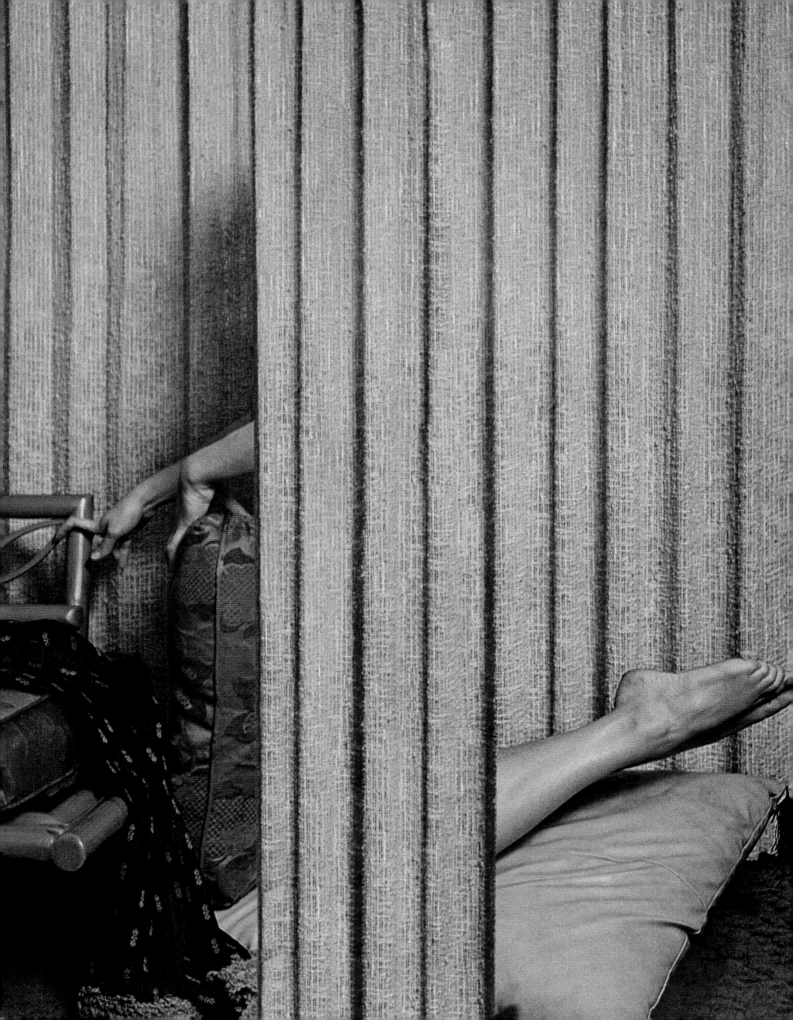

Something Borrowed, Something New

1

Given the abundance of pre-existing visual material in our hyper-documented world, it's unsurprising that an increasing amount of photographic art begins with someone else's pictures. There's nothing new about appropriating found imagery for fine-art purposes. But the sources, methods and goals are fast-evolving. If digital culture has transformed photographic practice – that is, how pictures are taken and displayed – it has had no less profound an impact on how found materials are sought and then manipulated. Located at the digital cutting edge, or innovating with tradition in more familiar ways, the projects in this chapter show found-imagery work at a crossroads.

For *Running to the Edge*, Julia Borissova collaged petals on to vintage photographs found in a St Petersburg flea market. Meanwhile Nicole Belle scanned her analogue vintage-store finds straight into her computer in a process broadly representative of the digital turn in photography. By contrast, the likes of Clement Valla and Brandon Juhasz create their very different bodies of work from material almost exclusively sourced from the Web. For Juhasz, searching online for photographs in digital stock-image libraries, or with Creative Commons licenses, provides nothing less than 'the new ready-made. Here are these pictures of anything I need to look up, I can purchase or download to use. No different than buying a toilet from Home Depot. They are made and part of our collective soul and I am using them with the intent to create and build upon [them] as art.' Juhasz quotes fellow artist-working-with-photography Jon Rafman as saying that 'screens now are our collective centre as a culture, not the city'.

Photographic appropriationist Joachim Schmid, who began by collecting snapshots literally dropped in the streets, is unlike most artists, who now start their image searches on the highways and byways of the super-rich online environment. The infinite variety of the Internet is proving a challenge to even the most dedicated and practised of professional picture-hunters. 'Ten thousand photos a day seemed a lot when we still looked at prints,' says Schmid, who is renowned for his heroic feats of looking in the late 1980s. 'Now the number is nearly ridiculous. Today more than 10,000 photos are uploaded to the Web every minute.'

The circulation of material on the Internet is difficult to control and regulate, and the legal and ethical rights and wrongs of appropriation continue to be discussed and argued over. 'There is an ongoing debate among copyright lawyers, artists and academics about the legitimacy of working in the way I and so many other artists do,' says Andreas Schmidt, whose practice involves, he explains, using 'Internet search engines to investigate and reflect upon the present role of photography and the culture we live in'.

'Nobody has a concrete answer. The law has to catch up with the speed with which artists are working today,' he argues. 'I consider what I do within my art practice as a basic human right, equal to freedom of speech. Lewis Baltz said that as soon as an image is on the Web, it belongs to everyone: 'If anything, I predict that more and more artists will use the Internet as a source, especially as "virtual reality" overtakes what we believed to be our reality.'

Eva Stenram
Drape (Cavalcade VI), 2012

Mishka Henner

'A new approach to photography is seeing the light – photographers without cameras. The need to press the shutter is replaced by a direct interest in images – not necessarily in making images. These photographers make books with photographs they find and sometimes they mix them with photographs they take. In this rising flock Mishka Henner is the trailblazer.' So declared the jury report for the 2010 Kleine Hans photography prize, which was awarded to the UK-based, Belgian-born artist for his various book projects using Google's satellite service and Street View to generate visual content. *Dutch Landscapes* shows conspicuously pixellated top-secret locations in Holland; in *No Man's Land*, women are captured standing at remote roadsides, apparently offering sex to passers-by.

The Difficulties of Navigation: I'm just using what's out there already – images and data that are waiting to be discovered. The main difficulty is that, with services such as Street View, Google Earth and a whole host of other imaging suppliers, the imaging and data terrain are unimaginably vast. Learning to navigate one's way through this terrain is by no means straightforward.

In 2011, when I decided to look for Libyan oil fields in light of the civil war Britain was about to enter, although I had my search criteria I had a huge amount of data to trawl through. And it took a long time to discover that while huge swathes of Libya were in low resolution, the oil fields – tiny specks in a vast desert landscape – were almost always visible in high resolution. But finding those oil fields was incredibly difficult. It's the kind of information that has a high commercial value so it's not easy to find for a reason.

With *Dutch Landscapes*, it was a case of amassing information from forums and crowdsourced datasets that were then matched to satellite imagery. Again, the problem wasn't so much finding the data or the images, but knowing what to do with it all: how to frame it, title it, all those things that bring simplicity and coherence to something that's otherwise daunting and complex. I often wonder if myself and others are working in a tiny window of opportunity. In the last few months, we've seen revelations about the NSA's ties to Google that dramatically alter the freedom we'd previously associated with the Web. It's quite possible that in the near future we'll have to learn to work with allegory and to develop codes of communication to get our points across. But that won't be anything new. It's something artists have been pretty good at doing throughout history.

Less Américains: It felt right and necessary to erase Robert Frank's *The Americans* [first published in Paris in 1958 as *Les Américains*]. Not just because of the dogmatic way in which that work is talked about and mythologized in photography circles but also because of an idea of America that Frank's original represented. *The Americans* was and remains a masterpiece but, by its very nature, it provokes and demands today's reader to reinterpret it rather than remain a passive spectator. I think that's true of all great works – they open a door of perception and possibility rather than close it.

Print-on-Demand Technology and the Evolution of the Photobook: I think the real shift lies in the confluence of the artist's book with the distribution capabilities of the Internet. Simply put, books contain ideas and ideas flourish online. We still imbue the physical presence of books with gravitas but the great irony is that print-on-demand means a book no longer has to be published by a recognized publisher or in any great number to have any influence. I can make a book that only sells two or three copies but the ideas contained within it spread far and wide. I'd sold four copies of *No Man's Land* when a campaign to ban it was launched on the west coast of America. Who would ever dream of banning a book that had sold only four copies? I think that tells you everything about the potential of print-on-demand.

Mishka Henner
Unknown Site, Noordwijk aan Zee
from *Dutch Landscapes*, 2011

Mishka Henner
Staphorst Ammunition Depot
from *Dutch Landscapes*, 2011

Mishka Henner
Abu Alwan Oil Field (28°33'46"N, 18°43'8"E)
Jebel Oil Field (28°37'55"N, 19°53'11"E)
Haram Oil Field (28°50'0"N, 18°50'35"E)
Al Kotlah Oil Field (28°36'10"N, 18°54'46"E)
from *Libyan Oil Fields*, 2011

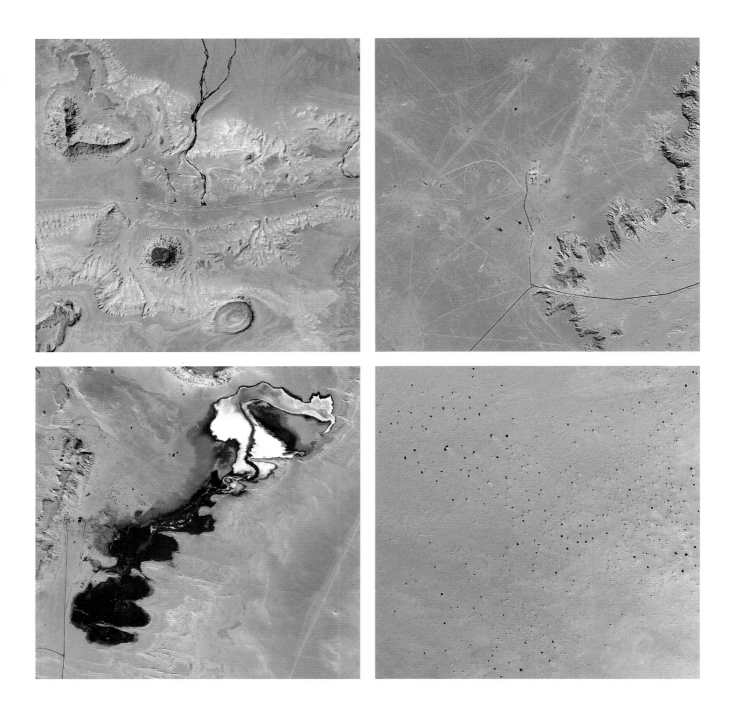

Mishka Henner
Nafura Oil & Gas Facility (29°14'24"N, 21°33'28"E)
from *Libyan Oil Fields*, 2011

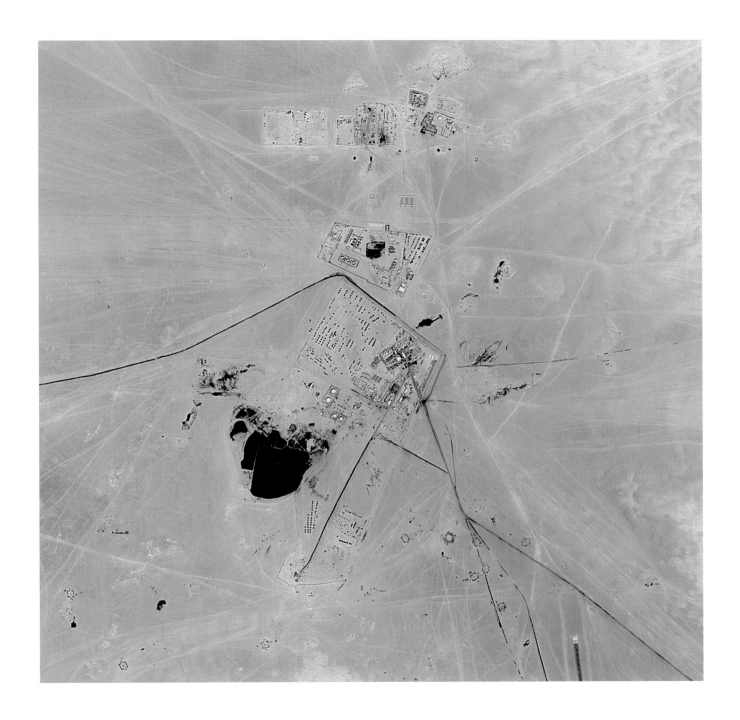

Joachim Schmid

Joachim Schmid has been one of the leading lights of contemporary photographic appropriation since the late 1980s. 'For reasons that are buried somewhere in the unexplored clefts of my brain I became interested in photography as a young man,' the German artist explains. 'But the prospect of becoming a photographer was seductive only for a short period of time. I found my doubts about the established photographic practices more interesting than the desire to add another pile of pictures to the existing ones.' Much of Schmid's output is derived from vernacular sources – non-professional, manual interventions are key to his practice, whether they take the form of tears, as in *Bilder von der Straße* (*Pictures from the Street*), or the addition of colour, as in *Estrelas Amadas* (*Beloved Stars*).

Bilder von der Straße: While studying museums of photography I was wondering why we as a society collect some types of pictures and totally neglect or even despise other types. In my opinion something was wrong with most collections. In a painting collection we probably don't need any samples of painted walls, but a museum of photography without snapshots and picture postcards and police photographs and so on is not complete. Looking at museums, we get a pretty good idea which pictures we collect, and I was curious to learn which pictures we do not collect.

Walking through the city with such questions in mind, I found a snapshot in the street. I picked it up, looked at it and dropped it again. A few minutes later I realized that I had found what I was looking for. It was gone with the wind. From that moment on I gathered all original photographs I found in public spaces. Most of these pictures are intentionally discarded, many are ripped up. It's exactly the opposite of a museum collection that is meant to preserve the finest samples of our culture for future generations. These pictures from the street must be so bad and disturbing that they were not meant to have any future at all. My project foils this plot, and I guess eventually it will end up complementing a museum collection. It's the missing piece.

Statics: After advertising my spurious Institute for the Reprocessing of Used Photographs, I was flooded with photographs: the success can be measured in hundredweights. For quite a while I subscribed to the idea that all photographs can be recycled in one way or another. My series *Photogenetic Drafts* is one example of recycling negatives that were donated to the institute. With many of the photographs I struggled and eventually I had to admit that they were totally and utterly useless. Throwing them into the trash bin would have been too easy. Following the example of industrial recycling, I got a shredder and reduced the photographs to small pieces, correctly sorted, of course; you don't mix glass with paper or plastic. The resulting strips were carefully assembled to create abstract visual fields – white noise.

Estrelas Amadas: In a Lisbon flea market I discovered a series of magazines from the 1950s, each one devoted to a particular actor. The former owner of the magazines, obviously a young woman, had coloured the lips of all the women in the brightest red, in a few photographs also nails and shoes. I knew immediately that this was treasure. Imagine Portugal in the 1950s, at the very edge of Europe, where people grew up in the capital of a very poor country under a dictatorship; they didn't have many options for their future, but a young woman started dreaming, with a colour pencil in her hand.

I am not very interested in the fact that these interventions are non-photographic, and I am not very interested in the photographs themselves – professional black-and-white Hollywood stills. Without these interventions I would not have picked up the magazines. The personal use of these photographs makes them so special, and the fact that the alterations are so meticulous in this absolutely stunning red. The colour in my prints is very close to the originals, I did not enhance it. I love it if people do something with photos, draw or paint over them, make collages, add writing or whatever. Any photograph can be personalized, turned into an article of daily use, no matter what it was intended to be or what it was originally used for. It's just a pity people don't do it more often.

Joachim Schmid
Statics (Women's Fashion Catalogue), 1999
from *Photogenic Drafts*

Joachim Schmid
No. 140, Belo Horizonte, August 1992
No. 217, Los Angeles, March 1994
No. 414, Paris, July 1996
No. 961, Belo Horizonte, March 2010
from *Bilder von der Straße*
(Pictures from the Street), 1982–2012

Eva Stenram

Swedish-born, London-based artist Eva Stenram uses found imagery – taken from sources as varied as family photo albums, erotic magazines and the Internet – to explore the act of looking. In *Drape* she reconfigures analogue pin-ups to create digital images that are as fascinating for what you can't see as for what you can; *Birds in Flight*, meanwhile, uses computer technology to rearrange the usual avian flight patterns and turn a reassuringly cosy image into something deeply sinister and uncanny. As she says: 'My work is about being a viewer. As I am usually not the photographer, the work is not about subject/photographer, but about my relationship to the image as a *viewer*. My work is often about this act of looking, as well as the relationship between the public and the private, which is at the core of the photographic experience.'

The Digital Age and the Place of the Photograph in It: I usually describe myself as an artist who works with photographs. Photography is my medium. I am fascinated by the many photographic images in our culture, and especially by the photograph's status within a digital world. More than ever before, it is in a state of flux, instability and exchange. Recently I have been working with 'found' photographic images – analogue negatives and slides, printed photographs, pages from magazines or images from the Internet. These are both my source of inspiration and my raw working material; they are scanned or downloaded to [create] digital files that I then manipulate, reinterpreting the image. Often I subvert the intention and function of the source photograph. Often certain photographs linger in my mind and then they propel a new body of work some time afterwards.

Pornography, Pin-Ups and the Role of Digital Manipulation: Initially, I came across some vintage pin-up images on eBay by accident. I already had the idea of using a curtain or drape from the background of a photograph to cover up what was in the foreground of the image. I made some experiments using non-erotic imagery that interested me. When I then came across the pin-up images in which the models were posed in front of curtains, the project suddenly fell into place. I started collecting more pin-up images, medium-format negatives, probably from the 1950s and '60s. I was looking for pin-up images in which the model was posed in front of a curtain or drape in a (semi-)domestic setting. I scanned in the negatives, and then extended the curtains or drapes digitally in order partially to obscure the models' bodies. I also started working with pictures from the 1960s US men's magazine *Cavalcade*.

Erotic and pornographic images are some of the strongest pictures in our society. They never fail to elicit a reaction when they are viewed. Pornographic images are staged scenes – yet they are 'real'. They are fascinating also because they are functional images. Normally, erotic and pornographic images offer a public glimpse into private and intimate space. Similarly, in *Drape*, the curtain or drape covers the intimacy of the body. The curtain reiterates its role as a marker between public and private space.

In both series, the background engulfs the foreground; the focal point slips off-screen and puts an overlooked part of the image in the spotlight. I am interested in reversing the hierarchy within the image. In *Drape*, the model slips away, but there is still a pleasure in looking – at what is left of the model (usually the lower legs and feet) and at the interior. The viewer somehow becomes more aware of his or her voyeuristic desire.

***Parted*:** This series came about when I had been buying large amounts of (other people's) old 35mm slides. In each set of photographs, the subjects have been separated from each other and displayed in their own distinct photographs (rather than together). So a photograph of two people becomes two photographs; a photograph of three people becomes three photographs. It's a way of deconstructing the photograph, being able to pay closer attention to each individual's body language and position within the frame. One photographic moment becomes two or three moments. Viewers of these pictures try visually to piece them together, as they were originally. For me, it was important that some time had passed between when the photograph was taken and when the manipulation/change took place. This time allows for the possibility of misremembering the original photo.

Eva Stenram
Birds in Flight I–III, 2006–08

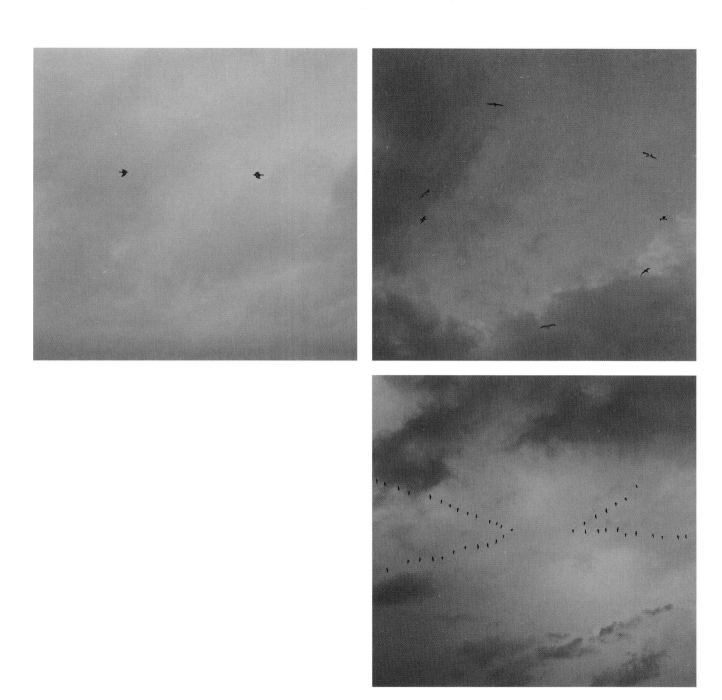

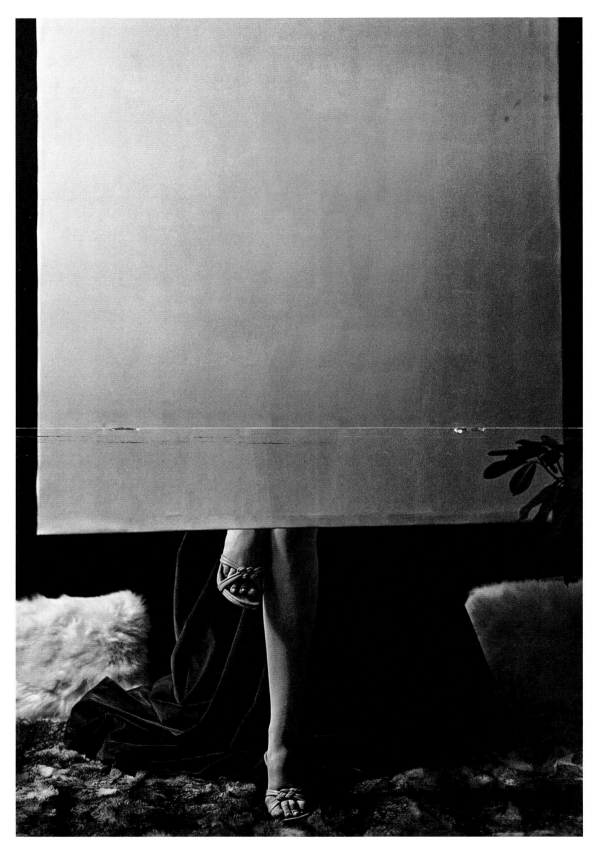

Eva Stenram
Drape (Centrefold I), 2012

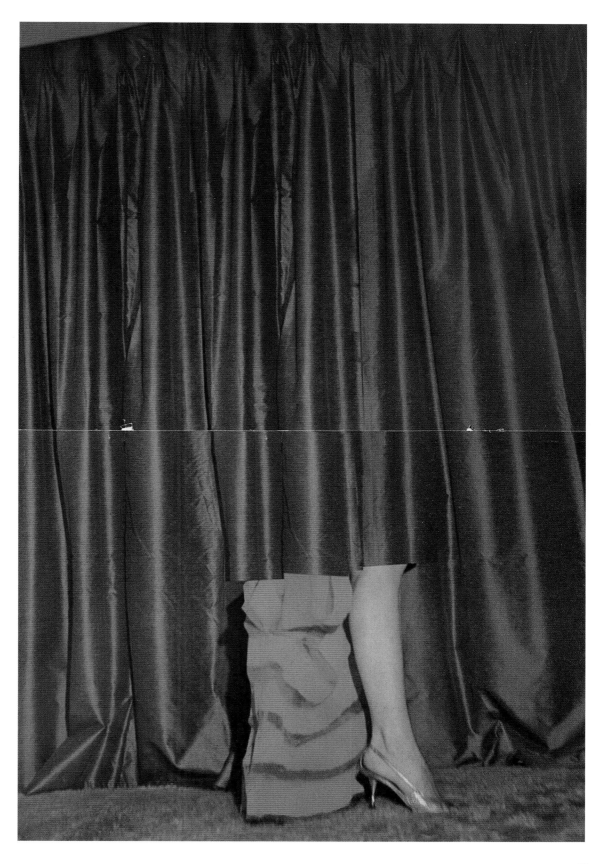

Eva Stenram
Parted (Trio), 2010

Nicole Belle

The digital turn in photography has seen new developments in the way that found images can be manipulated and combined. In the case of her *Rev Sanchez* project, US artist Nicole Belle scanned a series of analogue negatives dating from the 1960s and '70s into her computer and began to multiply the protagonists in the highly posed originals. 'The images felt like Kryptonite – potent stuff, and way beyond anything I was comfortable dealing with,' says Belle. 'Doubling, tripling or quadrupling these young people (mostly women) somehow solved the twin problems of camp and vulnerability. These girls, who seemed so desperate to look a certain way and please the photographer, suddenly came in a pack, a posse of themselves. They could hold their own; the creepy power shifted to them.'

Between Collaboration and Appropriation: A friend of mine tipped me off that a vintage store was selling a bunch of old negatives from the 1960s and thought it might be helpful to a previous project I had been working on. I went and bought some of the negs – there were no contact sheets so I was just holding them up and trying to imagine what the figures might look like reversed. I scanned them in and was amused by what showed up: all these campy shots of young people (mostly young women) in a park doing these exaggerated poses for the camera.

The originals are medium-format black-and-white, and while the pictures were amazing, there was something shabby about them, something imaginatively banal. They were part of an archive that seems to have begun sometime in the 1960s, through sometime in the '70s, judging from the clothes, cars, etc. All the vintage-store owner knew was that the photographer's name had been Rev Sanchez, and that he'd had a prosperous commercial career that was on the wane when the pictures were taken. She thought that 'Rev' was the first name, not an abbreviation for 'Reverend'. But I liked the ambiguity of the name. I named the series after him in an earnest homage to his original role in making them. The more I worked on them, the more I appreciated him as a photographer and

the more I felt, irrationally, that he had laid the technical groundwork for what I was doing. By the end, I felt the results were somewhere between appropriation and collaboration.

The Appeal of Found Imagery: I had long been interested in so-called 'found images' but had never come across anything that really clicked for me. But in my art practice, I don't really think I recognize a strict distinction between found and not found. I am a photographer and I like making photographs, but I don't think there's anything special about my pressing the button, or the exact moment when light becomes film, or a digital file. I've never been 'pure' about it in that way.

At that point I was really into digital manipulation, adding things or removing them from my images; I could work the Rev Sanchez images seamlessly into my process because I wasn't dealing with prints or published material. I had the original negatives, so I could scan them in and work on them on a fairly large scale, manipulate them just as if I had made them.

A Photographic Vocabulary of Femininity: What was different was my relationship to the subjects. I struggled a bit with how to treat them; I had a surprisingly emotional connection to them. I felt strongly that I needed

to do right by them. I've never been comfortable representing others in my work – it's such a burden, a responsibility, to represent someone else. These women were distanced by time, but they also seemed to represent a challenge to what I think I may have been attempting in my other work. To put too fine a point on it: how to make a photographic vocabulary of femininity that did not involve exploitation. They had been captured at an extremely vulnerable moment; they are trying so hard. It was a lucky confluence of circumstances. In doing what I was doing, I felt I was succeeding both in 'working' their raw images over to make them my own and in finding a way to put these young women in a more complicated and fortified stance towards contemporary imagery.

Nicole Belle
Untitled
from *Rev Sanchez*, 2008

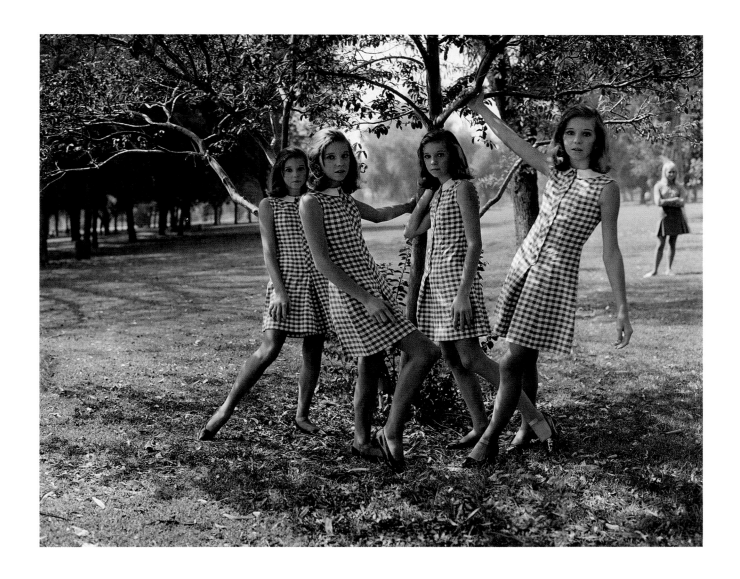

Nicole Belle
Untitled
from *Rev Sanchez*, 2008

Nicole Belle
Untitled
from *Rev Sanchez*, 2008

David Thomas Smith

Dublin-based Irish artist David Thomas Smith's photographic tapestries are both strikingly beautiful and politically charged. Stitched together from thousands of digital files derived from aerial views found on the Internet, the *Anthropocene* series takes its title from a term co-authored by Nobel laureate Paul Crutzen. 'Anthropocene' describes a new age for our global environment, in which mankind is an active agent. As *New York Times* writer Andrew C. Revkin explained, 'it is a geological age of our own making'. Smith's series focuses on sites and centres of global capitalism, whether because of their association with oil, precious metals, consumer culture or excess. The images draw on the patterns and motifs used by Persian rug-makers, mirrored vertically and horizontally.

The Documentary Tradition: I studied Documentary Photography at the University of Wales, Newport. I learnt a lot of valuable lessons there, especially when it comes to developing a body of work and the kind of commitment it takes to see it through. Before and during making *Anthropocene* I was making slightly more traditional photographic work, documenting a variety of different subjects, from the lives of first- and second-generation Irish emigrants in the UK to the decline of religious institutions in contemporary Western society. I think *Anthropocene* definitely falls into the documentary tradition. It's a story, a document, a record. It's certainly not traditional in the documentary-photography sense but I believe that it draws strongly enough from that tradition to be included at least on the peripheries.

Place, Photoshop, Process: I begin by searching for a specific area I want to look at in Google Maps. I take a couple of low-resolution screen captures and then play around with them in Photoshop to see if I can make an aesthetically pleasing image. These images are more of a rough draft as it's impossible to tell how the final image is going to look. When I'm happy with what I might get (and if the image resolution is high enough in that area) I'll go back to create the final full-resolution image. At this stage I'll zoom down to street level where I'll take thousands and thousands of thumbnail-size screen captures. These thumbnail images are then reassembled in Photoshop to give me a high-resolution image, which I then manipulate and weave into a motif. When that's finished the images are printed, usually the bigger the better. When the images are large they're at their most spectacular, as the details really begin to shine through. All the places depicted in *Anthropocene* are significant in their own right; they share a common thread, forgive the pun, in their socioeconomic importance in the world today.

Afghan Rugs as Influence: Initially I was influenced by Afghan war rugs made during the Soviet invasion of the 1980s and more recently those made during the American occupation. From there I discovered that Persian rugs were more than just a beautiful motif, they were objects that contained and recorded a particular history.

Google as Source: Initially I had some apprehensions, people told me I wouldn't be allowed, but I pressed ahead regardless. Eventually I contacted Google with some samples and fortunately they didn't have a problem with it. I think there are some drawbacks: control of copyright is probably the main one, especially for traditional image-makers. Once your images are out there they're not coming back. Unfortunately it's getting harder to make a living as an image-maker. Overall, I think that the advantages outweigh any problems. Artists have never had access to so much information and so many people at the click of a button; it's probably a tired cliché but it's true.

David Thomas Smith
Burj Dubai, Dubai, United Arab Emirates (detail)
Las Vegas, NV, United States of America (detail)
2009–10, from *Anthropocene*

David Thomas Smith
*Fimiston Open Pit, Kalgoorlie-Boulder,
Western Australia, Australia, 2009–10*
from *Anthropocene*

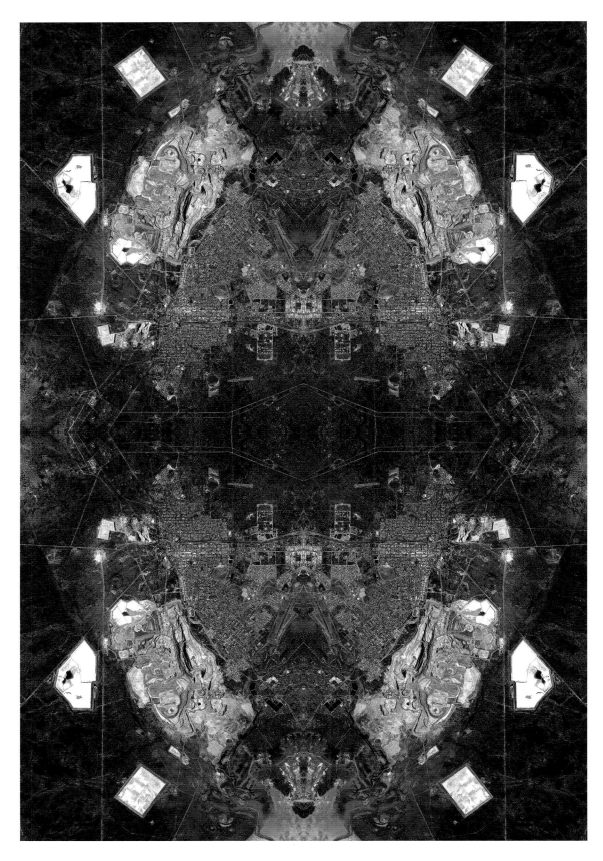

David Thomas Smith
Burj Dubai, Dubai, United Arab Emirates, 2009–10
from *Anthropocene*

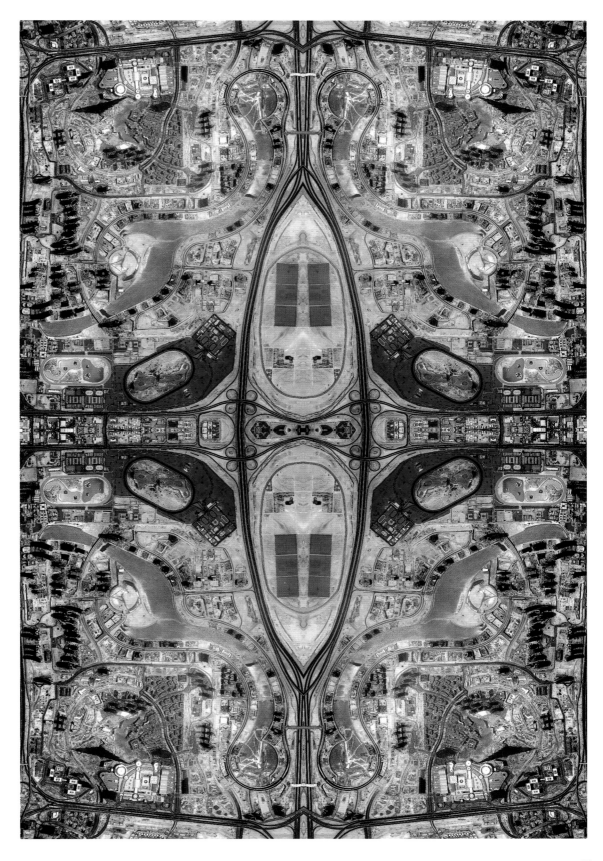

Jonny Briggs

'Photography provides me with an opportunity to play with perceptions of what's real and what's not,' says Jonny Briggs. But the UK artist subverts the expectations created by the ubiquity of Photoshop in surprising ways; frequently his images – *Un-seeing*, for instance – are exactly what they seem to be, much more often than you might imagine given their trompe-l'oeil appearance. Briggs's principal theme is his own family and he regularly uses imagery from his parents' archive. 'My route into photography has been informed by a dislike of being photographed when I was younger; this enhanced eye that watched me, recorded me, documented me,' he says. 'My work perverts and transgresses the family photograph, re-rendering the past and role-reversing my parents and me; now it is me capturing them.'

Family as the Source of All: Right from the start I was making work involving my family. Whenever I think about them, ideas just flow out of me. It's a sign to me that I'm in the right place, that there's something that I'm getting at – whatever it is. My parents are important viewers of the work for me; this is my opportunity to show them how I see the world, and it's a form of rebellion too, like a transgressive, perverse child. When they pose for the photographs there's a magic – I feel in a position of power, and almost as if I'm quenching the past. Seeing them through the lens is seeing them in a new light. When I walked round my most recent solo exhibition with my parents, my dad stayed silent throughout the duration, and afterwards too. He's not much of a talker, and in fact I think our last conversation was when I was in childhood. In some ways the work feels like a bridge between us, a way that we can communicate without and beyond words.

The Digital Camera Always Lies – or Not: In the digital revolution the preconception that the camera never lies has flipped into *the camera always lies* – there's a lot of mistrust in images now, and if anything appears peculiar within the photograph, we assume it to be digitally manipulated, Photoshopped or faked. These are preconceptions that I love to work with, where a lot of effort is invested in making sets and scenes that when photographed appear as if they have been faked. Furthermore, the photograph denies us the ability to move around an object to understand it, and denies us the opportunity of knowing what happened before and after the instant at which it was taken – I like the tension in this. Upon closer inspection, the images turn out to be more real than first anticipated. I like the feeling this flip gives me – and the moment before this flip there is a suspension of disbelief – an uncertainty over what's real and what's not. This uncertainty takes me back to my childhood mindset, when the boundary between real and imaginary was blurred.

***Un-seeing*:** Although people often assume otherwise, *Un-seeing* is a single colour photograph. I took two found images – giant black-and-white mural panels of woodland, which are intended to clad an interior wall, to make people feel like they're outside – back to the woods. I rephotographed them, parted like stage curtains, with a gap in the middle showing the 'real' woodland behind.
 I painted my father with grey face paint, as if he were part of the black-and-white image; in the full-size version the colour of his hairline and the seams of the paper mural can be seen. I like these clues that hint at an alternative truth behind the image.

Returning the Gaze: The theme of the look and the gaze regularly occurs in the photographs, where the images often feel as if the subject is returning the gaze – that the image is less passive than often assumed. Extensions and perversions of the look further feature, and how the look plays upon both our fears and desires; if we are gazed upon we feel threatened that either the looker is attracted to us or wants to attack us. It's no coincidence that when figurative works of art are vandalized, it is almost always across the subject's eyes.

Jonny Briggs
Un-seeing, 2012

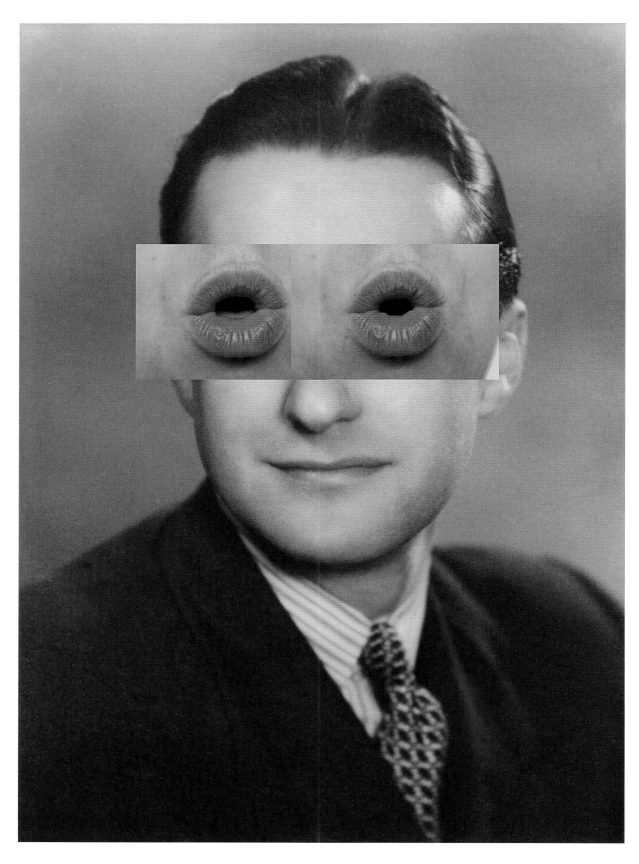

Noé Sendas

Brussels-born, Berlin-based artist Noé Sendas brings a sculptural logic to his reworkings of mid-century pin-ups. 'When I started to edit the pin-up photos from the 1940s I worked them in the same way that you would work a sculpture, using the notion of gravity, of weight and balance,' explains Sendas. 'If you erase the left leg from a figure in a photograph you should add a stone on the right hand of the same figure, so that it's balanced and does not fall over.' The disturbing, spectral images that emerge from this process of manipulation and erasure have an obvious affiliation to Surrealist precursors, although Sendas's interventions also confer an air of enchantment on his now-faceless subjects.

Sculpture and Scale: In 2009 I started the *Crystal Girl* series. I had been collecting pin-up photos for some time. I was in my studio, working on a large-scale sculpture installation, a complex work, very dependent on me and almost a burden to reinstall. It just came into my mind: if there were a fire, what could I take with my bare hands and run off with? At that moment, I decided to make small-scale works; I wanted to have the freedom of someone who just leaves home with a pair of diamonds in his pocket.

'Un-collage': People ask me: Where do you keep all the heads? All my manipulated photographs are faceless or rather, as I prefer to describe them, they are Nameless. I simplify images by using 'un-collage'; instead of adding new elements, I edit things out.

Crystal Girl: In the *Crystal Girl* series I am very sympathetic to the subject matter of the original material, but something has to be wrong for me to choose to work on an image in this way. When I choose to displace an object, person or situation in order to magnify the image's mystery or grace, it is because I want to tackle something that I find disturbing about the original image. My aim is to generate a new image within an equation. I sometimes present the final works in vintage frames, as if they had just been found at the archaeology site of Glamour.

Surrealism and *Sprezzatura*: There is certainly a connection with Paul Nougé, the Belgian Surrealists and their manifestos on photography and the role of the artist as a saboteur. Nevertheless, now and in these series I am more interested in the role of the artist as someone who deceives the sight, who casts glamour, a charm affecting the eye of the spectator, making objects appear different from what they really are by using the *sprezzatura* technique (the art that conceals art) to give the work the appearance of effortlessness.

Truth and Photography: Photographers adopt different philosophies, sometimes simultaneously, in relation to this question, all of them very respectable and with very interesting end results. Someone once said to Picasso: 'I don't like this portrait. If you paint my wife it should look like my wife.' And he drew out a picture of his wife to show to the artist. Picasso looked at the picture and answered: 'This is your wife? I am surprised! She looks small and flat.' I am interested in the huge potential of that small and flat figure captured on a piece of paper called a photograph.

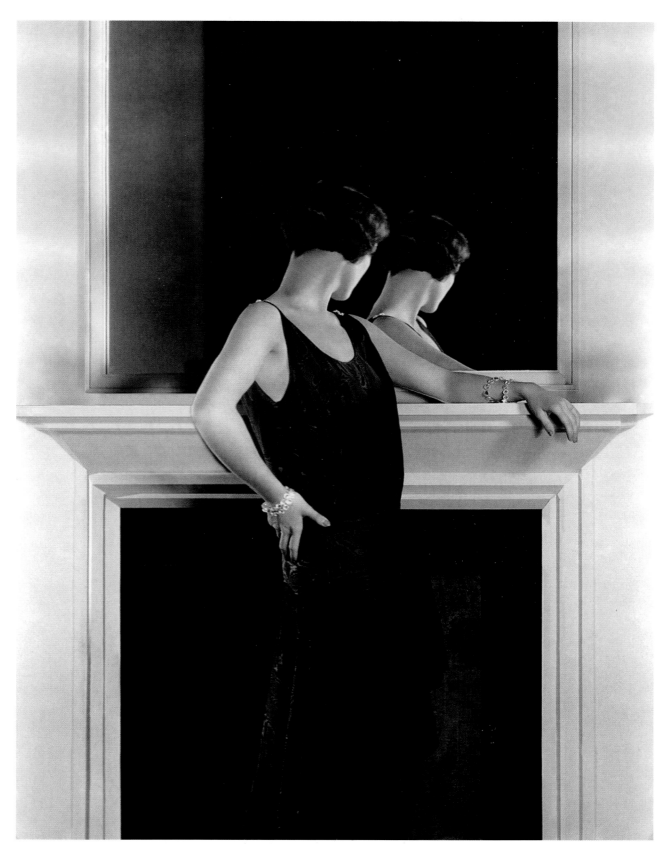

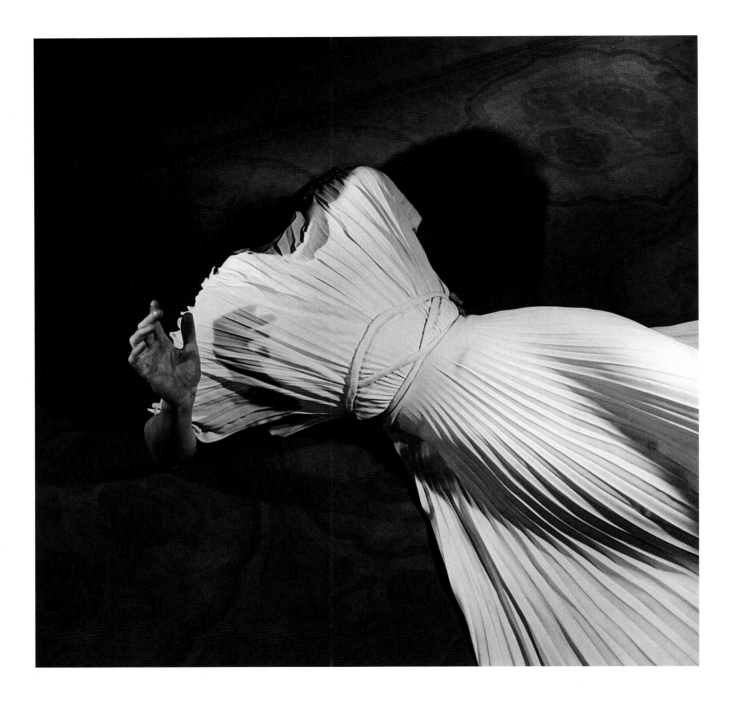

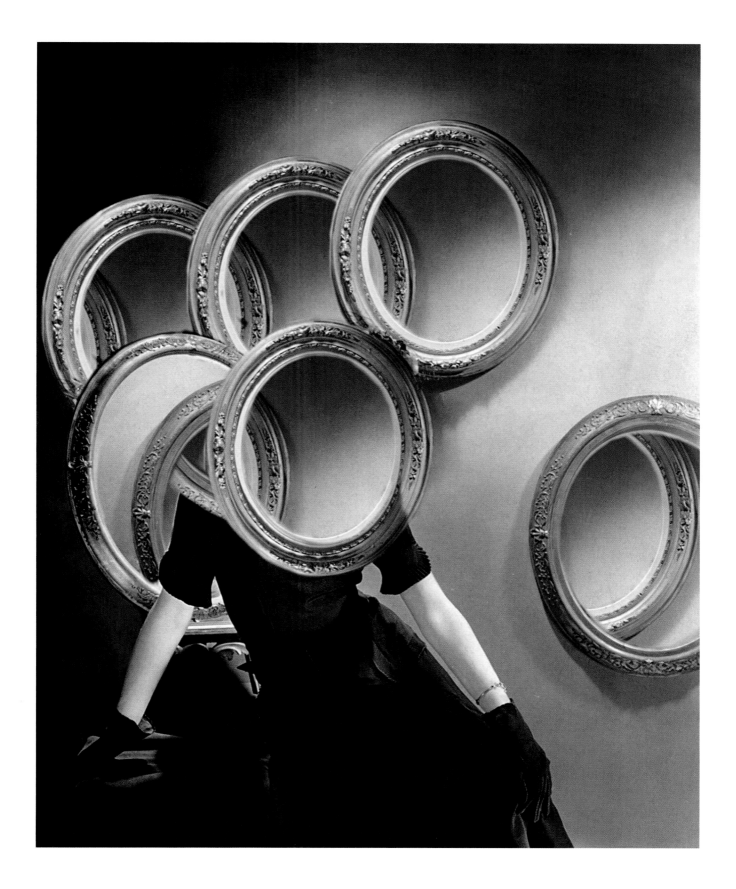

Julia Borissova

Russian artist Julia Borissova's conceptual work encompasses a variety of approaches to image-making, including staging. Her *Running to the Edge* series marks something of a departure in her personal oeuvre. Combining found photography and floral elements (especially petals), it's a remarkable work of appropriation that uses images from the early decades of the twentieth century to provoke philosophical reflection on broader themes of history and memory. Photography is the foremost medium of 'memory trace'; it is how we commonly record our lives. Here Borissova juxtaposes black-and-white or sepia-toned images with brightly coloured flowers – at once vivid invasions of the present moment into faded records of the past, and vanitas symbols suggesting the transience of life.

Exceeding the Documentary: It's not that in my art practice I reflect only on the past, or that I'm concerned with representing only that which no longer exists. Rather, I'm fascinated by the process of creating an image. Previously, I did only photography – and photographs are still the main component of my work. But I have become much more interested in the conceptual side of the work. Now my interest is in exceeding the limits of documentary photography. I employ a greater variety of photographic techniques and styles, and have become more active in interpretation, appropriation; re-enactment; staging. Often I refer subconsciously to the theme of 'home' in my work. Probably this is what worries me most of all now. I think about how important it is to have your own home, remember the place where you were born and be able to go back there.

DOM (Document Object Model): 'In this project [see illustrations on page 9] I refer to the concept of home. *Dom* means a house, home, a building or a household in Russian. Working on this series I had to create the objects for the shoot myself. My idea was to remove these homes from their usual context and put in some kind of scenery to create theatrical illusions, to make a collage of real and imaginary

life, where the model of the house becomes the embodiment of reality and the real landscape is transformed into a theatre set.

The type of housing shown in the series is called *Khrushchyovka*. These were built in the era of President Khrushchev, who was the first to introduce mass housing to Russia. Economy-class houses of this kind were built in a number of other European countries, and even in Japan. Their construction continued from 1959 to 1985. As of today, they account for ten per cent of the total housing stock of the former Soviet Union. But now they are going to be demolished. Nobody admires them; on the contrary, they arouse only censure. The main complaint against them relates to their size and the fact that they are very cold in the winter. But a lot of Russian people still live in these houses. I decided that they deserved to be the heroes of my project.

Running to the Edge: In this series I have concerned myself with the way that history and memory are perceived through images. I explore a way of creating content around the photos through their physical presence as objects, connecting them with natural elements, thus highlighting their temporality. These flowers and petals mark the present, but at the same

time they are a very powerful vanitas symbol. Black-and-white photographs 'mean' a different era; they are a visual analogy of the idea of memory slipping away with time. The concept of this work is fragility and disappearance.

The people in the photographs are unknown to me. I found them at a flea market in St Petersburg. The idea was to create an atmosphere of general, unspecified mourning for anonymous people through the medium of photography, a medium that is traditionally valued for its claim to authenticity.

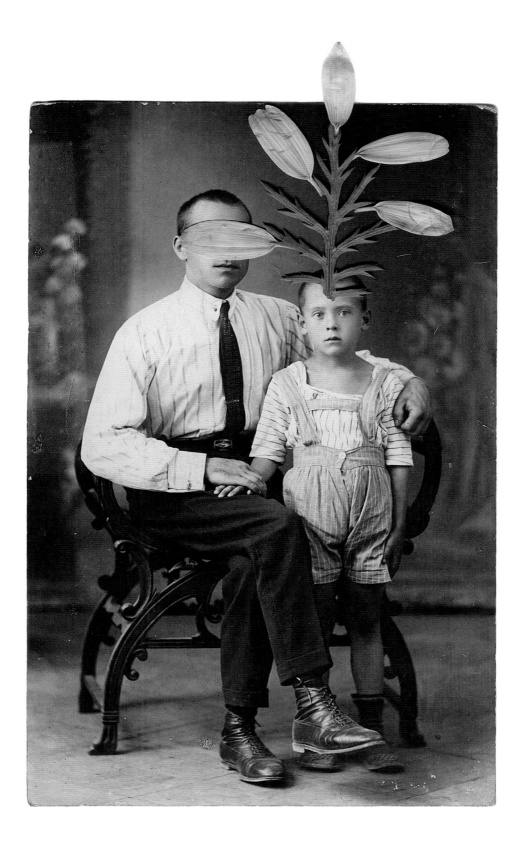

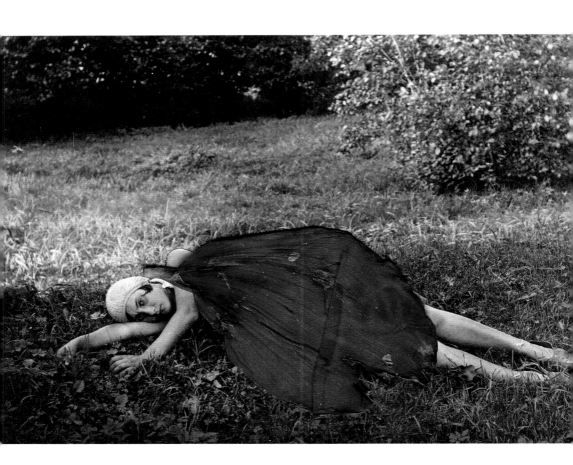

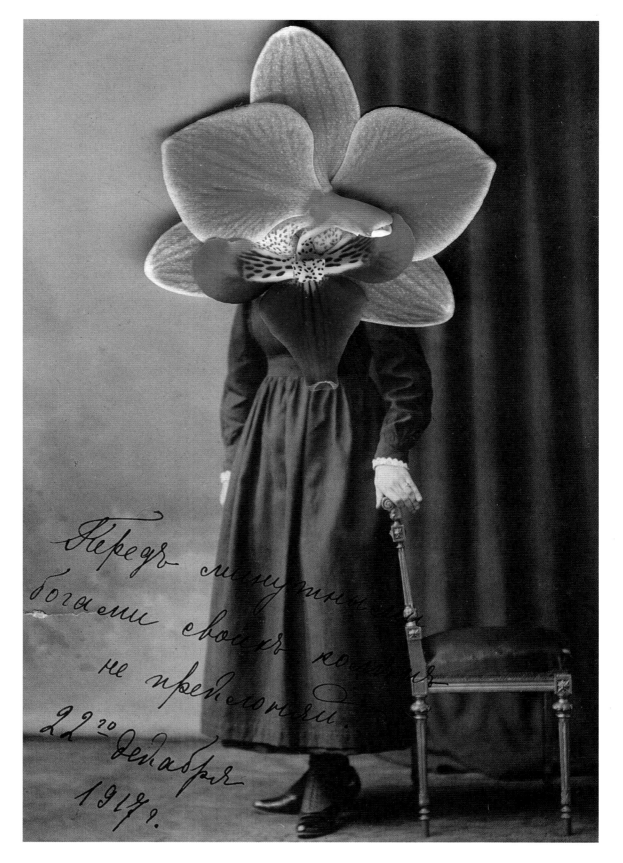

Roman Pyatkovka

Roman Pyatkovka began his career under Communism, and much of his work is aimed at subverting state control of private and artistic life. A product of the Kharkiv Photography School, he became a disciple of Boris Mikhailov. His fascinating *Soviet Photo* project employs Mikhailov's 'sandwiching' technique, layering visual clichés borrowed from heroic Soviet propaganda – an astronaut, a tractor driver – with original, deliberately amateur-looking portraits of naked women. 'They were ordinary women, who stood in lines, hauled around bags full of hard-won groceries, joined us for vodkas and lived in overpopulated communal apartments,' he has said. 'But they were also the women we were friends with, the ones we dated, fell in love with, and married.'

The Kharkiv Photography School: I was very lucky, as a young man, to meet the great photographer Boris Mikhailov. Boris is one of the founders of the photo art movement known as the Kharkiv Photography School. Here, 'School' means not an educational institution but rather a distinct genre with its own features and traditions. Many art experts today discuss this indigenous phenomenon, so it makes sense to talk of a specific photographic language born of the Kharkiv Photography School.

I come from the middle generation of the Kharkiv Photography School. This was the generation that debuted in Russia during the 1980s. Our art had no official recognition or state support, so our aesthetics were often driven by the fact of our being artists in hostile circumstances. Our art happened not because of the Communist system, but in spite of it. The lack of photo studios forced us to turn to private spaces, where communal apartments and dormitories, our personal and even intimate lives, became the proving grounds and the subjects of our art. Our models were our wives and friends, our neighbours and colleagues. The absence of high-quality photographic equipment and materials led to 'low quality' being championed as a new kind of aesthetics. The lack of formal education, oddly enough, made

photography more intellectual as it was taken up by humanitarians and various free-thinkers. Our existence outside the Socialist context critically distanced us from the Soviet art system and the political structure in general. Thus, if we're talking language, mine was born out of three things: ideologized Sots Art [Soviet Pop Art], inward-orientated conceptualism, and frighteningly simple, deliberately primitive realism.

'Sandwiching': *Soviet Photo* magazine was published between 1926 and 1992. It was the only magazine about photography in the entire Soviet Union. Like all other periodicals, it was state-published and full of Communist propaganda. I wondered what would happen if I were to combine these state-sanctioned pictures with my own underground works. It was a time when carrying a camera was enough to make you look suspicious in the eyes of the police, and when any depiction of nudity was considered pornographic.

In the late 1960s Boris Mikhailov invented a way of combining images known as 'sandwiching,' whereby two colour slides were combined into one slide frame. The resulting 'sandwiches' were used to make a slideshow. This is how Mikhailov created his legendary *Yesterday's Sandwich* series. In my *Soviet Photo* series, I used the same image-overlay method. Using

Photoshop, I faithfully replicated the original method. Therefore, this series uses not only Soviet-era pictures, but the creative method of that time as well.

Roman Pyatkovka
from *Soviet Photo*, 2012

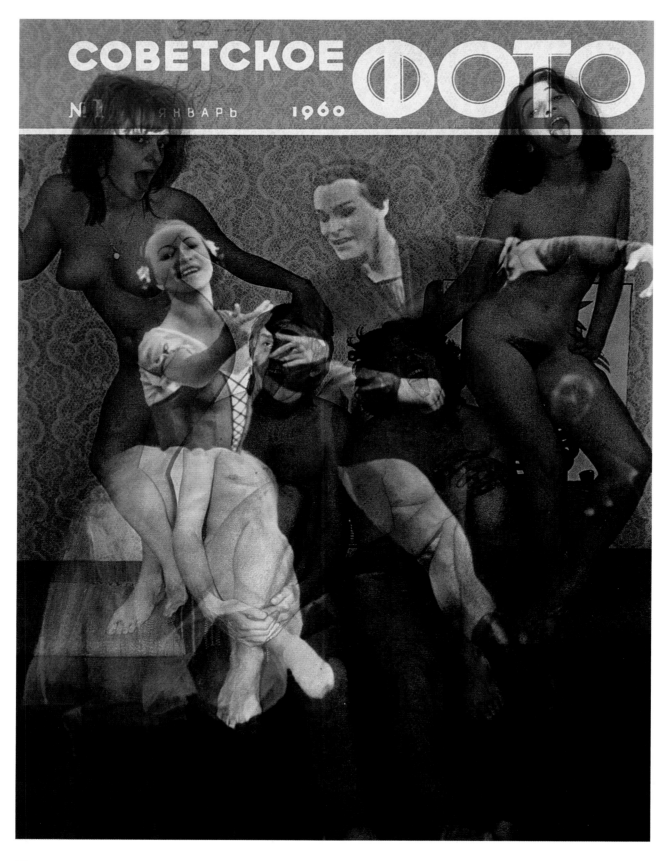

СОВЕТСКОЕ ФОТО

№ 3 МАРТ 1960

Roman Pyatkovka
from *Soviet Photo*, 2012

Brandon Juhasz

Brandon Juhasz's startling collage-based works have a distinct Pop Art lineage. They also make a radical statement about the centrality of the Internet to creative image-making: 'Stock images and Creative-Commons image searches online are the new ready-mades,' says the Ohio-based artist. 'I am interested in the idea of "folk" art – a shared collective storytelling that changes and is reinterpreted through different contexts. Photography lives like that now. We share our stories online and we contribute to this odd, non-linear documentation of our world.'

Artbot: I had a realization in my early twenties that I was making art that I thought was art. It was art that I thought art should look like. I was like an 'artbot' churning out technically proficient photographs/paintings that hit all the marks of what art looks like. Now that I can reflect on that time it had nothing to do with anything I wanted to say, just what I thought I should be saying. I stopped making art altogether for a while. I was just living life. I got a good job, got married. Then I started reading a lot and studying. I found all the debates about photography's ability to lie and manipulate fascinating, since I was experiencing a coming-of-age moment in my life where I was matching up what I thought adulthood should be and what it really is like.

Images as Objects: I was interested in exploring further where my expectations came from and I settled into thinking about images as objects and experiences that really shape our worldview. Powerful things photographs are. Plus, right around 2007 or so, digital photography was just exploding and I felt as though we were indexing our entire world on the Internet. I could have knowledge of anything I wanted instantly – I may not have experienced it in its full three dimensions or with all my senses but I knew enough to tell someone else about it or understand it. I find this ability

fascinating. Especially since we settle for that one-dimensional knowledge so often these days. So from there I married up what I was doing for work – package design – with these ideas and I started using images as my subject; making objects from images, simulacra, trying to make a photograph of photographs and forcing the viewer to look deeper into the image presented to them.

Creating the Awkward, Weird and Absurd: My work and process have evolved a lot. The earlier work, from *American Bigfoot*, say, all started with an image in mind. It was very concrete. Specific. I would sketch out the idea and begin sourcing the images I needed from the Internet: Flickr, Creative Commons, Google Images, stock sites. If I couldn't find it I would photograph it on my own. Then I would figure out how to build it and through Photoshop I would create templates/die-lines. I then would print them out, cut and glue and assemble the diorama and rephotograph it. In the beginning I wanted the end pictures to be as close to real photographs as possible, with little clues and awkward moments to tip off the viewer. But recently I have been working more to accentuate the crappiness and make them more awkward – a whole new world made from photographs that are weird and absurd.

Going 3-D in *I Can't Promise to Try*: I have become rather good at making the models so that they last longer and stay around my studio after the shoot. I have become very interested in them as objects and found that they have a real life to them. Since the early time of this exploration when I was academically investigating the nature of photography I have evolved into storytelling and finding the power that materials and objects have to more subtly tell my stories. It's not just about photography, it's how we live our lives, the products we use. How we interact. Photographs were just the tip of the iceberg. I hope to continue using photography but with a more robust, diverse supporting cast. I am falling in love with materials and objects, you could say.

Ubiquitous Photography: As a culture our relationship with photography has changed so much as a whole. I feel like it is diluted. We do it so much, so regularly and with so little care – automatically we snap pictures of everything – that I am concerned photography carries much less weight than it used to. It has less meaning to us. Do we ever even return to the hundreds of photos we take a year? Are we numb to it as a medium? I don't know.

Brandon Juhasz
Oh Shit
from *American Bigfoot Is Monkey Suit*, 2011

Brandon Juhasz
A Return to Nature
from *American Bigfoot Is Monkey Suit*, 2011

Andreas Schmidt

After leaving university, UK-based, German-born artist Andreas Schmidt took a traditional route into professional photography, taking pictures for architects, interior designers and magazines while also pursuing personal projects. The emergence of the Internet as both source and medium quickly transformed his practice, however, as he started to use online search engines, publishing the results in book form. 'My artist's books are impromptu, spontaneous outbursts and attacks, high-velocity bullets aimed at random. There is no unifying idea behind them other than "everything goes",' he says. 'The Internet has revolutionized publishing and the distribution of books and has handed some power back to the artists. I think it is a truly exciting moment to be a book-maker.'

The Internet as a Creative Source: It was an easy and logical step to engage with this new medium, similar to when most photographers switched from black-and-white film to colour. I use Internet search engines to investigate and reflect upon the present role of photography and the culture we live in. On 10 October 2008 my first two artist's books were born. They were twins. At 11:23 pm *Identity* arrived and at 11:57 pm *38 Andreas Schmidt* showed their faces to the world. In my book *38 Andreas Schmidt* I simply show 38 pictures of Andreas Schmidt that I found searching the Internet via Google Images. Without going into any great detail, there is a reasonably famous actor, a reasonably famous football player, a reasonably famous baritone and a few reasonably famous photographers.

Porn is the fastest book I ever made. I typed the word into the Google Images search bar and within 0.15 seconds I had 137 million results. I took screen shots of the first 38 (a recurring number in my books) page results and commissioned a retoucher to black out the images. The result is a twenty-first-century Malevich, spread over 38 double pages.

Real Fakes: My book *Fake Fake Art* is a double-take. I rephotographed a select number of pages from the book *Real Fake Art* by German photographer Michael Wolf, who had taken numerous portrait photographs of copy artists and their copy paintings, in Dafen, China. I then searched the Web for images of the painters whose work had been copied (Ruscha, Richter, Bacon, Hopper) and commissioned a Chinese retouching firm via email to replace the faces of the Chinese copy artists with the faces of the original artists, at a total cost of £76. The aspect of cheap labour is something that relates back to Michael Wolf's book in so far as he indicates the price he paid for each of the paintings he commissioned – in his book you can find out that a Richard Prince nurse painting, for example, cost him $29.

Conceptually, it was very important for me to make the photographs as believable as possible, so I deliberately excluded artists I couldn't find a colour photograph for (René Magritte, for example, only exists in black-and-white on the Web). Eventually *Fake Fake Art* was made up of 19 totally absurd but 'plausible' portraits sequenced in the same order as in Wolf's original book *Real Fake Art*, so in a way it is also a copy or a fake book. Two very strange effects occur when you look through *Fake Fake Art*. Because the real artists appear in the photographs and because to a certain extent we want to believe in all photographs, the paintings momentarily become more real and more authentic. At the same time we are acutely aware that the photographs have been manipulated because, like the paintings shown in them, they themselves are quite badly executed, such as when we encounter a grotesque-looking Francis Bacon with breasts, for instance. We also know that Gerhard Richter would not have been photographed in a back street somewhere in Shenzhen, China, holding up what looks like a bad version of his painting *Mustang-Staffel*, but we never fully want to abandon the possibilities presented to us. Such is the magic of photographs.

Andreas Schmidt
Gerhard Richter 3, John Currin,
Edward Hopper 2, Francis Bacon
from *Fake Fake Art*, 2012
Porn, 2011 (overleaf)

Clement Valla

Brooklyn-based artist Clement Valla's magnificently uncanny *Postcards from Google Earth* consists of a series of Internet-sourced images that appear to show highways, bridges and other features of the manmade landscape melting. Valla didn't have to manipulate or distort his materials to create these dystopian visions. 'They just look strange because of the competing inputs,' he explains. 'The topography from which the three-dimensional model was built and the aerial imagery come from different sources – one is photographic and the other is a map, an information model. Most times, the discrepancy between these different inputs is minimal and they add up to a seamless illusion, but in these instances, the discrepancy is hard to ignore. These moments reveal how the system works, how it maps aerial photography on to three-dimensional models. These images draw our attention to the system itself.'

Art and Automated Systems: The images that make up a large part of my work are generated by algorithms. Sometimes I write the algorithms, but more often the images are generated by commonly available, readymade ones. These sometimes produce images that are uncannily easy to read as art-like – as if they had been made with some aesthetic purpose. Of course, unless we choose to anthropomorphize computers, these algorithms are specifically *not* producing images the way a human might produce art. So these things exist as two-dimensional visual fields I can read as artistic images – as carrying meaning. But until I've read them and found meaning in them, are they images or just visual fields with no authors? The larger and more complicated the algorithms, the harder it is to have any sense that these images are authored in any traditional sense of the term.

The Appeal of Google Earth: Google Earth's images are created by complex networks of sensors, scanners, cameras, cars, drivers, plane pilots, engineers, corporations and governments. Their data comes from all kinds of sources – mapping companies, their own fleet of cars, governments, crowdsourcing. Their software comes from different companies they have bought up, and new versions and iterations are being worked on by all kinds of engineers.

So, when I am looking at an image on my screen produced by this whole network, who really produced the image? The answer is that no person really planned for this or that particular image to be produced. Rather the image is the result of process. And it's entirely conceivable that, as I fly around this simulated planet and point my virtual camera at specific places and at specific angles, I am seeing an image materialize on my screen that no other human has ever seen. Which is strange, because I am obviously looking at something artificial. After all, this isn't something created by the forces of nature – a landscape, a cloud formation, an interesting pattern on rocks – into which I am reading meaning. It's something that contains meaning but wasn't an act of creativity. I see more and more of these images produced by automated technologies around us, and I'm trying to figure out exactly how we deal with them, talk about them, conceptualize them.

The Digital Uncanny: I gravitate towards algorithmically produced visuals that look like they were composed by humans; that look like art. That's where the uncanny comes in. The machines producing the images I am interested in have no conception of art, of the aesthetic or of images. They produce efficient, functional grids of pixels. But it's possible to look at these images and interpret them as 'art', as a kind of aesthetic experience. It's a little like a landscape: a particular configuration of naturally occurring phenomena that happen to come together into an image of nature that stands out for humans. The major difference is that these images are spat out by systems that were human-made. And whereas we might think of algorithmically generated, encoded images as something that should look totally cold and alien, the images I'm interested in look like art. Like they were produced to have meaning and effect. It's unsettling.

Clement Valla
Postcard from Google Earth (40°26'29.66"N, 79°59'32.91"W), 2010–12
Postcard from Google Earth (34°1'45.70"N, 118°13'32.98"W), 2010–12

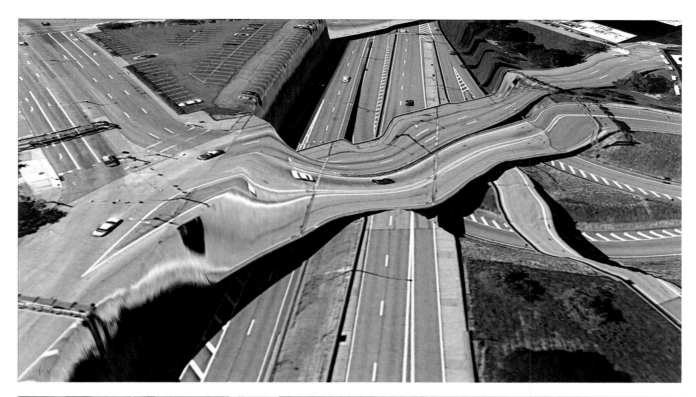

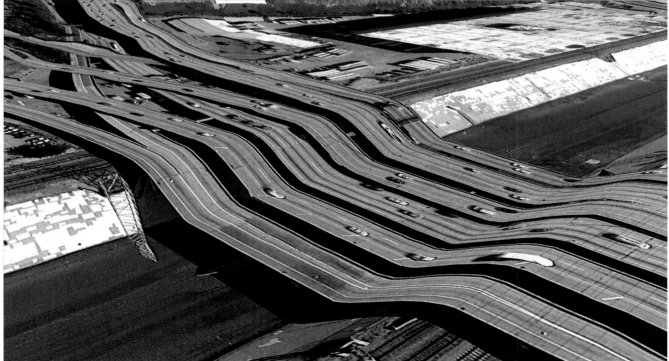

Clement Valla
Postcard from Google Earth (48°24'31.45"N, 122°38'45.52"W), 2010–12
Postcard from Google Earth (46°42'3.50"N, 120°26'28.59"W), 2010–12

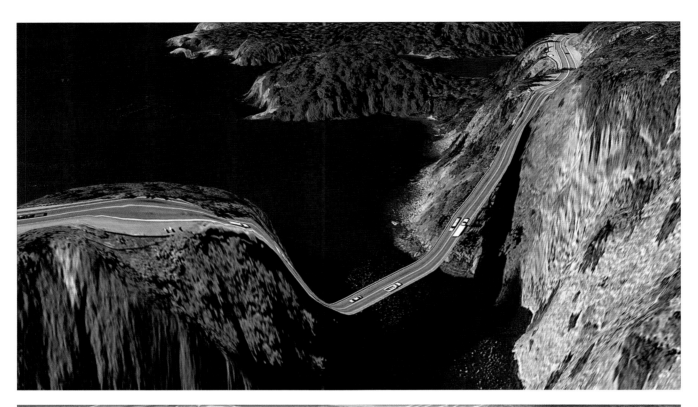

Clement Valla
Postcard from Google Earth (46°32'23.37"N, 6°38'28.25"E), 2010–12
Postcard from Google Earth (39°46'30.47"N, 105° 8'39.34"W), 2010–12

Layers of Reality

2

Although we speak habitually of the camera as having an 'eye', that eye does not see the world in the same way our eyes do. As Garry Winogrand said: 'I photograph to find out what something will look like photographed' – not simply to document an image that his own vision was already capable of presenting to him. Photographs are often said to provide human 'memory traces', but those traces are always inexorably shaped by the camera's own particular way of seeing.

The degree in which photographic seeing differs from human seeing varies enormously. The artists featured in this chapter all work in a manner that is immediately and unmistakably distinct from ordinary human vision; the ways in which they build or develop their final images underline this difference. In *Memories of the Gaze*, for instance, Jae Yong Rhee sets out to document a characteristic feature of the Korean industrial landscape, which is in the process of disappearing. He photographs the richly coloured traditional rice mills from all angles and across all seasons; then layers the resulting shots on his computer to produce ghostly final images that show the buildings spinning and apparently beginning to dissolve. Many of Valérie Belin's portraits are likewise the upshot of a sophisticated process of layering or superimposition. As she says: 'photography offers me the possibility of probing the evanescent frontiers between reality and illusion, to reveal the profound supernaturalism of my work'.

In its manner of picturing the world, Jonathan Lewis's *Designer Labels* series foregrounds the basic building-block of all digital images, the pixel, illustrating the oft-made claim that the computer screen is the new darkroom. Lewis says that his work 'focuses as much on the mechanics of the digital process, turning the mirror back on the system itself, as it does on the world outside... like everyone else I am intrigued by the growing digitization of our culture. So for both these reasons the pixel, for me, seems a natural point of departure.'

Sohei Nishino's *Diorama Maps* are built from what could be seen as analogue pixels. The Japanese photographer spends months documenting his urban walks and then assembling the images into a unique, impressionistic record of his city travels. In a similar vein, the Chinese artist Yang Yongliang uses photographs of 'blots on the landscape' – ugly, manmade features – as the basic building-blocks of his *shanshui*-influenced images. Olivo Barbieri adds a perspectival layer to his aerial shots, using tilt-shift lenses to give the individual elements in the world's greatest built environments the look of architects' plans; while Dan Holdsworth shoots using analogue film but then employs some of the most up-to-date data-processing techniques to create his eerie, emptied-out landscapes, which redefine the sublime for the post-photographic generation.

The result in the work of all these artists is a sequence of images that envision the world as no naked human eye could ever see it.

Dan Holdsworth
Forms, cg 01 (detail), 2013

Valérie Belin

French photographer Valérie Belin first won international acclaim for the pin-sharp realism of her portrait studies: the detailed, hyperrealistic human forms in her *Black Women* and *Bodybuilders* series are shown sharply cut out against plain backgrounds, abstracted from any specific context. The layering effects she has deployed in more recent series such as *Crowned Heads*, *Black-Eyed Susan* and *Brides* give her subjects a softer, dreamier appearance, the superimpositions creating, as she says, 'a form of hybridization between living and inert matter'. The continuity of vision is clear, however: 'Much more than a figurative medium, photography offers me the possibility of probing the evanescent frontiers between reality and illusion, to reveal the profound supernaturalism of my work.'

Photographic Hybridity: The *Crowned Heads* series deals with the idea of physical perfection and is reminiscent of the 'Miss' competitions in which physical superiority is rewarded. I chose to create these portraits using a three-dimensional modelling technique: they are obtained by overprinting several photographs of the same model. These girls also lose a sense of reality because this kind of composition creates a *sfumato* effect that dissolves the texture of the skin. More precisely, you could say that these photographs constitute a purely artificial but extremely realistic virtual representation of the face.

The *Black-Eyed Susan* series is an extension of my investigations into the hybrid nature of photography. I produced two distinct images, from which to constitute a third: faces of women are visible, blending intimately with bouquets of flowers. For each, an elegant woman was chosen to be styled in a manner uniquely suggestive of the 1950s. The addition of round shapes (necklace) and the billowing expansion of the character's outline (hairstyle) ensure a link between the face and the flowers. For example, the waves and rolls elaborated in the hair connect with the baroque shapes of the flowers. The pearls also procure a formal link between the flatness of the character and the relief of the bouquet (a pearl looks a bit like a rosebud). I created

and photographed the bouquets in a second phase, by connecting them with portraits previously produced (thus providing a decorative plant framework evoking wallpaper). The floral motifs are simplified and ornamental, chosen for their graphic character. The range of colours is reduced to two or three nuances; black remains predominant. Recalling the basic colours of a comic-strip panel, it is suggestive of an illusion, of superficial artifice.

Superimposition and Ceremony: In the *Brides* series, I pursue my work on ceremony and rituals already tackled in the series *Moroccan Brides* and *Bodybuilders*, where I focused on portraying the metamorphoses of the body, when it fluctuates from one state to another. This recent series extends my use of superimposition, which has developed a 'surreal' character through the profusion of detail in my work. Portraits of brides in their traditional robes (white dress, holding a bouquet) are superimposed here on urban landscapes composed of fast-food and sex-shop windows, in a direct and vulgar style. Two opposing entities therefore appear to clash: on the one hand, timeless rituals, with eternal values, sacred power and effects; on the other, the pulsating urban world with its neon lights, logos and other retail merchandising whims. Nonetheless,

the fusion created is such that a double transformation is taking place: the bride forfeits her carnal substance, part of her body evaporates and what remains of it appears to be the fragile remains of a palimpsest. In parallel, the urban elements lose their roughness on contact with the bride. The neon lights turn into stitchwork, tiaras or lace.

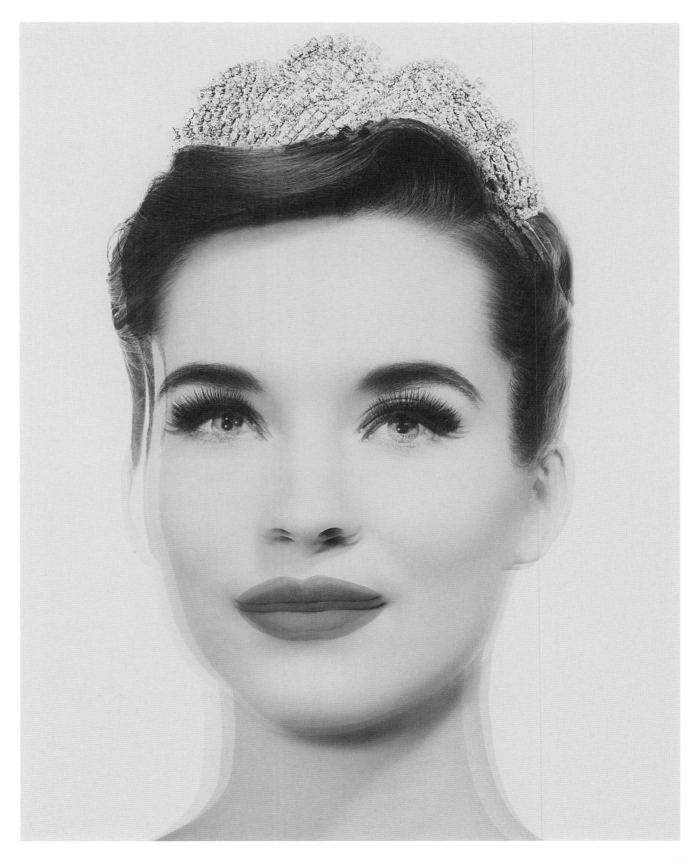

Valérie Belin
Painted Daisy (Carmine Blush Chrysanths), 2010
from *Black-Eyed Susan*

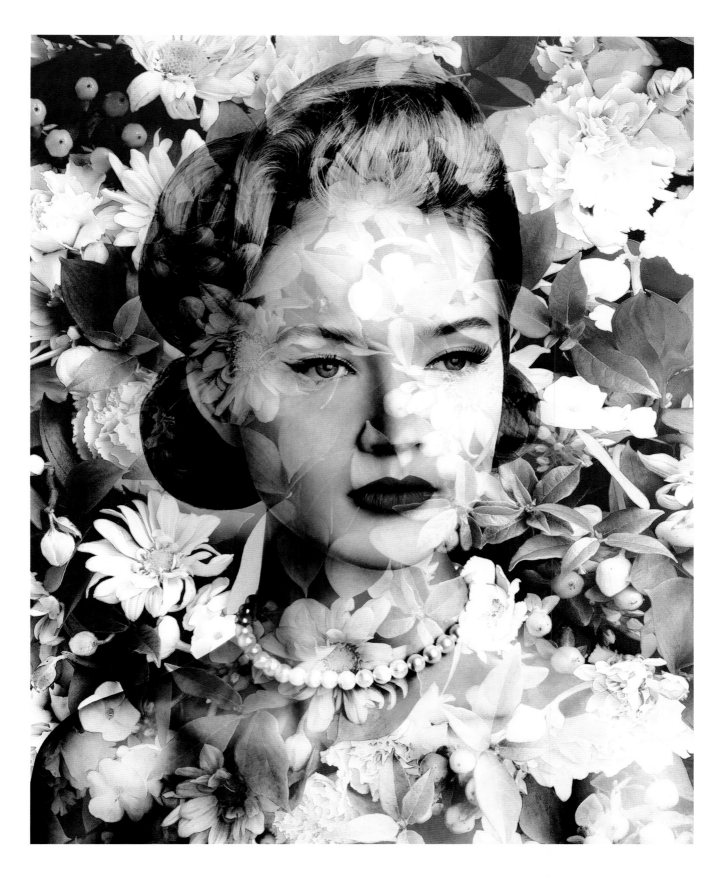

Jae Yong Rhee

Korean photographer Jae Yong Rhee's *Memories of the Gaze* series uses the very much of-the-moment technique of digital layering to offer a moving tribute to his country's vanishing industrial landscape. Each of the finished works of South Korea's distinctive rice mills is created from approximately 150 separate photographs taken from all angles across a period of a year. 'Aside from their historical and cultural significance, one is absolutely thrown off guard by the aesthetic beauty of these rice mills,' says the artist, for whom the project has been something of a nostalgic pilgrimage. 'All of them have tin roofs painted in vibrant colours that are hardly found in other types of Korean architecture, far from what I'd expected to see in the run-down structures made decades ago in rural villages.'

Time, Memory and the Subconscious: The main philosophical source for *Memories of the Gaze* is the scene in Marcel Proust's *In Search of Lost Time* where the boy's once-lost memories of Combray are brought back vividly with the taste of the madeleine (cake). This concept of finding a conduit that can bring involuntary memory, enabling our deep subconscious to re-emerge into consciousness, captivated me.

There are three concepts that are at the core of the *Memories of the Gaze* series: memory, time and the subconscious of a gaze. At regular intervals I photograph an ordinary object or scene; this then becomes an unclear memory – I capture the gazes that I project on to the object or the scene and that then subsequently disappear into my subconscious – I bring these recorded past memories (gazes) up [from the subconscious] to a present point of view and reconstruct the images, to create one final image.

What is important here is that each unit of the photograph has to be shown in one final image, and to do this I choose the method of layering. My choice is not based on an aesthetic approach, but rather a technical approach for bringing the gazes that have disappeared into the subconscious up to a present moment.

Methodology: I travel all over Korea to find the 'right' rice mill that I want to photograph. After I decide on a rice mill that I think will produce an effective image after the layering process, I begin to photograph it. I do try to follow basic principles in photographing the rice mills, for example, to capture them over the four seasons; but I am also quite flexible in practice, in terms of the exact number of shots I will accumulate or over what period (for how long) I will photograph the subject. I suppose sometimes I will continue to collect images of the same rice mills for a period as short as a year and sometimes as long as they survive, until they're demolished. The rice mills have been photographed from multiple vantage points, as I circled around them 360 degrees. So far, all the works in the rice mill series are layers of 140 to 160 photos taken over approximately one year, with a Nikon D800 and Carl Zeiss 35mm lens.

Capturing a Vanishing Korea: There is a direct connection between the rise and fall of rice mills and the development of modern Korea. Rice mills, symbolic of the agrarian society that Korea once was, have been losing ground rapidly amidst industrialization and urbanization. Of the few that are left, most of the smaller rice mills that have lived with us for a long time have been closed down, to be replaced with high-tech large-scale facilities due to mechanization in the agricultural sector. It is a challenge to discover these traditional, small-scale rice mills, scattered around the remote countryside.

Jae Yong Rhee
Self-Analysis I, II, 2008

Jae Yong Rhee
Gilsan Rice Mill
Gunsan Rice Mill
from *Memories of the Gaze*, 2012

Jae Yong Rhee
Gungsan Rice Mill
Gyerim Rice Mill
from *Memories of the Gaze*, 2012

Jonathan Lewis

British artist Jonathan Lewis's *Designer Labels* series is a mixture of the avant-garde and the deeply traditional. The pixellated look of the final images is an expression of cutting-edge digital technology, while Lewis's method for capturing his noir-ish photographs of London's most upscale commercial district was developed around the old-fashioned photojournalistic virtue of patience – waiting for night to come and heavy rain to fall. Some see the resulting works as an attack on consumer culture. Lewis isn't sure: 'It's true that these emporia are represented from the standpoint of an outsider looking in, marooned as I am in the wind and rain, but my motivation stems more from curiosity than any strong desire to criticize.'

The Pixel as a Point of Departure: A pixel – and, by extension, a pixellated image – exhibits a machine-like quality which might be construed as lacking in 'feeling' or 'meaning'. But the hand that guides that machine is the same hand that might just as easily make a mark, drip paint or click a shutter; which is to say that I don't think you can distinguish between the pencil, the brush, the camera or the computer when it comes to an evaluation of their power to communicate. In fact, if you really wanted to establish such a hierarchy I think it could be argued that the extraordinary versatility of the computer, not to mention its omnipresence in our daily lives, renders it the pre-eminent tool with which to investigate the current human condition. I certainly wouldn't make such claims for my own work, which focuses as much on the mechanics of the digital process, turning the mirror back on the system itself, as it does on the world outside. But like everyone else I am intrigued by the growing digitization of our culture. So for both these reasons the pixel, for me, seems a natural point of departure.

Creating the *Designer Labels* series: Mostly it involved waiting for it to rain, which one might not consider a problem living in London, but it was frustrating to discover how often a heavy downpour could fade to naught after only 20 minutes, the time it usually took me to get into town. The roads and pavements only really sparkle, and produce a mirror effect, when it is raining hard, so I spent many an evening on Sloane Street and Bond Street waiting in vain for the elements to deteriorate. If it went my way I would often find myself standing in the middle of the road with an umbrella in one hand and camera in the other, dodging cars and waving on taxis. Altogether quite a comical affair – that is, until the police spotted me. On numerous occasions they ran me through the system, thinking that I was engaged in some bizarre form of terrorist activity or casing the high-end boutiques for a robbery. I have a docket somewhere accusing me of disorderly behaviour.

At home on the computer I would then run my pictures through a short sequence of algorithms to achieve a slightly distorted pixellation (the pixels in this series are elongated into rectangles) and make my decisions about what was or was not working. Once I had settled on the system I never allowed myself to crop or make further adjustments, as an important aspect of the way I work and the aesthetic that I seek involves surrendering to serendipity.

Jonathan Lewis
Ermanno Scervino
Sonia Rykiel
from *Designer Labels*, 2009

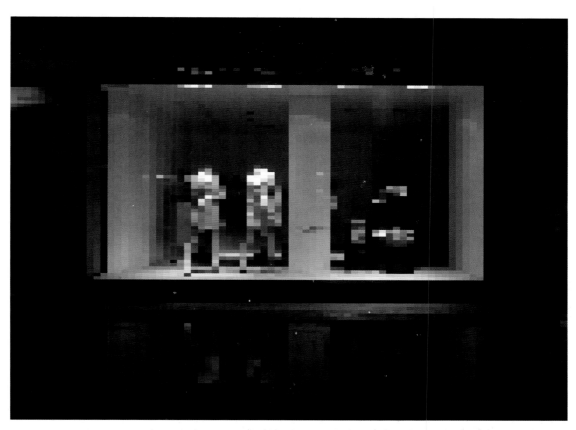

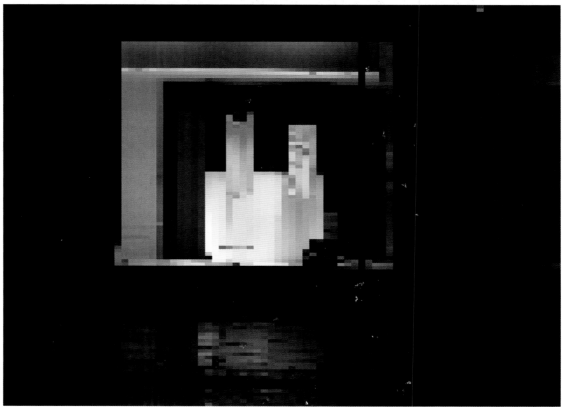

Jonathan Lewis
Krizia
from *Designer Labels*, 2009

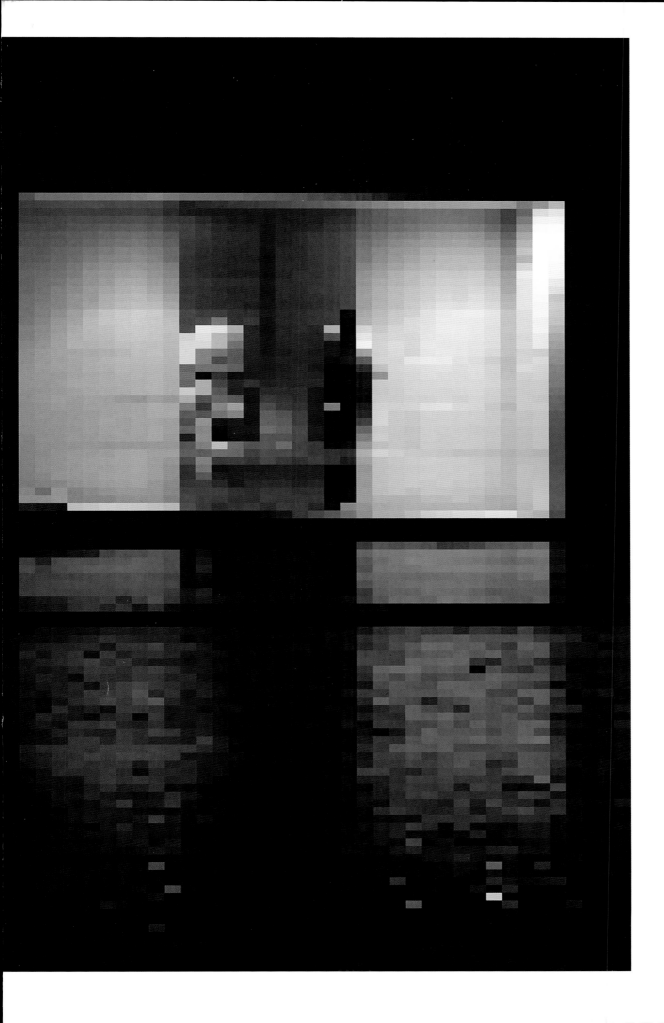

Sohei Nishino

Though they are the result of intensive research and documentation, Japanese photographer Sohei Nishino's *Diorama Maps* of cities including London, Paris and Tokyo are conveyors of wonder and sensation rather than inch-accurate surveys of urban space. To create each work, Nishino spends about a month walking around a particular city, seeking out locations and shooting innumerable rolls of film, which he develops and prints, before then spending further months assembling the images into a huge collage following the dictates of his memory and sense impressions. As writer and curator William A. Ewing has observed: 'The old Cubists would have adored these maps: we look up while looking down; we look down... and see the sky. Nishino's giddy maps remind us that cities, for all their giddy chaos, are at the core miraculous human achievements.'

The Influence of Eighteenth-Century Japanese Cartographer Inō Tadataka: I always have him in my mind; he created the first map of Japan by walking around the country. He started at the age of 55 and was still going at 71. Unfortunately, he died before completing this great project, which was finished three years after his death. In this age when we can know the world just by staying at home, we really need a passion like his.

A Photographic Triathlon: Normally, each project takes about three to four months. The process is almost like a triathlon for me and consists of shooting; developing, printing, cutting, arranging; and reshooting. I have created 15 city dioramas so far, but the number of locations and photographs I shoot is now almost five times what it was at the beginning. It is very important for me to express the local colour and characteristics of each different area. The shooting isn't planned very specifically beforehand. Once I get to the city, I walk around it intensively as if I were scanning it. Then I see how my body reacts. The parts of the city where my impressions are strongest are bigger in the final map; sometimes, if it fails to make an impression on me, I won't shoot some part of a city even though it is supposed to be important. The oddness of the resulting shape makes my work unique and quite different from a precise map. I sometimes use Google applications when I'm shooting in a city. I have experimented with making a collage using Photoshop but it came out completely different from what I had imagined, so I stopped.

The Importance of Self-Reliance: While it would save a lot of time if I asked an assistant or the lab to do some of these things for me, I use my body to complete all the various processes necessary for my work. This is because I think our normal memories are unreliable; the sense that I get through my body and my physical memory of my body are the only things I can really trust. By experiencing the whole process physically and doing all the work myself – including the walking, film processing, cutting out of images – I try to wind my memory back by means of these physical activities.

Sohei Nishino
i-Land (detail), 2007–08
from *Diorama Maps*

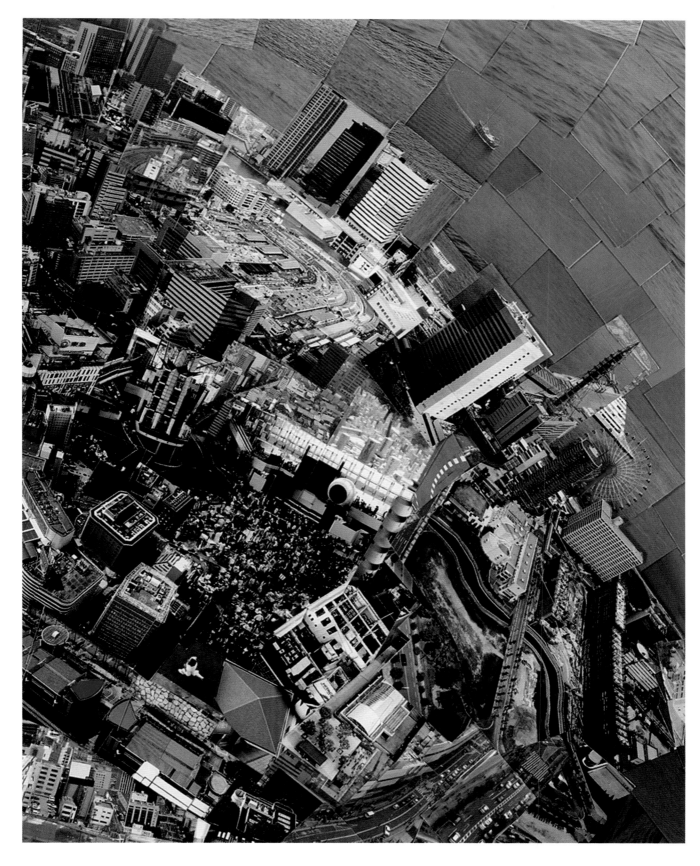

Sohei Nishino
Rio de Janeiro, March–June 2011
from *Diorama Maps*

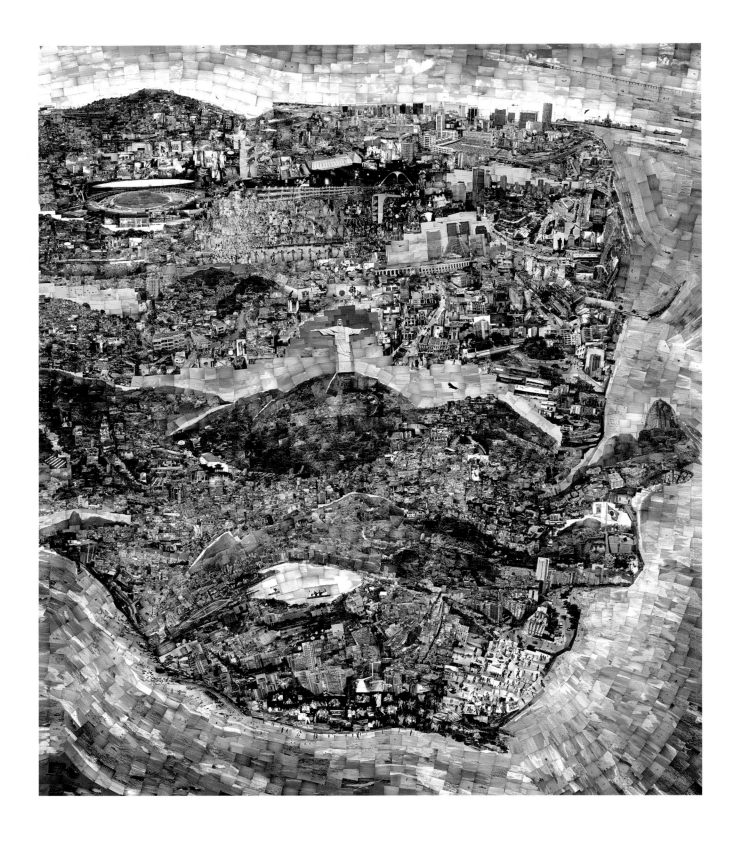

Sohei Nishino
Rio de Janeiro (detail), March–June 2011
from *Diorama Maps*

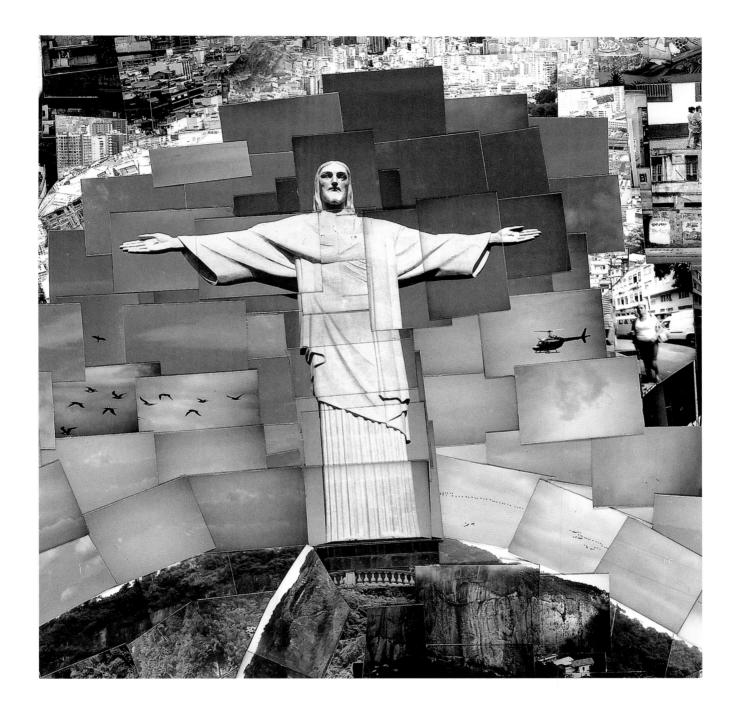

Olivo Barbieri

Italian photographer Olivo Barbieri's great subject is the sprawling modern metropolis. Barbieri's first major project focused on the glow of artificial light enfolding Asian and European cities. He then developed his signature style for his ongoing *site specific_* series. This involves him flying high above the world's great urban spaces in a helicopter and employing tilt-shift lenses and other innovative techniques to turn vast cityscapes into what look variously like miniature models and architects' plans. 'It is a completely different view from the air,' he has said; 'you can understand the real shape and size of a building.' The resulting images hardly look like photographs at all. Not that this troubles Barbieri. 'I've never been interested in photography, but in images. I believe my work starts when photography ends.'

A New Renaissance Workshop: I was attracted to the works of Man Ray and Andy Warhol. I was pretty sure photography would become the century's most important art form. I always work with good technicians; I ask for technical solutions for the concepts I want to accomplish. I am a theorist, not a technician. Thanks to new technologies I've found there is a new 'Renaissance Workshop' dimension to my practice.

Cities and New Ways of Photographic Seeing – from tilt-shift lenses to *site specific_*: Today's megalopolises are perhaps the biggest experiment mankind has ever performed. I was looking for a new system of vision to identify easily the starting 'point of reading' inside a picture. Soon [by using tilt-shift lenses] I found that everything was turning into a scale model, a plastic model of the portion of the pictured world. The pecking order and the dimensional relations among objects, buildings and people were changing. I asked myself what would happen if I detached myself from Earth and used a flying object such as a helicopter. After September 11th, I wanted to understand what you feel when you turn your point of view upside down: going from a threatened terrestrial being to a flying and threatening object. I wanted to represent the world as a temporary installation in transition, and [reveal] a possibility that only art gives us: to consider it unreal, unfinished, in order to be able to interpret it, judge it, change it.

The Future of Photography: In my formative years I had to study the works of Gisèle Freund, Walter Benjamin, Marshall McLuhan, Pierre Bourdieu, Umberto Eco, Susan Sontag. Back then they exactly envisioned what is happening now. It's never been useful to talk about photography as such, I think, but rather *images*.

Olivo Barbieri
site specific_MEMPHIS 12, 2012

Yang Yongliang

The devil is in the detail in the work of Yang Yongliang. The Shanghai-based artist fuses calligraphy and *shanshui* painting with the latest technology to create striking landscapes that demand a double-take. From a distance, the works in the *Phantom Landscape* series have a harmonious appearance that draws on the centuries-old tradition of Chinese landscape painting. Upon closer inspection, however, the viewer discovers that the images are built from 'blots on the landscape': details showing building sites, electricity pylons; nature imperilled by the rapid advances of industrial society. A strange beauty is born from scenes of urban despoliation. The works in *Heavenly City* have a more obviously ominous appearance, conjuring visions of unstoppable urban development being whirled up into the sky in sinister nuclear clouds.

A Dual Education: I had a tutor who was a former teacher at the Chinese University of Hong Kong. I studied Chinese traditional art and calligraphy for about ten years during my childhood. My tutor collected antiques, so I had direct contact with traditional Chinese culture and art when I was very young. My academic background can be divided into two parts: one part involves traditional Chinese culture, as just described; the other part concerns Western art, modern digital technology, photography and software applications. I combine both traditions and approaches in my own creations.

Photography, Photoshop, Post-production: My working process is actually not very complicated, but it requires a large amount of time all the same. First, I find places to take photos in the cities, then I collect what I want and create a huge database and separate them into different groupings. Finally, I use Photoshop for the post-production work. *Phantom Landscape* is one of my earliest series in this style of production. I started work on it in late 2005. It is designed to reveal the reality that urbanization is damaging nature, and contrasts the seemingly beautiful and peaceful with ugly and chaotic details. *Heavenly City* was finished in 2008. The idea behind the series comes from the nuclear threat to human life: human beings created this massive power which is capable of destroying them. I used some three-dimensional imaging programs to achieve the simulation of the clouds in this series.

Yang Yongliang
Untitled 3, 2008
from *Heavenly City*

Yang Yongliang
A Bowl of Taipei 3, 2012

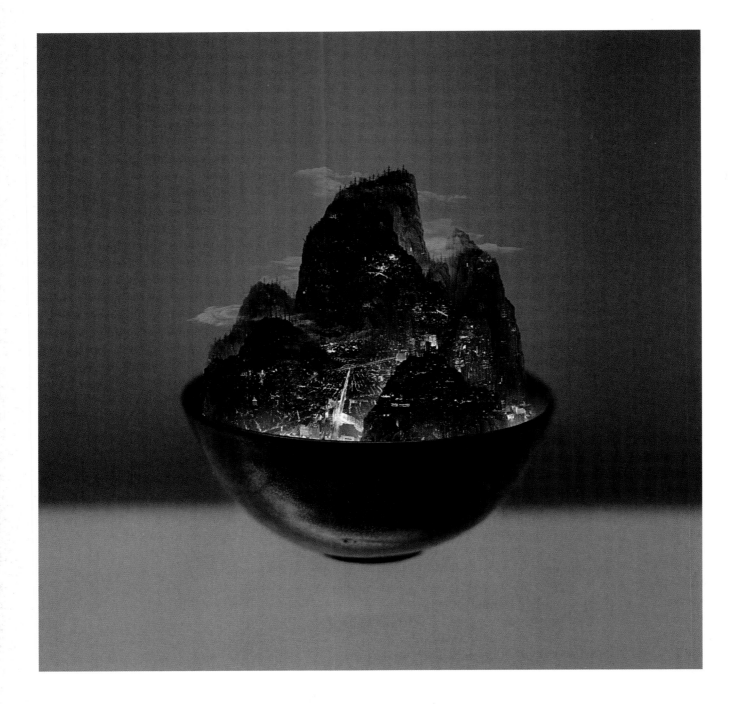

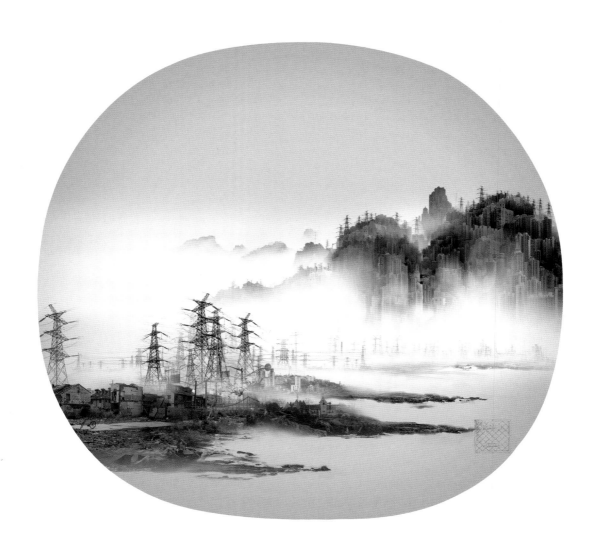

Dan Holdsworth

You won't find any people in the photographs of Dan Holdsworth. As he explains: 'When you place a figure in a landscape, you are playing with narrative – the viewer will then become interested in the story behind that figure. I am more interested in asking: Why are you here in front of this photograph, and what does it mean to you? – bringing to the viewer a more direct experience of the landscape and the environment.' Capturing liminal, deserted city zones and the remote glacial landscapes of Europe and North America, he presents environments that are simultaneously pre- and post-human, offering a sense of a world outside human time. He shoots using analogue film but draws on some of the most advanced data-processing techniques in producing his final images.

Continuity of Vision: In my early work *Megalith* I explore the image space of architectures that can appear to be virtual models of the world rather than documents of actual things. They exist in the mind's eye. This is important as it creates distance, so that the human world can be viewed from a very different position. Within the recent landscapes of *Forms* (see p. 72) this perceptual dislocation finds itself in feedback with the viewer's reading of the surface. The series explores a phenomenon known to cartographers and astronomers as 'false topographic perception phenomenon', in which the space of a surface appears inverted, expressed in, for example, geological features becoming their opposite – mountain ridges appear as valleys and vice versa.

Fade to Black: The work in Iceland for *Blackout* developed over ten years. The pictures were taken during the daytime, but as there is a volcano under the ice cap, a lot of debris is drawn down through the glacier. At the terminus, you have this great face of ice, and the ice is totally black. It is like a negative of itself. The mechanics of the earth are very visible there. You have this land of ice and this land of fire coming together in this form. Also, when you abstract the landscapes in the photographs, as I have done, you are not really aware of the landscape, so you get

this idea it could be human pollution, a coal spill or something chemical. I overdeveloped the work, experimenting with chemicals. That's why the blacks are so dense. The photos are intensely monochromatic, and I structure and edit them to be like that, losing the moss on the rocks, or the green hills on the side – all done in-camera. There are mineral colours hidden in the black. As the conditions I photograph under are very prismatic, you get this transition of colour through the field of the image, which might shift from magenta to blue to yellow to green. You can only capture these subtleties using film.

Colour: Colour and the edge of perceived colour in my work is related to a perceptual exploration in consideration to a volume of material. *Blackout*, for example, is a work made in full colour that plays with the edges of the reading of an image and our expectation/reading of the image. Further, in *Blackout* the digital inversion of the source material both restores a 'glacial' structure to something approaching the familiar whilst simultaneously/paradoxically rendering the landscape into the unknown.

Data-Driven Photography: I think the place of photography in the history of art is yet to be fully written and recognized. In my research for

Transmission: New Remote Earth Views I looked at the nineteenth-century survey photographers of the American West. Many of these photographers were the first to image the landscape, which was often photographed before it was painted. So I could see that there was this fascinating symbiotic relationship between mapping new frontiers and the sublime, the direct feedback of scientific knowledge expanding perceptual frontiers through artistic production. The mapping data I have been working with in *Transmission* has been processed with an algorithm that removes all of the vegetation and structural details. The information remaining is a raw topography, the geology of the Earth and the human geology of our hard infrastructure. What the image presents, therefore, is a surface outside any specific timescale; that is to say, a surface that has an ambiguous relationship to human time.

Dan Holdsworth
Megalith 01, 2000

UNIVERSITY H.S. LIBRARY

Dan Holdsworth
Mount Shasta D9
Grand Canyon B3
from *Transmission: New Remote Earth Views*, 2012

Dan Holdsworth
Yosemite C2
Grand Canyon B5
from *Transmission: New Remote Earth Views*, 2012

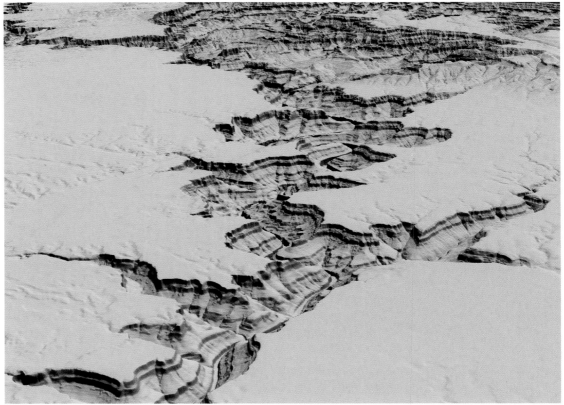

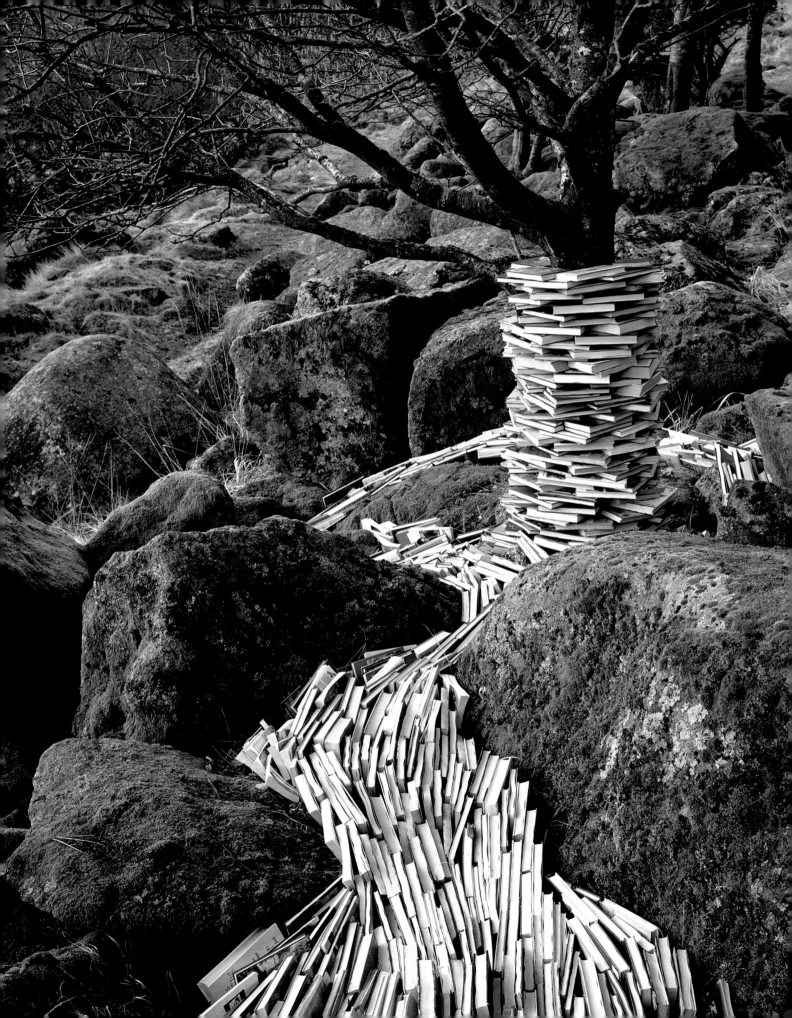

All the World Is Staged

3

One of the richest and most important strands of twentieth-century photography is encapsulated in the phrase 'the decisive moment'. This philosophy of image-making, in keeping with an ideal of photography as providing plain, unvarnished transcriptions of reality and popularized via the (often surreally inflected) work of Henri Cartier-Bresson, is interested in the way the world seems magically to assemble itself for the camera. In theory, the photographer positions him- or herself in some interesting location and then simply waits behind the viewfinder, in readiness for the moment when all the desired (not to mention, additionally, fortuitous and unforeseen) elements arrange themselves into a perfect and highly suggestive composition – and the shutter can be released. However, it has been suggested that some of the more famous examples of this kind of photography benefited from active intervention by the capturing artist: for instance, André Kertész, in his masterful cityscape *Meudon*, arranging to have the man in a hat (a friend of Kertész) walk across the street at precisely the moment the smoke-billowing train passed overhead.

Recent decades have seen a reaction to this decisive-moment approach in the emergence of the so-called 'directorial mode', in which the image-maker openly constructs or orchestrates tableaux. In some cases, although the resulting works exist only in the form of photographic images, the artists responsible no longer think of themselves primarily *as* photographers. For instance, Rune Guneriussen, whose uncanny landscapes are peopled with books and reading lamps, and who comments: 'I don't feel much like a photographer any more. A friend of mine described my works with [the words] "you don't take pictures, you make pictures". When I'm making the installation I have in mind that the camera is going to have this or that viewpoint. My mind is focused on how the installation works sculpturally and how it relates to its surroundings.'

Photoshop does not feature significantly in the practice of the artists shown in this chapter, whether their work is rooted in an exploration of the human figure (Leonce Raphael Agbodjelou, Shadi Ghadirian, Hisaji Hara, Laurence Demaison, Christy Lee Rogers) or scientific scenarios (John Chervinsky, Caleb Charland, Alejandro Guijarro, Daniel Eskenazi, Berndnaut Smilde) or more humorous or philosophical propositions (Olaf Breuning, João Castilho). Where digital editing tools are in evidence – as in the work of Angelo Musco and Erik Johansson – the final images are usually constructed from meticulously composed and arranged original photographs.

Chance – a key ingredient in the creation of most photographic work – still plays its part. As Scarlett Hooft Graafland, who traverses the globe to create her Surrealist natural scenes, says: 'Sometimes I spend days at a site waiting for the right circumstances. And sometimes it just happens – pure luck.' Which suggests that even the most elaborately staged work isn't entirely divorced from the decisive moment after all.

Rune Guneriussen
It's Common Knowledge, 2009

Laurence Demaison

French artist Laurence Demaison's works are simultaneously documentary records of real moments in time (no digital trickery is employed in their creation) and acts of personal transformation. Darker, even morbid themes figure strongly, but there's also a humorous element to her remarkable analogue-only project. Demaison's work began to evolve in 1993 after she was forced by circumstance to take her place on the other side of the shutter. Since then she has been her own model – almost exclusively, bar a recent extension into the use of dolls – so giving shape to a highly individual project. 'I discovered the delight of working alone,' she says, 'of not needing to try to translate mental images into words, of not bothering anyone else.'

Bodies and Beginnings: I first became interested in photography in about 1990. I did nudes and female portraiture and for several years I shot friends and models. My work was highly aestheticized, having as its object to show a beautiful body to advantage. It wasn't very interesting. I used myself as my own model for the first time in 1993 for a project on the hairless vagina [Haïkus] – my friends didn't much fancy posing for that one! Since then, I've never used anybody else in my pictures. It completely changed the direction of my work since I hated my body. What to do? I made up my mind to camouflage it as much as possible and to reconstruct it to make it more acceptable to me: to make something 'beautiful' out of something 'ugly' in some way. The first goal was to turn myself into something else, but also to try to express a profound malaise. Suicide, pain and death are almost always in the background of my pictures – often with a little bit of irony to lighten the effect.

Analogue Only: There's no digital element in my work – no doubt from habit, since I began my work when digital didn't exist, but also out of a need to be honest. When you're working with film, you can't cheat much. All of my images are made in the studio but it's still essential for me

that they reflect a moment that really existed, and show it just as it was, without modification. It seems to me that that's what photography is – that's what makes it magic.

In concrete terms, what I did for the *Bulles* (*Bubbles*) series was to use a flash to take my own portrait through moving water: a glass container filled with water, my face above, the camera below, and my hand moving the water. What I wasn't expecting was the way the bubbles form little magnifying glasses. The realization of *Saute d'humeur* (*Mood Jump*) was tricky. In reality I'm lying on an illuminated surface, with a structure of false walls, floor and ceiling that lifts up so that I can slide underneath.

Right from the off I've always done my own darkroom work. At first I did it in the kitchen, then in a small annexe, now in a real laboratory. There are many ways of interpreting negatives in the darkroom. I think it's an important part of the creative process, and I can't imagine trusting anyone else with those choices.

Beyond Self-Portraiture: For a long time I'd had in mind the series of images showing a baby committing suicide. But for some reason I couldn't give myself permission to give up self-portraiture. I crossed this threshold in 2010 because, without question, I

couldn't transform myself into a baby. And at that moment I discovered something wonderful: the ability to see what I was photographing! After 17 years of juggling the crazy demands of having to be simultaneously in front of and behind the lens, suddenly being able to see and control every detail of the work gave me immense pleasure. I've never laughed as much as I did in creating this series!

Laurence Demaison
Bulle n° 1 (Bubble No. 1), 1998

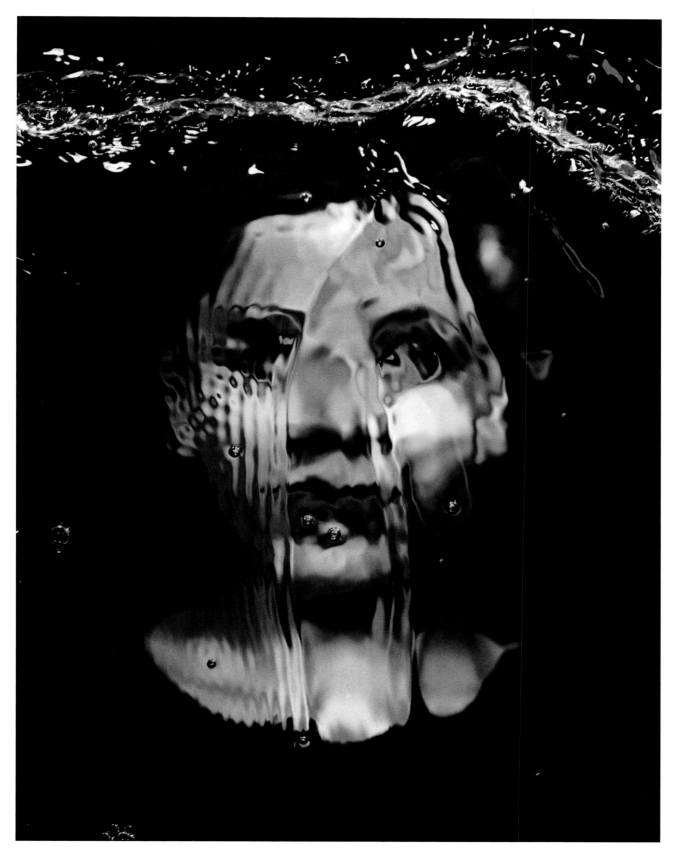

Laurence Demaison
Saute d'humeur (Mood Jump), 2004

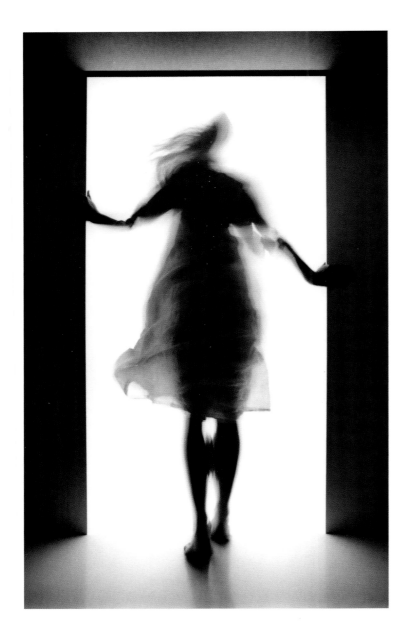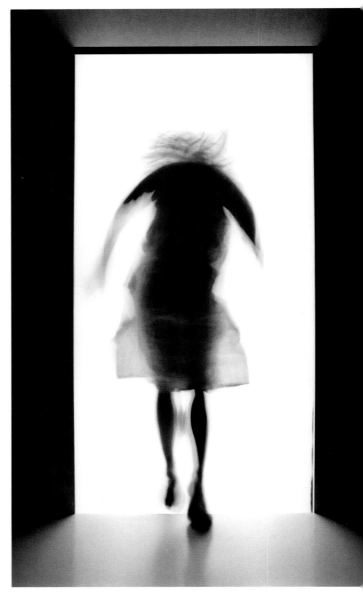

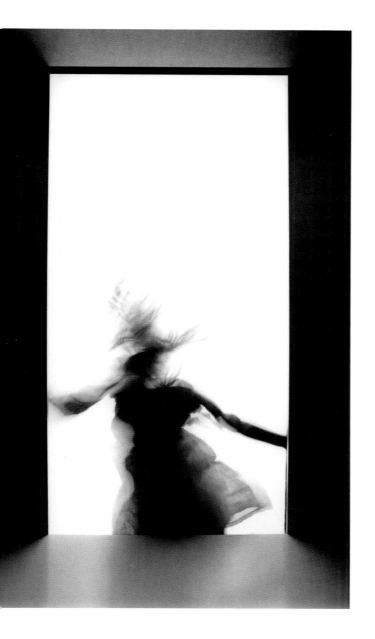

Hisaji Hara

'One long autumn night in 2005,' recalls the Japanese artist Hisaji Hara, 'I was slipping in and out of sleep, when a painting by Balthus suddenly and inexplicably flashed across my mind. I immediately began searching on my computer and discovered a small image of *Thérèse Dreaming* (1938). The painting, displayed in a corner of the LCD screen, emitted a strange brilliance. From this moment, I began to foster a strong desire to pursue the nature of his paintings in detail through my photographic expression.' And so was born *A Photographic Portrayal of the Paintings of Balthus*, in which he restaged a number of the French–Polish master's most famous canvases, deploying the iconic Japanese figure of 'the schoolgirl' in place of Balthus's disquieting adolescents as a means of crossing the cultural divide separating East and West.

The Place of Balthus in the Artistic Tradition: There were so many modern artists who tried to do something new, something that had never been done before, and tried to innovate with their various '-isms'. Balthus had never walked in step with those movements. Instead of pursuing Modernist values, Balthus stuck to a deeper tradition of painting. What he tried to do by sticking to this tradition was obvious: he wanted to achieve universality in his paintings.

To Replicate or Not to Replicate: Throughout the series, I tried to replicate the posture of Balthus's models as precisely as possible since those postures are fundamental to the paintings and were probably inherited from his predecessors in the Italian Renaissance. It was actually very hard for my models to hold the correct posture for more than a few seconds – most of the postures in Balthus's paintings are almost impossible for human bodies to attain. On the first day of shooting, the female model sprained her neck by holding her posture too long and had to refrain from shooting the next day. Meanwhile, I decided to change the dress and background in the paintings. I think there is an interesting paradox here. If I had tried to replicate his paintings more precisely – not only posture but dress and background – I might have

failed to catch the essence of Balthus's work – its universality. One afternoon, about a month before the beginning of the shoot, I was on a train. There were almost no passengers in the car except myself and a few female high-school students. The students looked tired and some of them were having a doze. Suddenly, I realized that they looked exactly like the girls in Balthus's paintings. I got off the train at the next station and called my Japanese model to tell her that I had decided to use school uniforms for the whole series.

Atmosphere and Exposure: Often I filled entire rooms with thick, heavy artificial fog using a machine large enough for a concert hall. Aerial perspective was controlled by manipulating the concentration of fog hanging in the air. I also used multiple exposures. I attached an enormous matte box to the lens and hung shades to hide portions of a single sheet of film to allow me to make separate exposures of the same scene. This seemed a natural solution when an image called for the model to play two roles within a single frame. Balthus himself never worked with a great variety of models, preferring instead to portray the same individual over a long period. I followed his example – for the whole series, I worked exclusively with the same two models. Another

significant reason for the frequency of multiple exposures in this project was my intent of dissolving the 'correct' rules of perspective demonstrated by the lens. When the focus is manually shifted between exposures, or the thickness of fog is adjusted, or if the light filtering through the windows changes suddenly, irregularities occur in the strength of light registered by the lens. Such images sharing a sheet of film fail to maintain the integrity of 'optically correct' perspective. Rooms and the lives within them appear warped as a result. I am profoundly interested by these distortions, these irregularities of atmosphere, which resemble Balthus's treatment of space through paint.

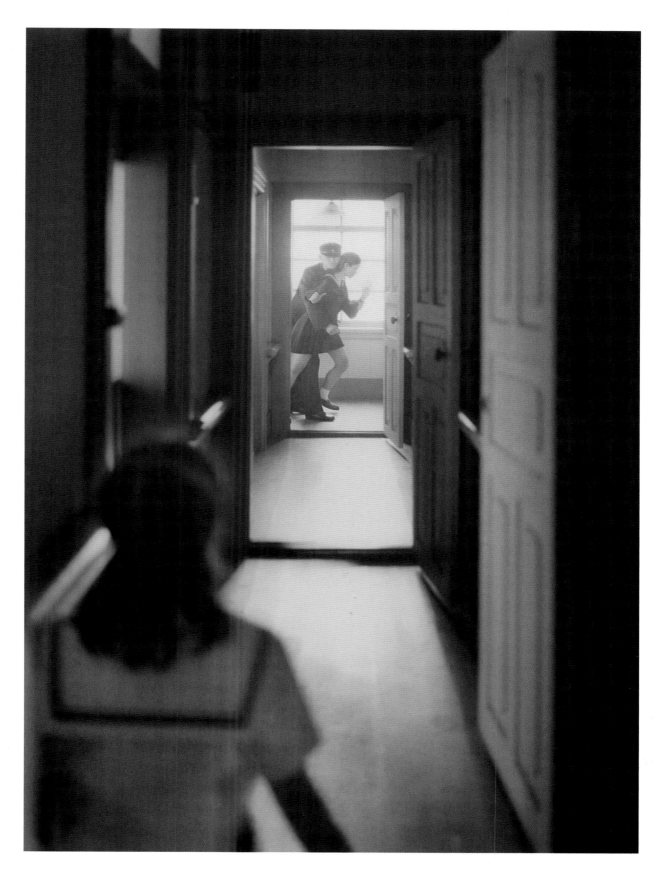

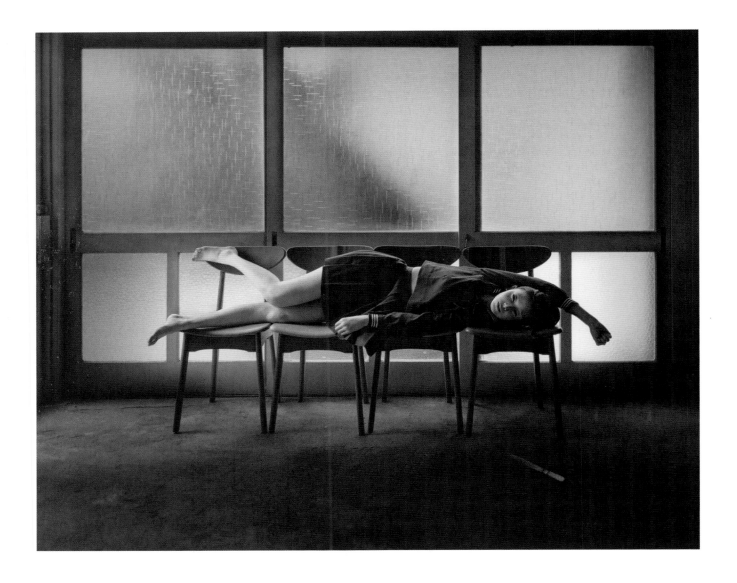

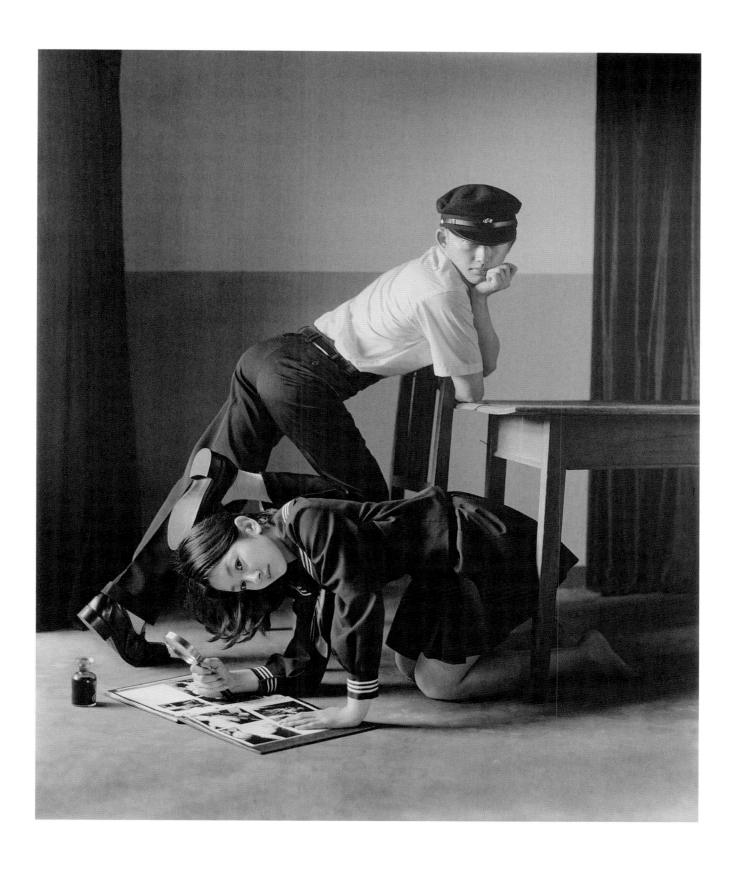

Shadi Ghadirian

Tehran-based, internationally acclaimed photographer Shadi Ghadirian's portraits offer witty, mischievous reflections on the roles of women in contemporary Iran. The *Like EveryDay* series was created after Ghadirian got married. In these images, objects associated with the role of traditional homemaker are deployed subversively, held in front of the models' faces in the manner of ready-mades, humorously masking the sitters' faces and suggesting the primacy of women's domestic roles. *West by East* and *Ctrl+Alt+Del* further explore the ways in which women's lives are shaped by society at large. 'Quite by accident, the subjects of my first two series were "women",' she has written. 'However, since then, every time I think about a new series, in a way it is related to women.'

The Power of Photography: I studied photography at university. It was an opportunity for me to meet artists and professional photographers, such as Bahman Jalali and Kaveh Golestan; after a while I became friends with them. Look up their names and you'll see how important they were and what changes they brought about with their photography. This made me realize the power of photography. So I started to tell my own stories.

The Expanding Iranian Art World: We have many galleries in Tehran now and some of them are working exclusively with photography, like the gallery I work with (Silk Road Gallery). There's now a new generation of artists who are braver than my generation were. I can see a good future for Iranian art. Artists can exhibit their works and travel now, so they can see other people's work and take inspiration from that. We couldn't do that so easily in the past.

Portraits of Women: I am a woman and I live in Iran. I want to tell my story, which is more generally the story of my generation. I was five years old when the revolution happened and then we had war for years. As a consequence I believe that my generation had special experiences. And you can add to all of these – being a woman! Not to mention

a photographer! Naturally that's hard; just as naturally, I want to focus on women's subjects.

Cameras and Techniques: I started with a Canon AE1 (that was my first camera), then I bought a Hasselblad and now I work with a Canon 5D Mk II. *Ctrl+Alt+Del* was made digitally using Photoshop; the technique for *West by East* was different. That series was made in my photographic studio. My models went behind a big pane of glass to pose and then I brushed the black colour you see in the final photographs on the glass between us.

Leonce Raphael Agbodjelou

One of the pre-eminent image-makers currently active in the Republic of Benin, Leonce Raphael Agbodjelou brings his individual style to a traditional method of working, taught by his father, photographer Joseph Moise Agbodjelou. 'Portrait photography in Benin has always had a split role. On the one hand it has been about making images of a young urban population keen to establish the modernity of their lives. Yet on a deeper level, the portraits record a people caught between tradition and progress – a pre-colonial past and post-colonial future,' he says. 'In a local sense, photography is marked by deep mysticism and dark dramas. In my work, I want to draw on these deep artistic traditions to give my portraits a sense of timelessness and an element of the supernatural.'

Picasso and the *Demoiselles de Porto-Novo*: Picasso was using imagery that referenced where I'm from. The traditional African masks made a fantastic combination with the naked bodies in his paintings. It was visually striking and it told a story. The grand old colonial house in these images has belonged to my family for generations. It was built by my grandfather, a merchant who made a fortune selling lemonade to the French and Portuguese armies. The mansion was constructed in 1890 by local Afro-Brazilian artisans under colonial rule. Benin's Afro-Brazilian culture stems from the slave trade, a very important part of Benin's history during which over 12 million slaves left the country's ports.

Today Porto-Novo feels like a city of the past, loaded with faded grandeur and dilapidated interiors. These Portuguese-style colonial buildings tell a visual narrative of Africa and its colonization. The *Demoiselles de Porto-Novo* images are both historic and modern. The girls are often bare-breasted as traditional village life dictates, wearing ceremonial or vodun masks. These masks I sourced from local villages. The interiors, with intricate carved woodwork and peeling paint, are alive with the ghosts of the past. Many of the images include old framed portraits of my grandfather. The series also raises

questions about religious practice in West Africa; one image combines a bare-breasted Egungun masked female with a Pentecostal calendar in the background. This new work is deeply personal, focusing on Porto-Novo, its citizens, a complex history and an unknown future. As always, I am shooting on a medium-format camera using natural light. The side-light from the open window shutters makes these images fantastically evocative and gives the skin tones and pastel-coloured paint a particular richness.

The *Egungun* Series: The *Egungun* series focuses on the vodun masqueraders of Benin and southwest Nigeria. They have remained at the forefront of cultural practice for Yoruba communities since the eleventh century. The Egungun are effectively multi-purpose performers, taking on a variety of roles that encompass spiritual rituals as well as acrobatic displays. They are revered and feared to this day and constitute a major pillar of local society. The costumes themselves are incredibly decorative, each crafted with the utmost care to include unique variations. Whilst some are made of glittering textured fabrics and embroidery, others, like the Adjeran, are made entirely out of animal skins. These are savage characters, while the rounder figures, Ade, are responsible

for entertaining the festival crowds in fantastical displays, and are particular favourites of mine. The styles are constantly changing, and huge amounts of resources go into creating new fashions. They change dramatically with the generations. It is a dynamic culture and I want to capture that magic and excitement in my photographs. The designs are created by specialist tailors called Alarans. These positions are sacred and often occupied by elders in the community. In the lead-up to and during ceremonies, the designers dedicate 100 per cent of their time to the costumes. The work takes place in hidden locations and it's impossible to gain access to the studios without special permission. I had to undergo a process of initiation with the tribal chiefs in order to get such close access for my work.

Leonce Raphael Agbodjelou
Untitled, 2012
from *Demoiselles de Porto-Novo*

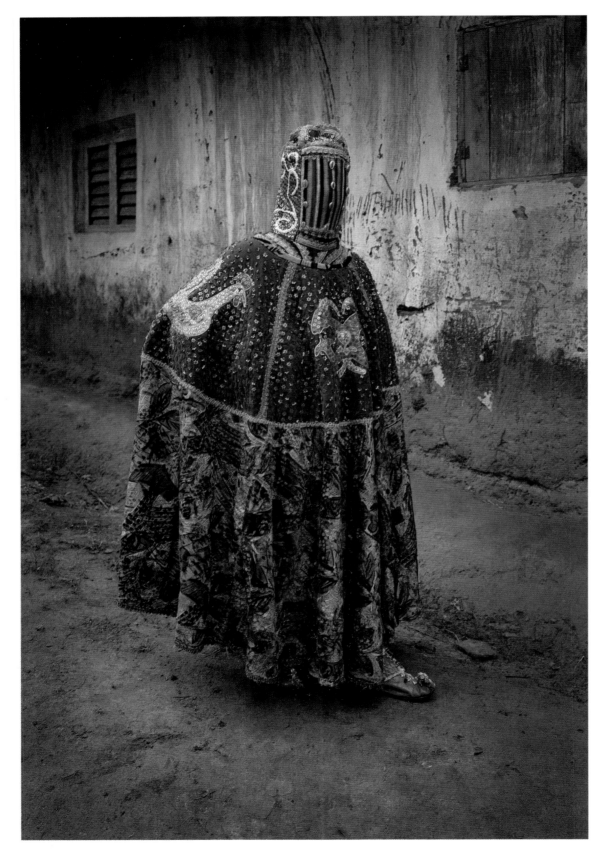

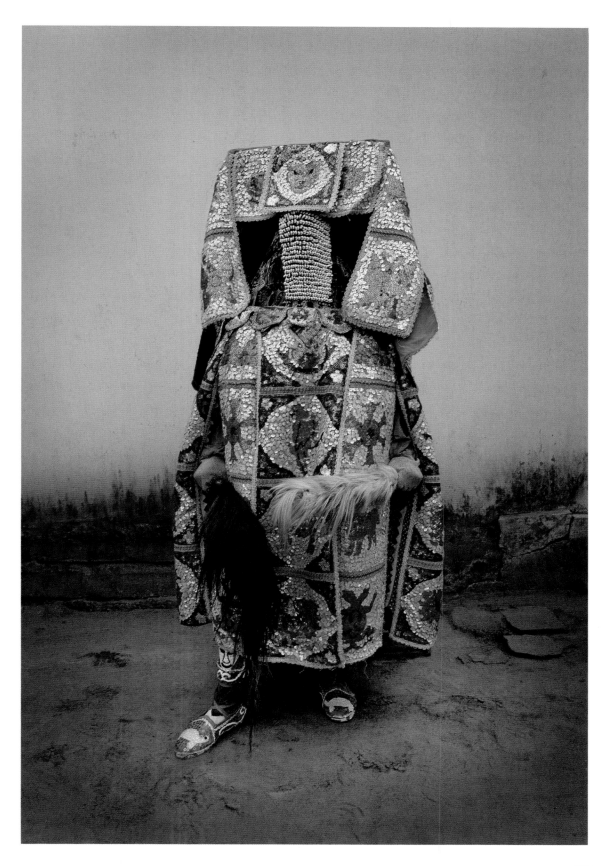

Christy Lee Rogers

US artist Christy Lee Rogers grew up by the sea in Hawaii, so perhaps it's only natural that she chooses to work in water. With their sensual rendering of flesh, use of bright colours and dramatic lighting effects, Rogers's photographs are most obviously reminiscent of Baroque art. Shot at night, no digital trickery is used in their making. 'I love what I get naturally and don't want to alter my expression in Photoshop. My intention is to create something magical that could exist, not something that I feel people will think is fake or false,' says Rogers. 'I want people to know that what they see is possible and for them to connect with it because of that.'

Beginnings: Los Angeles must have been hot and I was shooting at a friend's house that had a pool. A wedding gown came with me and as night fell I shot her in the water. There were specific emotions that I wanted to express and the messiness of water was a more interesting place to capture them. There were no major thoughts or plans about water; it was a natural instinct to go in that direction and it felt right. I had become bored with shooting reality: there was this feeling of needing to create something visually that didn't completely exist except in my mind and heart. There was also a need to explore and set myself free from the world artistically. When I saw the images that I shot that first night it was like love at first sight. I knew I had discovered my new soulmate, this new art form.

The Appeal of Water: What I find fascinating about water is that it presents a dichotomy of opposites, which is so similar to humanity. It can be peaceful, purifying and nurturing, but it can also be devouring, powerful and lethal. The ocean in Hawaii is so rough – people get terribly hurt by crashing waves and persistent currents. The body can't exist [for long] under water but yet it requires water to survive. Water nurtures and it destroys. Sound familiar? We all

have good and bad in us, the ability to create and destroy. I want to look into that area of the human condition and explore. Water is really the best place to do this.

Planning versus Chance: Every shot is an experiment and sometimes you get something unexpected, like the wind blowing across the water, which produces a fantastic effect. Even the moon can change the lighting in beautiful ways. I keep notebooks with thousands of ideas. During the initial idea phase for a particular series, there's usually a feeling of being overwhelmed because the collection must be profound in my mind and very precise. After coming to a decision on my direction for the new work, I'll book a ticket to Hawaii. When that moment arrives, I've already been conceptualizing the shots in my mind for about four or five months.

Underwater Choreography: Water can become quite chaotic, especially with choreographing many subjects together, so we practise one by one. I teach each person my style and how to position themselves in relation to me and in relation to the lights. There are key points that they have to practise and hopefully master. Posing is not something that I feel works for real expression so I have my subjects stay in

constant movement. And I love to use real people as my models as they bring something very important to the images.

Christy Lee Rogers
Birth of a Star
from *Of Smoke and Gold*, 2013
Upon the Cheek of Night
from *Odyssey*, 2011

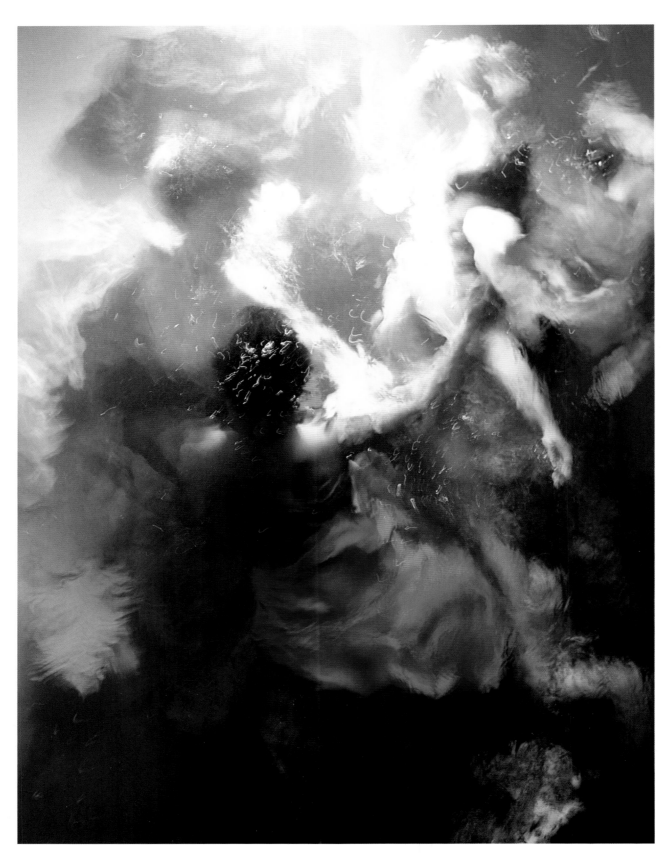

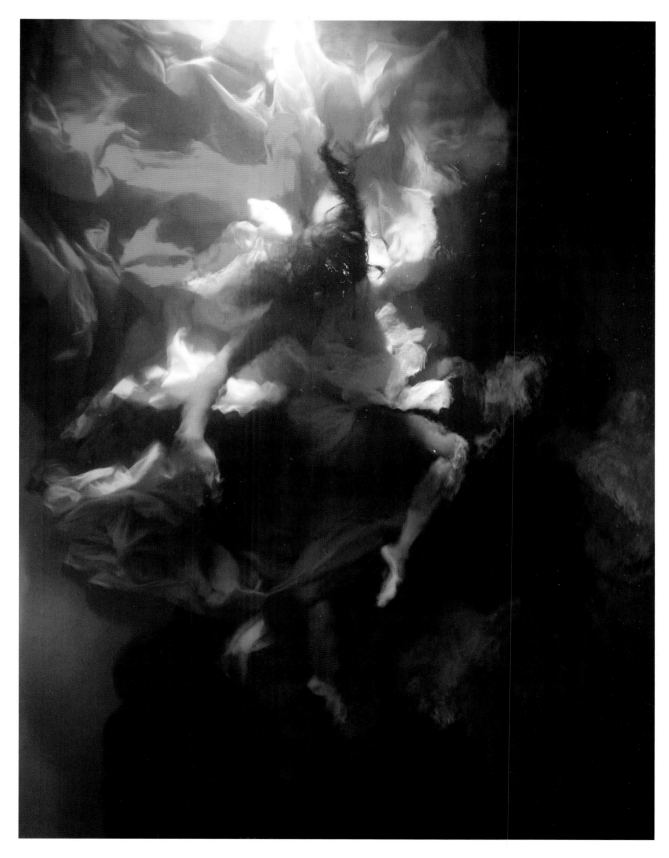

Angelo Musco

Now based in New York, Italian artist Angelo Musco builds surreal photographic landscapes out of the naked human form. Deeply marked by the trauma of his own birth – he spent eleven months in the womb and was paralyzed on one side for some time after his birth – Musco uses the body as his brushstroke, creating huge painterly tableaux. His compositions are often suggestive of the intricate interior architecture of natural organisms, shown at vast scale. Fittingly, they are the fruit of an epic working method that combines intensive research, extremely elaborate photo shoots involving hydraulic lifts and numerous models (you can volunteer to participate at Musco's website) and a lengthy post-production process of 'beautification'.

A Project Begun in the Womb: My birth really left its mark on me, and I am reminded of that trauma every day. I think having some emotional and physical harm done to our bodies causes a heightened awareness or appreciation of physical things, so it became integral to the language I use and an underlying theme over the years. I started off studying painting at university and experimenting with photography. Today's technology has really allowed me the freedom to reimagine and manipulate how the nude body is used. The bodies become like brushstrokes or a material I use to weave.

A Million Bodies and More: I do a lot of research – I collect images, pictures, scientific data, mythological stories – which culminates in building models and templates. Another key step is considering what sort of photo shoot needs to be scheduled, and what type of space is needed in order to capture the images and get the body angles needed to build the piece. We found a beautiful vacant bank in downtown Manhattan with very high ceilings that allowed my assistant and me to use hydraulic lifts above the models to get the necessary perspective for both pieces. We have a final phase we call 'beautification'. That happens after the image is completed, when we go over it inch by inch to clean, edit, shade,

light, alter colours and polish the work. *Phloem* contains over a million bodies, with the largest being about 10 centimetres (4 inches) and the whole piece is 6 metres (20 feet) long.

Creating an Altered World: In my studio I have three people working with me, and then for a photo shoot we'll grow to eight to ten people. We use a variety of different techniques for photo and video shoots. Video is an area I'm exploring more and more. At a photo shoot we need a background that contrasts clearly with skin tones so that we can easily separate the bodies from the background; green or blue works very well. The bodies or group poses are separated from the background, cleaned up and placed into an archive that we then pull from to build the image. We construct large scenes from many, many small units. The final print can be anywhere from 1 metre square (11 feet square) to 3 x 20 metres (10 x 66 feet). I gravitate towards larger images so that the amazing details are not lost. You can explore a 20-metre (66-foot) piece as if it were a drawing, discover super-sharp details and have the opportunity really to enter into my altered world.

Models: Anyone can register at www. angelomusco.com/registration/ to model. I use all sorts of body types but the photo shoots do require a certain

level of agility and stamina. The nature of some works dictates the need for different shapes and ultimately there needs to be a level of harmony in the composition. At a shoot there is a two-way dialogue because I feel that each model has a voice in the creative process with the energy and body language they present.

Angelo Musco
Iride. 2013

Olaf Breuning

Few artists crack funnier jokes than Olaf Breuning. The Swiss-born, New York-based multimedia artist's photographic works navigate elegantly between the worlds of high and low culture. For critic Travis Jeppesen, 'Breuning's art reflects the shallowness and veiled lunacy of the everyday, and the ease with which it may be disrupted, if only the effort could be made.' Breuning declares his frustration with the self-referential art world, in which contemporary artists lack the courage of a pioneering spirit, preferring to place themselves within an art-historical context of other artists' work. The result of this realization was his *Art Freaks* series (2011), for which he covered naked models in body paint, styled with recognizable visual elements from the oeuvres of well-known artists.

Beyond Documentation – Installations as Photographs: Since my background is in photography, all of my projects are conceived because I want to make a photographic image. It sounds stupid, I know, but in a way my photos document what I do in order to make a photo. *Smoke Bombs* may look like a performance or installation, but the structure was specially built in order to create the photo. The photo was the intended final product. I have done two so far and plan to do a few more in the future. What I really like is to have unpredictable factors: to have many people involved in lighting the smoke bombs; and then others such as the wind. Then there's human failure – one person is responsible for lighting more than one smoke bomb. It's heavy-duty work just to get one photo out of it at the end.

Art Pioneers: In my work I try to speak about our time and, sure, I speak from an artist's point of view. For me, it is a little frustrating that the pioneering works of art are more or less done. Also I realized that a lot of contemporary artists today are incapable of making works without mentioning an art-historical reference for what they're doing. It seems as though we hide behind our archives and history. My comment on this in the *Art Freaks* series is not satirical, more ironic, and means that I just 'eat' all the great pioneers and spit them out in my language as the 'art freaks'. It was just a fun project but in amongst all the fun there was also a desperate attempt to reflect the time I live in as an artist. I hope that soon I will be able to think that it's possible to do genuinely pioneering work again...

Humour in Art: *Complaining Forest* came out of an artist's residency I was invited to do in Denmark as part of a show that they were organizing ['When a Tree Falls in the Forest...' at Sølyst Skulpturpark]. I chose a piece of forest and had the spontaneous idea: We admire silent nature but what would happen if a forest started to complain? I am a big complainer; nature does not complain. I think my work is finally more than just an art joke. Humour is a fine line: it can be simple and stupid. But I hope I do more than that with my work.

Olaf Breuning
Pattern People, 2013

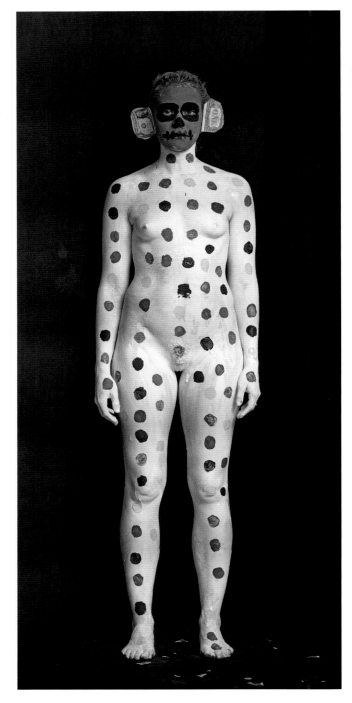
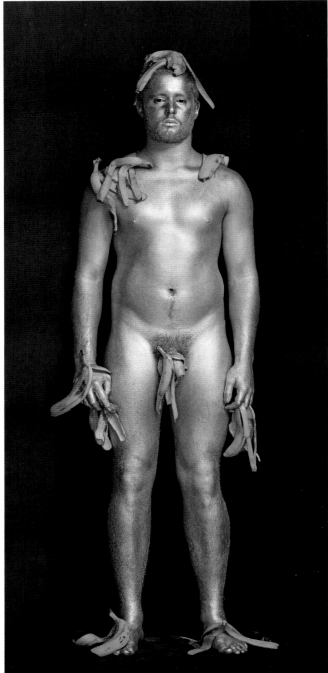

Olaf Breuning
Edvard
Frida
from *Art Freaks*, 2011

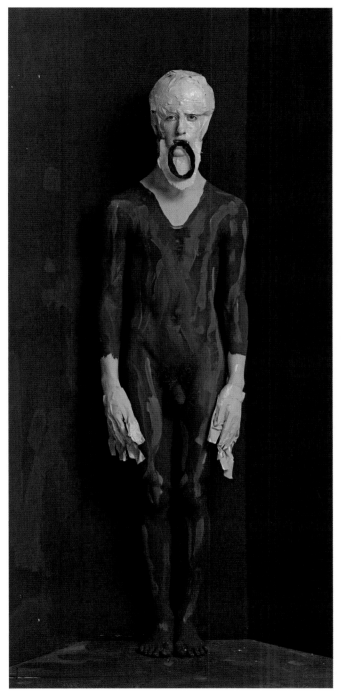
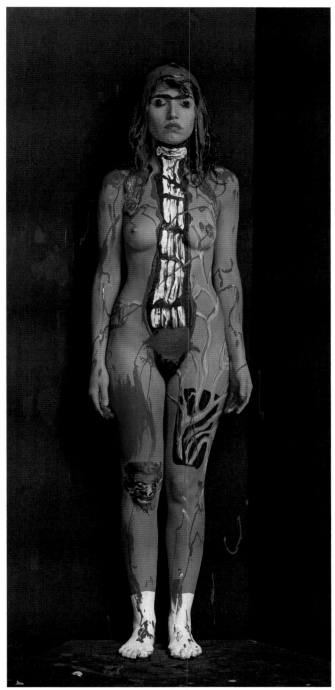

Scarlett Hooft Graafland

Globe-trotting Dutch artist Scarlett Hooft Graafland is a photographer with a 'sculptor's mindset'. 'The ideas arrive from a sculptural way of thinking, then later I recalibrate them as photographs,' she says. Her work, made in landscapes as varied as southern Madagascar, the salt deserts of Bolivia, and the Canadian and Finnish Arctic, employs an extraordinarily vivid and entirely natural colour palette and draws on the language of Surrealism. 'I really like the medium of photography; that you can orchestrate the work in a certain way, search for the most suitable landscape, for the right weather circumstances, like heavy grey skies or just one cloud in a blue sky,' she says. 'Sometimes I spend days at a site waiting for the right circumstances. And sometimes it just happens – pure luck.'

Preparation, Preparation, Preparation: I try to be as well prepared as I can before I travel to a country: do some research, read about the history of a place, the geography, vegetation, cultural background. But most of the time when I stay for some time at a place, get to know people, travel around, my ideas will develop, become more solid.

I am interested in anthropology and I do research in an anthropology library here in Amsterdam. It definitely is an important aspect of my work, even though it might not be so obvious in the outcome of the work. But most important is the contact with the local people, hearing their stories, getting an idea of how they live and survive in often harsh natural circumstances. This is what really interests me, the interaction with the local community. I like to stay with people at their house, try to get a better understanding of a place, experience it at first hand. And to experience it in time: you have to stay for a couple of weeks in order to get some understanding about the life and the habits of a place. Also coming back in a different season can be very useful, a totally different experience. To find the 'right' locals is one of the most important parts of my work. Without them I am nowhere, they are my entrance to a new world.

Refusing the Temptations of Photoshop: I do not feel the urge to manipulate my images in a digital way. I've never felt attracted to those tools – maybe because the options would then feel infinite. I like to work in a framework, with the possibilities that are on the site. That defines the work, and limits it as well. With these limitations, you have to find solutions, improvise, to see what materials are available, what you can do with the different types of weather... For example: for only two weeks a year, at the beginning of March, there is a thin layer of water on top of the salt desert in Bolivia. The effect is mind-blowing: the site becomes one big mirror! I deliberately went to Madagascar during the time when the renala baobab trees have leaves, in December.

The Intensity of Analogue: I make my photos with an analogue medium-format camera and print directly from the negative. I like this old way of producing the work, even though it is much more time-consuming than the digital process.

What attracts me about Surrealism is that there is a 'way out'. The subject matter can be heavy, but by the use of a surreal, sometimes humorous element, there is still some air to breathe. I love to play with colours! It might be childish but it really excites me to find landscapes with such bright colours, like the redness of Laguna Colorada and the whiteness of the Uyuni salt desert in Bolivia; the bright green of the spiny forest in the south of Madagascar. This is also what I love about analogue photography – the intensity of the colours in the prints.

Scarlett Hooft Graafland
Harvest Time, 2006, from *Soft Horizons*
Windmill I, 2010

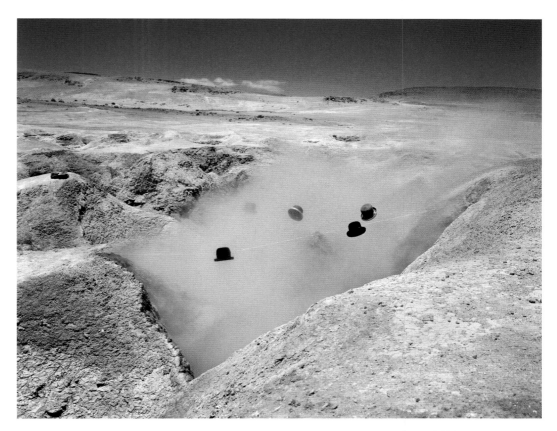

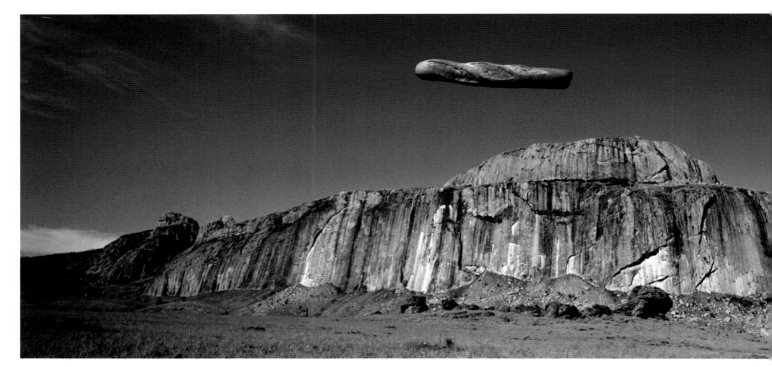

Rune Guneriussen

Telephones flocking lemming-like to the sea, bedside lamps gathering to take part in a curious midnight ritual, books flowing through the landscape like water or standing stacked in a stream – Rune Guneriussen's dreamily surreal and harmonious inspirations pair brute, beautiful nature with the manmade universe of objects. The Norwegian artist describes his work as situated at the meeting point between installation and photography. 'All my work is done in a three-dimensional manner,' he says, 'and my effort goes into making the installation, which is a huge undertaking and involves days of work. So when I go to set up the camera – a large 8 x 10 film camera, which alone takes two or more hours – it still does not feel like the major part of the job.'

Self-Definition: I don't feel much like a photographer anymore. A friend of mine described my works [saying] 'you don't take pictures, you make pictures'. When I'm making the installation I have in mind that the camera is going to have this or that viewpoint. My mind is focused on how the installation works sculpturally, and how it relates to its surroundings.

Processing the Unconscious: [Process] covers so many aspects of an artist's work: research, artistic development, test shooting, test building, practical solutions, location scouting. But let me pinpoint the planning of the unconscious: since I have the ideas with me for such a long time, they tend to pop up again and again. Every time, you break them down and build them up again. And you do this again and again. It will eventually yield results. The works are generated from a point of conception going back from one to seven years. I am very picky about which concepts to work with. Time is of the essence. But usually each work demands a few years of maturation. When it has been around for that time it has proved its significance – then it is worth putting into existence. The work on the specific installation demands a week or two, and then it takes another week or two to finish: a very long process, which is why I only finish 10 to 12 works a year.

Object Relations: This way of working with nature and forming the landscape has been with me since I was a child. It is like being in a sandbox and shaping the sand with your fingers. I still have some early shoots with lamps done 16 years ago and also the lamps I really started working on eight years later. I believe there was a good reason for waiting such a long time before developing it further.

Another turning point was a few years ago, when I met a girl and already on the first date I was invited to her home. Quite dazed by my date, and with great hopes for the future, I was turned on by her retro kitchen and its four inhabitants: two red and two yellow chairs. They came alive from the first moment I set eyes on them. On our third date I spent the night there and when the morning came I took a cup of coffee and started taking photographs in a very concise and impulsive way. It was the starting point for many projects to follow. It was such a moment. I married the girl a few years later.

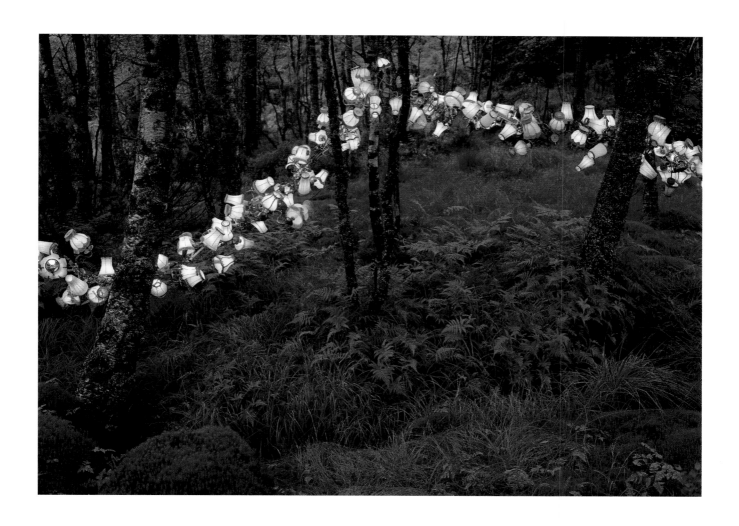

Erik Johansson

Erik Johansson's images are far removed both in concept and manner of execution from the ideal of 'decisive moment' photography that dominated pre-digital-era photography. 'I don't capture moments, I capture ideas,' says the Swedish-born, Berlin-based photographer and retouch artist. He combines his use of a Hasselblad H5D-40 digital medium-format camera with plenty of prior conceptualizing and much computer-based merging and manipulation of images afterwards. 'I see myself as a photographer because I want my work to look as if it were captured by a camera. Of course I shoot all the material myself, but to me photography is more a way to collect the wherewithal to realize the ideas in my mind. The moment is created when I put the parts of the puzzle together.'

Problem-solving Photography:
I studied computer engineering at university. Being an engineer is a lot about problem-solving and that is how I see my work as well – it's all about problem-solving, finding a way to realize something impossible. Every big problem can be broken down into smaller problems. That is how I approach my photography. I get a lot of inspiration from other artists but it's usually Surrealist painters rather than traditional photographers: Salvador Dalí, M.C. Escher and René Magritte. Their work really touches me. It's thought-provoking, which is what I'm also trying to achieve.

Location, Location: My process is divided into three different steps. The first part is planning. Once I've come up with an idea that I think is good enough to realize, I need to find the places to shoot. This can take anywhere from a few days to several months, sometimes years. This is the most important step as it defines the look and feel of the final photo: it's my raw material. This step also includes problem-solving, how to make the reflections, materials, etc. realistic. The second part is actually shooting/collecting the material. I never use stock photography in my personal projects; I always want to be in complete control of my photos and feel like I've done everything myself.

It limits me in the sense that I can't personally realize all the ideas I have, but limitations are good sometimes to define the work.

Piecing the Puzzle Together: All the photos need to have the same light and perspective when it comes to creating a realistic result. This last part takes anything from a few days to several weeks. This is actually the easiest step – provided I've made a good job of steps one and two. This part is like a puzzle: I have all the pieces, I just need to put them together. For the photo *Go Your Own Road* I wanted to make a statement that you can do whatever you want to. I think the photo symbolizes that in a very good way. Ironically, being one of my best-known photos, it enabled me to go my own way as well.

Commercial Commissions versus 'Art' Projects: To me there isn't really a big difference: it's all about a concept and realizing it as effectively as possible. The main difference is that most times I don't come up with the ideas myself for the commissioned work but it's fun to try to visualize another person's idea. In the long run I want to erase these borders completely – it should just be about concepts that make people think.

Erik Johansson
Go Your Own Road, 2008
Common Sense Crossing, 2010 (overleaf)

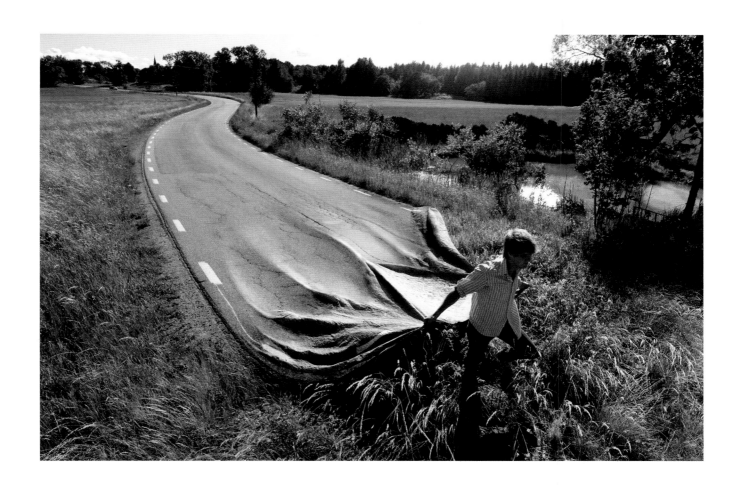

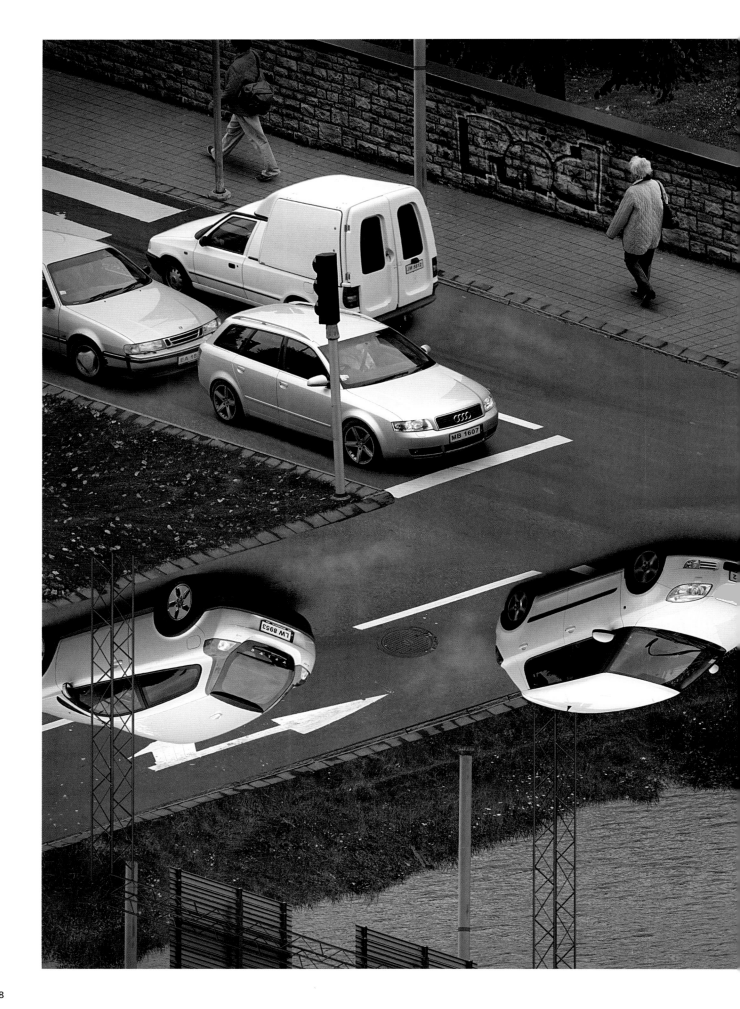

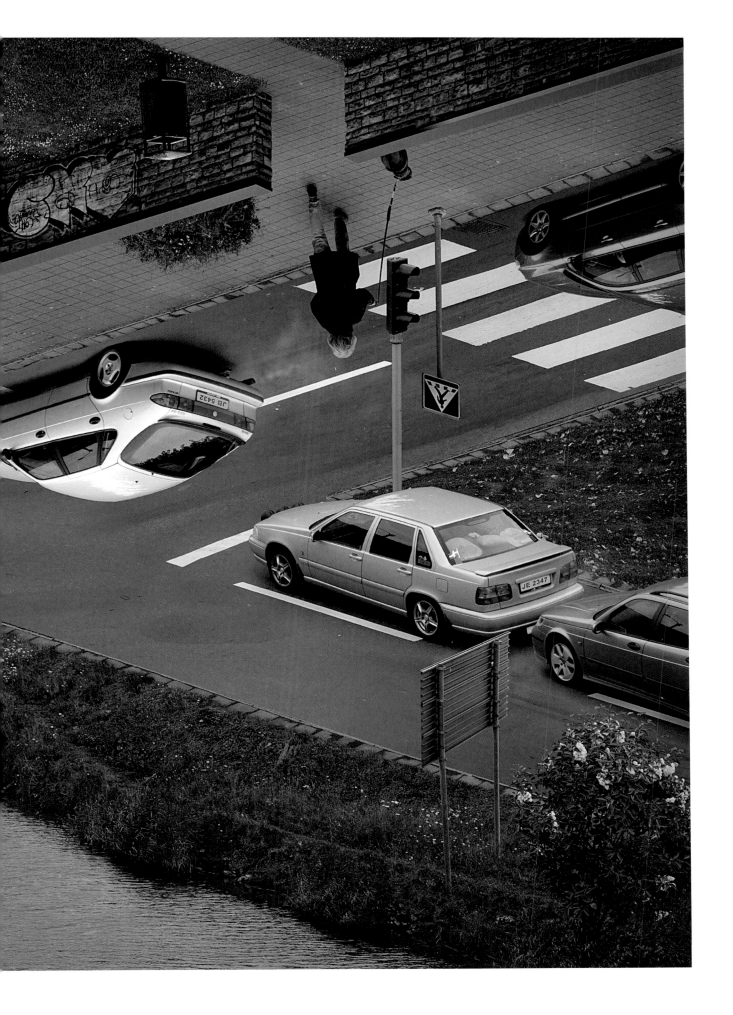

João Castilho

Brazil is an increasingly important player in the global art scene, and João Castilho is one of the country's most intriguing – and versatile – art photographers. In less than a decade, Castilho has won numerous prizes for his projects, which grow out of the so-called 'Imaginary Documentary' style and are wide-ranging in subject matter. Much of Castilho's work is characterized by his extraordinary use of saturated colour; in his *Vacant Plot* series, it confers an air of Latin American 'Magic Realism' on images of unemployed Malians relieving their boredom at day's end. *Veiled Movie*, meanwhile, uses sensational subject matter to conceptualize issues of framing and the action of time and light.

Space: The work is only complete when it has been installed in space. For me, the creation of the images is a prior step, a kind of pre-production work. It is in the gallery space that the real work is done; this is where it happens. Only when the relationship with the architectural space – that might be a gallery or museum or the pages in a book – is brought into play does the work acquire the dimensions it should have. This is when I decide whether a particular work should consist of a single image or a sequence of them, or whether it should take the form of an installation.

Working Methods and Inspirations: I almost always prefer the last light of day or what I call a 'shard' of light when I'm taking my photographs. This makes the colours in the images more saturated and helps create a quiet atmosphere. *Vacant Plot* was the first wall installation I did. The work shows portraits of unemployed youths on the outskirts of Bamako, Mali. They and I used to go to this vacant lot at the end of the day to play football. I started making portraits of them in front of this light-coloured wall: black skin before a light background created a striking contrast. When I was about to show the results, I wanted to make small prints so that they could be together, so that they could be seen together from a medium distance; then, when viewers approach, they can see the images individually.

Vade Retro is a photo-essay of philosophical inspiration, a reflection on the political situation and on man's place in the contemporary world. The images show figures, hybrid beings, bodies shattered, breaking up the traditional hierarchy between man and nature, man and animals. In this environment, darkness and discontinuity astound everyone and everything, throwing them into a state of deep restlessness.

Veiled Movie has a strong connection with the cinema. I rephotographed frames of erotic and pornographic films from the 1970s and 1980s that had deteriorated thanks to the action of light on them – they had become reddish and yellowish. The title of the work in Portuguese refers simultaneously to the chemical metamorphosis of this film material and to the covert movement of such products in society. The 24-part photo installation refers to the rotational speed of the film, which is 24 frames per second. The work is assembled in a block but no image is the same size as any other, which destabilizes the whole.

Digital and Analogue: Digital technology is ever-present as everything goes through the computer now. But its use varies greatly according to the particularities of each project and the methodology we adopt to develop this or that series. *Veiled Movie* is a work that started with appropriation: these movies were shown in cinemas in the interior of Brazil. The physical nature of the source material is of the utmost importance in this work: the fact that the film itself remains sensitive to light and continues to suffer its action after [the movie] has been completed; the soundtrack inserted between the image and the film perforation; the perforation of the film itself; the mask I use to cut the frame... But at the end of the process I used a digital camera to photograph the results.

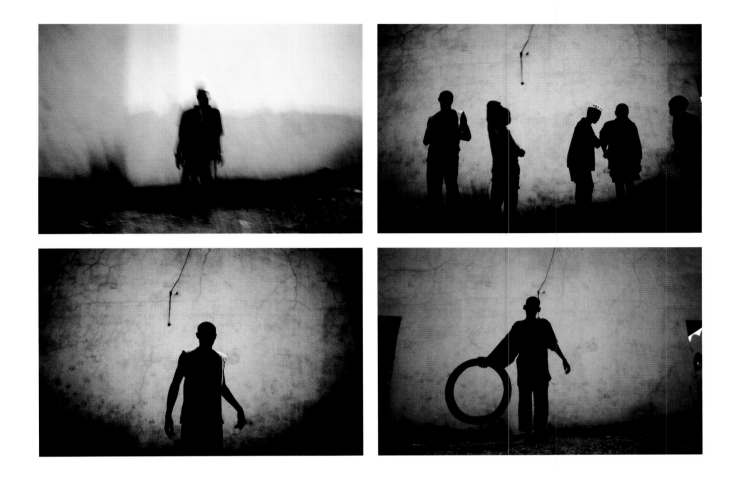

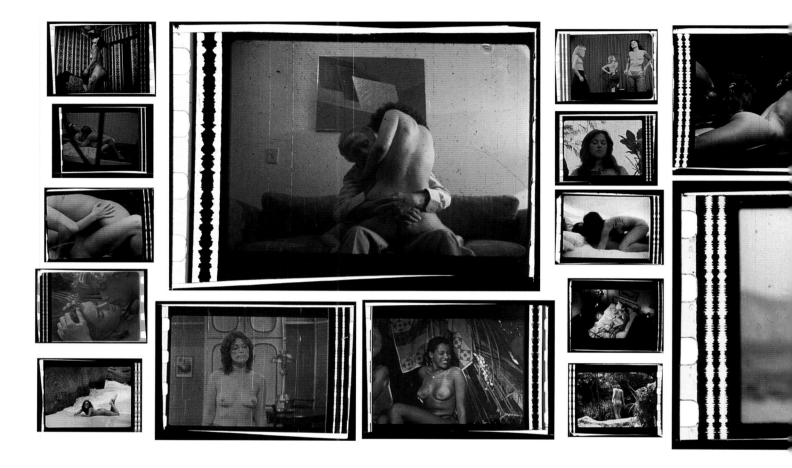

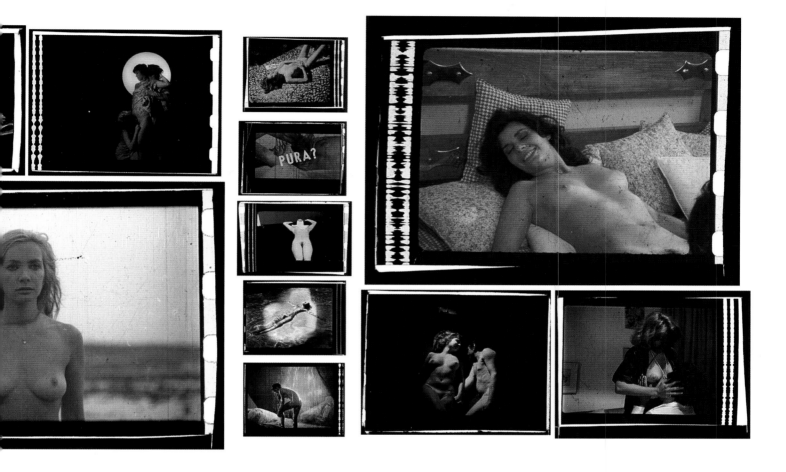

John Chervinsky

'I am fascinated by the concept of time,' says John Chervinsky, photographer and scientist. 'I can measure it, account for it in an experiment in the lab, and live my life in it; but I still don't know what it is exactly.' In his *Studio Physics* series, Chervinsky, who spent 18 years running a particle accelerator at Harvard University, creates playful, trompe-l'oeil variations on the pioneering visual time-and-motion studies of Eadweard Muybridge and Harold Edgerton. He composes and photographs a perspectively sophisticated still life; next he sends a section of the image to China to be painted; the resulting painting is then inserted into the original still-life set-up, which is rephotographed as a whole, laying bare the changes wrought by time between the creation of the original scene and the present moment.

Art and Applied Science: I've spent the last 26 years working at Harvard University in various applied physics laboratories. I ran a facility in the School of Engineering and Applied Sciences called the Cambridge Accelerator for Materials Science for 18 of those years, and started a programme to use particle-accelerator technology to aid museum conservators in the analysis of art.

While some might consider it ironic that I entered the field of art through science and technology, I feel precisely the opposite: the reasons for making art and doing scientific research are undeniably different. However, in the applied sciences, their means of production are remarkably similar. Throughout my career at Harvard, I've always had access to wood- and metal-working shops, darkrooms, wet chemistry labs and very fast computers. Aside from some very specialized scientific equipment, I don't expect a well-equipped art-school studio to be too different. Both fields require creative engagement; both fields require a level of technical mastery; and both fields have practitioners who strive for a greater understanding of the world and to make it a better place.

Extending the Image-Capture Moment: All of the *Studio Physics* images start with an ordinarily composed still life. An empty picture frame is placed within the field of view of the camera and photographed. The image is cropped to within that frame, digitized and sent via email to a painting factory in China. They produce an exact-sized reproduction with oil paint and ship it back to me. That part of the process takes several weeks, but meanwhile the objects in my table-top set-up are changing: the fruit starts to rot, the hands of the clock move forward or the sand is pulled by gravity through the neck of the hourglass. The idea is to extend the image-capture interval from a fraction of a second to a period lasting for weeks. Eventually, I receive the painting, place it within the frame and take another photograph. The frames serve as reference points in time and space.

Constructs of Representation: I would like the viewer to consider not only the passage of time that has occurred inside and out of the frame enclosing the painting, but also inside and out of the entire framed photograph hanging on a gallery wall. Furthermore, I hope to encourage the viewer to think about the very nature of representation: inasmuch as a painting is a representational construct of reality, so is a photograph and so is our way of perceiving that photograph. Now more than ever, we experience our world through various layers of representation constructed by others, ostensibly for our benefit.

John Chervinsky
Flowers, Painting on Door, 2011
from *Studio Physics*

John Chervinsky
Clock, Outlet and Painting on Wall, 2011
from *Studio Physics*

John Chervinsky
Balloon, Rock on Table with Painting, 2010
from *Studio Physics*

Caleb Charland

US photographer Caleb Charland combines scientific curiosity with a hands-on approach to making pictures. 'I utilize everyday objects and fundamental forces to illustrate experiences of wonder,' says the artist, who trained at the School of the Art Institute of Chicago. 'The English scientist Michael Faraday, whose experiments with electricity and magnetism allowed for the practical use of these forces in the modern world, once said: "All this is a dream. Still examine it by a few experiments. Nothing is too wonderful to be true, if it be consistent with the laws of nature; and in such things as these, experiment is the best test of such consistency." To understand the world and to profit from it, one must interact with it, one must experiment.' No digital trickery was used in the making of these images: all were created in-camera.

Science and Photography: Since my first photography course as a sophomore in high school (1996), the way of making photographs, or getting them to 'work', has always been scientifically based in my mind. Keeping all the variables aligned from the exposure to the print was a challenge. But it was still a medium of wonder for me, that beautiful idea of tracing light in precious metal.

Later on I realized another influence on my practice. I was building a lot of things that relate directly back to a childhood spent helping remodel the house with my dad. Seeing how he was able to alter and perfect the environment of the home instilled a sense of confidence in me that I could build my own world for the camera. I was nearly nine at the time and learned there was something magical in those materials. Snapping the chalk line expelled electric blue nebulae, a mishandled hammer drew sparks from a nail, while copper pipe, in a propane halo, emitted lime-green meteorites in all directions. These moments hover in my consciousness as visual echoes of the cosmos, revealed to me then in steel, dust and flame. If each picture is a puzzle, the pieces were formed that summer day.

Fathom and Fray: This series only existed as a group in retrospect, after many of the images were complete. I had divided my practice into various approaches or silos, thinking a body of work had to be cohesive in most respects (such as how they're captured and how they would ultimately be presented); that each group would be seen and presented similarly. But then I realized a much more interesting thing would be finding the points, or the frays, from which the images all stemmed. They all stem from that moment of wonder and being curious in the world; using photography's many inlets to explore the world. Even if something is not shot with a view camera it can quite happily occupy the space next to it and have a sense of harmony with it.

Silhouette with Matches: For me the power is the simplicity. It's two exposures on the same sheet of film. The first exposure was for the landscape, shot just after sunset. The second, the matches, occurred hours later under cover of night. I just left the camera set up waiting for dark. In a larger version of the image you can see I left a mark, a piece of wood, at the bottom of the frame. This mark showed where I positioned my feet after dark. Once I was standing there I lit and tossed several hundred matches to create what I had originally thought of as a light-rubbing. I enjoyed making rubbings of textures and objects as a child; in retrospect it seems photographic to me. Without any skill of the hand you could create a really accurate index of something. I can't really draw at all – I think that's what drew me to photography, the ability to have the light record itself.

Caleb Charland
Silhouette with Matches, 2009
from *Fathom and Fray*

Caleb Charland
Four Spheres with Compass, Penlight and Drill, 2007
Kettle with Ping Pong Ball, 2010
from *Demonstrations*

Alejandro Guijarro

Spanish photographer Alejandro Guijarro's *Momentum* series stands at the intersection between art and science, 'Documentary Realism' and Abstract Expressionism. Guijarro has toured the world's premier academic establishments and scientific institutions – Oxford and Cambridge, Berkeley and Stanford, CERN – in search of blackboards whose contents capture the mixture of absolute certainty and misty ephemerality that characterizes human knowledge. The wonderfully condensed quality of mathematical formulas gives them an appearance of clarity and finality that is brought into question in Guijarro's images with their scuffings and erasures. The final photographs are to-scale replicas of their subjects. 'The resulting object is capable of tricking the eye of the beholder,' says Guijarro. 'It becomes ambiguous whether you are standing in front of the real thing or a just a representation.'

The Place of Reality in Photography: We are living in an interesting time to work with this fast-changing medium due to the consequences of the digital revolution. I work with and against photography. I am trying to push its boundaries, exploring what photography is still allowed and able to do. Lately my work has been much more influenced by artists like Cy Twombly, Mark Rothko or Gerhard Richter. The main concern of my work is to study the relationship between photography and so-called 'reality'. I use 'devices' (fog, pollution or the erased gestures on chalkboards) to question that relationship. As I said before: 'With my work I am questioning the generalized claim that photography is factual truth. My work deals with the idea that initially "reality" is neither graspable nor comprehensible but constitutes a bizarre passage of non-knowledge to knowledge, a paradoxical coexistence of sense and non-sense. My work functions as a renegotiation of this paradox. The incomplete images test the beholder, challenging him to grasp the physical world he inhabits.'

Do the Math: Once, I was speaking with a physicist and he said that the only way to represent reality was through mathematics. That statement triggered the idea for *Momentum*. There is a contradiction in those chalkboards: physicists use them to write strong, precise and unquestionable statements about what the world looks like, but if you touch them with the tip of your finger they fall down. I am intrigued by that contradiction between the sturdiness of the ideas and the fragility of the medium in which they are written.

The blackboards function as a metaphor for the history of science: someone comes up with a theory about what the world looks like and after a while it gets erased by someone else and that one gets erased by another one. It seems to be an endless process but there always remain traces of past theories. I am interested in the philosophical implications that this branch of physics brings up. Quantum mechanics means the end of the determinism set up by classical physicists in the eighteenth century.

At the beginning it was quite difficult to get access to these institutions. I sent several emails without getting an answer, but after a while I managed to meet a physicist who used to work at CERN, but was now working in a lab in Spain. I told her my idea and she introduced me to someone from CERN; a physicist there introduced me to someone from Stanford and so on... You need to know someone in the community to get access.

Working to Scale: When I visit a university and see something that I am interested in, the first thing I do is measure it. Then I reproduce it at exactly the same size. I use a large-format camera but, even though this kind of camera gives a very detailed image, I take several photos, sweeping the chalkboard from left to right; I scan those negatives and eventually stitch them together on the computer. The result is this huge digital file that allows me to print with enormous precision. Afterwards, I frame it. Also, I am concerned about the relationship between meaning and context. These chalkboards make complete sense in their original context: physicists can understand them and relate them to specific and precise representations of the world; but when you place them in the gallery space, their meaning evolves and the equations become large, ambiguous drawings open to a number of new possibilities.

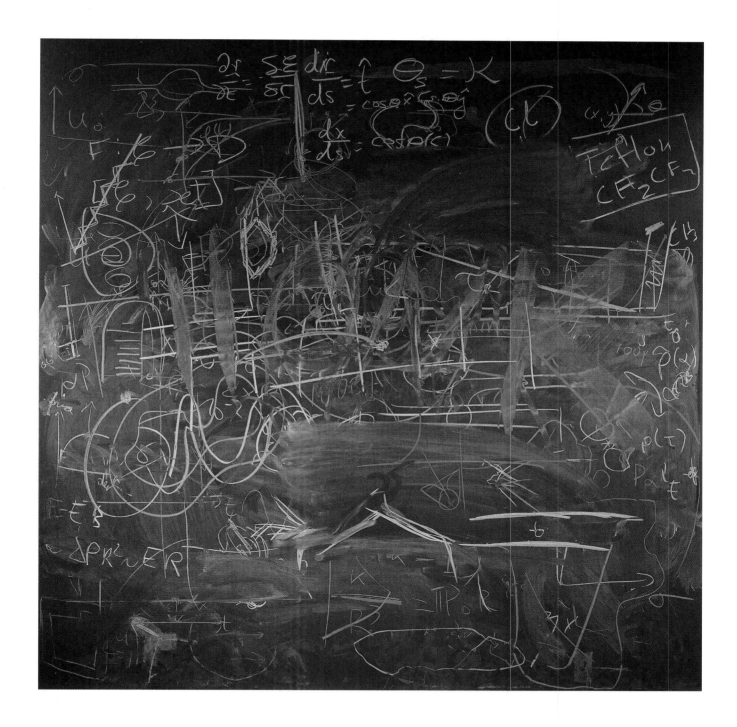

Daniel Eskenazi

The starting point for Daniel Eskenazi's *Pictures of You* series is an ancient Chinese connoisseurial practice: contemplation of 'scholars' rocks'. These naturally occurring geological formations are prized for both their inherent beauty and their elusive resemblance to landscapes or figures. Eskenazi pared his canvas and colour palette down to the bare minimum – shooting in black-and-white against a simple black background – and set about experimenting with a smoke machine. He explains: 'The tonal range came from the thickness and shape of the smoke together with directional lighting.' It is left to the viewer to reflect on and interpret the abstract, fleeting forms. 'I do not know of any other art form that is quite as subjective as scholars' rocks,' says Eskenazi.

An Eastern Aesthetic: I have no formal training in photography but I grew up in the visual arts, starting to work for the family business in ancient Chinese art soon after I graduated. This has been wonderfully instructive, training my aesthetic sense both in composition and content, with strong influences coming from the purity and minimalism so often found in Japanese and Chinese culture.

Scholars' Rocks: There is a 1,000-year-old Chinese tradition of admiring geological formations that have been selected from nature for their aesthetic form. In the Han Dynasty (206 BCE–220 CE) they adorned gardens and from the Tang Dynasty (618–907 CE) they were also brought indoors so that they could be appreciated by the literati. This resulted in paintings, poems and essays being written about the spirit of individual rocks. The Chinese terms for scholars' rocks refer to them as 'unusual' and 'strange', with connotations of 'interesting', 'wonderful' and 'special', where 'beauty' can be found in the 'ugly'. The literati contemplated the flow of energy around a rock and how incense smoke should flow around its form. It was perhaps as a result of this that I came to make the series, initially by passing smoke over a rock of my own but soon by becoming fascinated by the forms the smoke was making on its own.

Creating Solid Smoke: The camera side of things was quite straightforward: I used a digital Hasselblad with two flash units together with some polarizing filters and a simple black background. The hard part involved producing smoke that was thick and that flowed at not too fast a rate from a small smoke machine. This required a lot of experimentation with tubing and cooling to reduce the temperature of the smoke so that it would not dissipate too quickly when it came into contact with the surrounding air, as I wanted to create the appearance of a solid object from a gas. I chose black-and-white for its purity: the smoke itself was white and I felt no need to add colour. I also felt that by adding colour I would be leading the viewer into a predetermined mood which would have tainted the form.

Subjectivity: There are definitely forms in the series that are more clearly distinguishable, but the majority are elusive: the viewer has his or her own unique experience. That's why I feel the title of the series is so apt. My own response to them is unimportant... I do feel, however, that they are all tied together by a sense of the uncanny – you feel a sense of recognizing the image without ever having seen it.

Daniel Eskenazi
Untitled VII
from *Pictures of You*, 2013

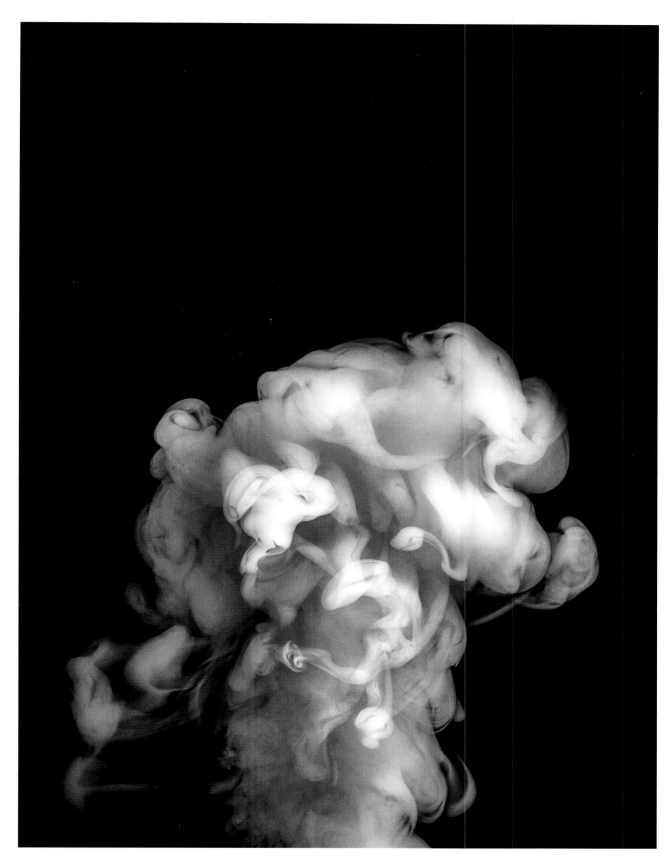

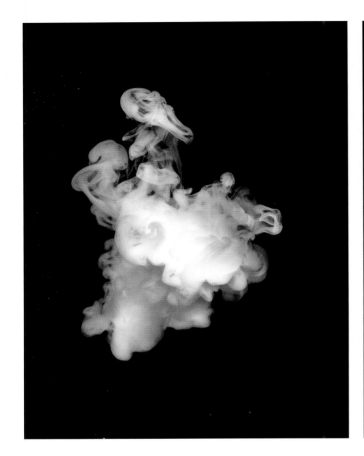

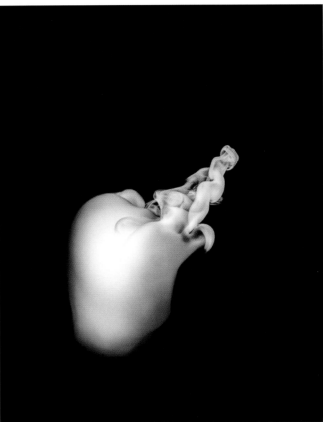

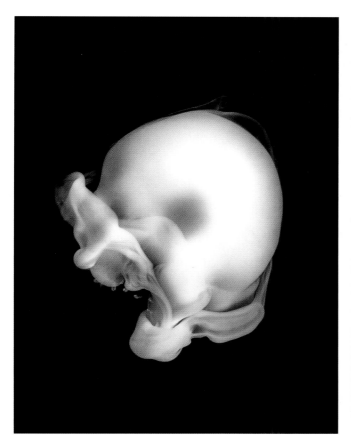

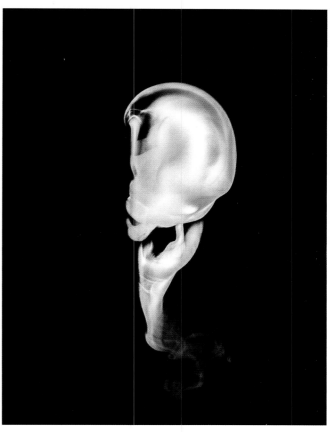

Berndnaut Smilde

One of the principal roles of photography has always been to capture impermanent states of being and eternalize the ephemeral. Dutch artist Berndnaut Smilde's remarkable collection of indoor-weather pictures began with an unusual desire: 'I wanted to see if it could be done – exhibiting a raincloud.' To realize his surreal dream, Smilde visited a series of historically interesting, empty interiors armed with a fog machine and the means to generate dramatic lighting effects. But is the artwork the photograph or is the photograph merely documentation of a performance-cum-installation? 'The work is really about the idea of a cloud inside a space and what people project on to it,' says Smilde. 'This is best represented by an image.'

Real Clouds versus Photoshop: I use a fog machine to spray moisture through the air. It helps if the space is really cold so the cloud stays in shape for much longer. I find that the best images are captured when the cloud is compact and heavy-looking. Naturally, it would be easier just to use Photoshop, but I think it's paramount that my work is physically present. I think the light and the shapes being tangible really transforms the meaning of the photographs. My work would be quite empty and pointless if I took the easy way out, methodologically speaking.

Spatial Possibilities: If you take away the objects and people that occupy buildings and spaces, there is a stronger emphasis on the bare architectural elements that people tend to take for granted. The clouds create a collision between the original state of the space and its actual function. I like to make people think about the possibilities behind every space, because very often we just think of museums as being museums, offices as being offices... By creating these clouds, I let the viewers' imaginations run wild. Clouds can be associated with a variety of emotions: perhaps they are happy, cartoonish clouds, or ominous ones that hang over the space – or they can be seen as fragments from a classical painting. Viewers are free to conceive of the meaning of these spaces as they wish.

The Place of Architecture: Usually I prefer spaces that have some historical traces. I find that I am typically drawn to spaces that are conventionally designed for other functions but have been used as exhibition venues. They lend the richness of the past to my work, and allow me to play with archetypal notions of display culture. You could say the spaces function as a plinth for the work. In my recent work the architecture as a representation of an ideal space is getting more important. I am pleased when a photograph really shows the material aspect and qualities of a space. In the case of *Nimbus NP3* the location is an exhibition space built from sea-containers. The space has a temporary and industrial character, which I really like. Specifically, I like the metal of the containers and structure, and the text on them. The Green Room in San Francisco is an American interpretation of the Hall of Mirrors in the Palace of Versailles.

The Question of Medium: The photograph is the actual artwork. I am not much interested in the process of making. The physical aspect is important but the work in the end only exists as a photograph. The photo functions as a document of something that happened at a specific location and is now gone. In the past I have invited audiences to view the clouds in person, but I found that it's not the best way to present the work. To take the images, I always work with a professional photographer; we use just a camera and a flash.

Berndnaut Smilde
Nimbus Cukurcuma Hamam I, 2012
Nimbus Green Room, 2013

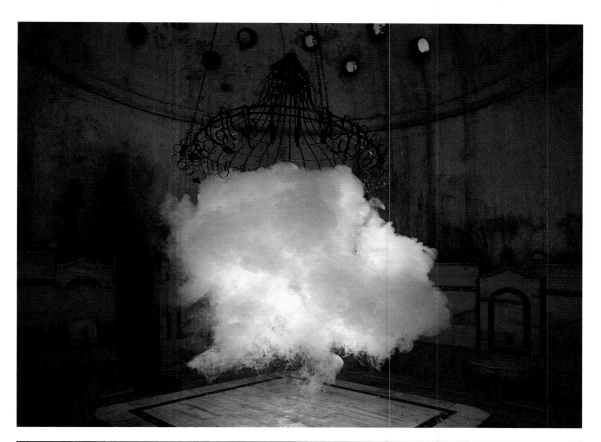

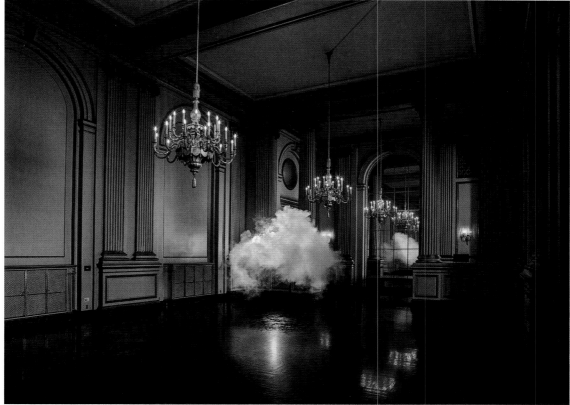

Hand and Eye

4

'Whatever it grants to vision and whatever its manner, a photograph is always invisible: it is not it that we see.' So said Roland Barthes. The 'materiality' tendency in contemporary photographic practice – which stresses the work's physical, even sculptural presence in space – is a direct challenge to the great French theorist. It is also a riposte to the increasing ubiquity of the immaterial image in the digital era, in which our handheld devices bounce photographs around the globe for easy, screen-based consumption and immediate disposal.

As Charlotte Cotton has written: 'Contemporary art photography has become less about applying a pre-existing, fully functioning visual technology and more concerned with active choices in every step of the process. This is distinctly tied to an enhanced appreciation of the materiality and objecthood of the medium that arches back to the early nineteenth-century roots of photography.' As a result, a lot of contemporary art photography involves the direct laying-on of hands in its creation.

'The work for me really does need to be a physical object. They're not that nice as screensavers,' says Aliki Braine, who deploys a hole punch in the making of many of her distinctive works. 'They are really crunchy and tactile, and you can see all the defects of the intervention.'

'I began photography with a concern for the surface of things,' Charles Grogg explains of his experiments with fragmenting, burning and sewing his images. 'But after a while I wanted to dig through the layers into something more.' Torsten Warmuth likewise envisages the clicking of his camera's shutter as just the beginning of a creative process that involves a variety of interventions in the darkroom. Jorma Puranen paints bits of wood in gloss and then photographs the reflected landscape on the wood's surface – though, in his case, the final work is comfortably two-dimensional, the processes employed in its making are often highly physical and require the active intervention of the artist's hand.

Chen Nong hand-paints the frames of his epic photographic series; Julie Cockburn embroiders and collages her found images; Brendan Fowler describes his 'Crash Pieces' as 'sculptures that involve photography'; while Steffi Klenz and Chloe Sells subject their negatives to chance darkroom processes. Dafna Talmor, who uses combination printing, a technique first developed by the Victorians, in the making of her *Constructed Landscapes* sums up one of the unique thrills of such defiantly analogue image-making. 'What's really important to me about the process is its irreversibility,' she says. 'When working digitally you can always undo an action and maintain a master file, whereas here once I've physically cut into a negative there's no turning back. I find that element of risk, and doing it blindly, exhilarating.'

Jorma Puranen
*Shadows, Reflections and
All That Sort of Thing 53*, 2012

Aliki Braine

French artist Aliki Braine began by sketching, moved on to photography and then made the common-or-garden hole punch a vital part of her practice. Extracting compositional arrangements from Old Masters, Braine makes works dominated by the circle, a form that is surprisingly unusual in photography given the traditional shape of the camera lens. These are also works imbued with a deep sense of their material presence. 'Photography is at the same point that painting was with Abstract Expressionism in the 1940s: we see a material photograph, we don't just see an image,' says Braine. 'It's because we're so saturated with photographic images that we're able to look at a photograph's material, not just the image it carries.'

From Drawing to Hole-Punching Negatives: Back in 2006, I was given a residency at the Edward James Foundation in the idyllic English countryside. I set out with the intention of making drawings as an eighteenth-century amateur draughtsman would have done. But I didn't like the drawings I was doing, so I started to think about making drawings on photographs, using the photograph as a prop. I looked at Alexander Cozens's *A New Method of Assisting the Invention in Drawing Original Compositions of Landscape* (1785). One of his techniques was to make random blotches of black ink to help stimulate images of landscape. So I began doing that with a hole punch on negatives. The crunch of the hole punch on the neg is unbelievably pleasurable. I use medium-format negatives and a little lightbox. I find it quite easy. I'm quite precise. Other people make my prints: although they're really physical, I hand over the printing work to others. Sometimes I bring them dregs – I've worked on the negative so much that there's almost nothing left.

Old Masters and Sticker Art: In some of my works, I extract information from Old Master paintings (see p. 10). Scenes by the likes of Carracci, Gentileschi and Uccello lie behind the seemingly abstract arrangement of sinister dots and holes in works in the *Hunt* and *Ugly Spots* series. The materials and techniques I employ are very simple: as well as the hole punch, I use circular stickers. A generous application of black ink to the negative blocks the light in the enlarger and produces the distinctively uncanny white forms in the *White Out* series.

Materiality: The premise of my work has always been to show the photograph as an object, to make its materiality felt and understood. The work for me really does need to be a physical object. They're not that nice as screensavers. People often want to put their fingers on the prints. They are really crunchy and tactile, and you can see all the defects of the intervention. It's because of the digital shift that photography is thinking about itself. Our eyes have become sophisticated enough to be able to enjoy a photograph even when it doesn't carry an image. I tend to include the black edge of the negative because it increases the awareness that it's a photograph, especially when it's very abstract.

The Circle: The circle is a unifying presence in my work. I don't know where that comes from: when I was a postgraduate student, I was interested in the grid. But then I started cutting out punctuation marks, which have a lovely circular feel. I suddenly couldn't understand why all images are always in a square or rectangle: why aren't they circular? We see the world in a lopsided circle. I'm obsessed with Goffredo Wals's circular landscapes. Photography lends itself to the circular frame, perhaps due to the feeling of peering through the camera or other looking machines like telescopes and lenses.

Aliki Braine
Draw Me a Tree: White Out 2, 2006

Chen Nong

Few contemporary artworks combine the epic and the hand-crafted quite like Chen Nong's. To create his extraordinary images – ambitious narratives and scenes suggestive of historical re-enactments – the Beijing-based artist assembles a team of assistants and helpers, often drawn from friends, who make costumes and props, and appear as models in his location shoots. The final works are realized without recourse to any digital intervention. Rather, Chen Nong achieves the distinctive look of the projects using a large-format camera and shooting on black-and-white film. The images are then hand-coloured, giving them something of the quality of watercolour paintings. 'It's quite a journey to make the projects happen,' he says, with just a hint of understatement.

From Painting and Sculpture to Photography: I remember I used to like to draw and paint when I was little, so I'd always look for opportunities to learn. Unfortunately, because of personal circumstances, I ended up in a factory working on TV components and electronics, and failed my entrance examination to art school. After my time at the factory, I had the chance to work in a cement sculpture studio. I was there for seven years. During this time, I developed my interest in photography. I decided to move to Beijing in 2000, and since then I've been using photography as a creative form to express my thoughts and ideas.

Epic Photography: First, after I go to a particular place, I will make sketches based on an idea I've had, going back and forth until I'm satisfied with it. Then there's a process of searching for props and models; sometimes the models are my friends and we make props together as well. I like the process of making; it allows me to take more complete control of how things will look. The length of time required and number of crew involved depend on the size of the particular project. As I said, I normally work with some good friends. During the shoot, we divide the tasks: some will be in charge of co-ordinating things (locations, transportation, equipment), others will be models, stylists, hair and make-up artists. Most of my subjects or ideas are drawn from current social situations. For example, when I did my *Three Gorges* series, there was massive demolition going on in the area because of the project that was being carried out by the central government. It looked like a war zone. This kind of environment makes me wonder what will happen next.

Analogue Materials: I use an 8 x 10 large-format camera and film. I still really love film photography, for one. Medium- and large-format film has a spectacular quality to which digital images cannot compare. I enjoy working in the darkroom and, as I mentioned before, I used to like painting. So that's partly why I chose this process of working. What I want to visualize in the end can't really be achieved with colour film. It is possible to adjust colours on computers after scanning, but I still think it lacks dynamism. The influence of the digital age will really make an impact on me when it means that film isn't available any more. But for now, I'm not really affected by it. Mainly I use traditional watercolour paper, covered and painted with light-sensitive materials. This is the best way to achieve what I want. On a couple of my projects I've tried using Chinese rice paper. That's still in the experimental phase, and I don't know how it will turn out.

Chen Nong
Three Gorges Series #1, 2005–06
Three Gorges Series #2, n.d.
Yellow River Sketch, n.d.
Yellow River, 2007–08

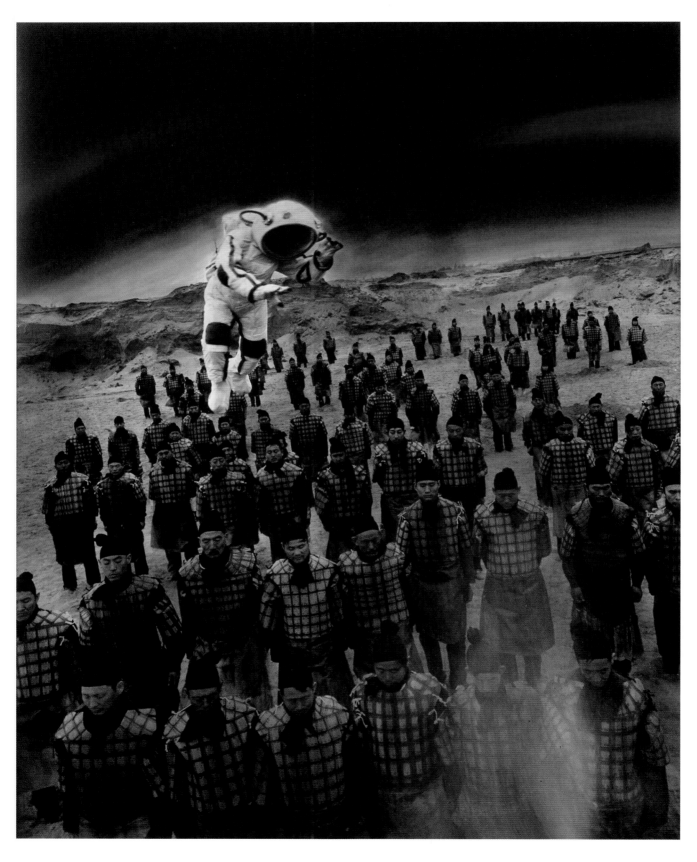

Chen Nong
Water Lily Series #3, 2006–07

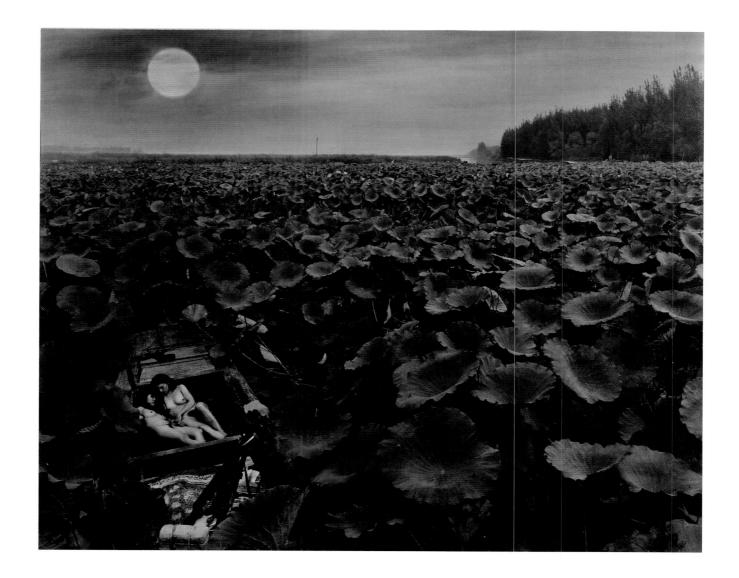

Charles Grogg

California-based photographer Charles Grogg makes work that is immediately recognizable for its use of fracturing, stitching and suturing. 'I began photography with a concern for the surface of things,' he explains of his experiments with fragmenting, burning and sewing his images. 'But after a while I wanted to dig through the layers into something more. So I began tearing prints, printing in pieces, stitching prints and so on, in an attempt to defy the surface of the print.' The materiality of the final work is of paramount importance. 'I am absolutely looking for a tactile quality,' Grogg says. 'In fact, I made a series of maple frames without glass for a show, float-mounting the prints in the naked frame so that the dimensionality of the paper would be at the fore.'

Stitching as Control: Tethers and supports hold things in place. Look how a still picture has to compete with a world in motion – with a collective consciousness on speed – and is so much at a disadvantage in being noticed that it can easily become a mere distraction, or worse yet, more detritus washed into the tsunami of contemporary life. I tend to think of addenda to photographic images as dangerous territory. It's really easy to overdo it. I use stitching as an overt attempt at control, which seems to me absurd and also beautiful, so I have not yet reached the point at which I would say I have done too much to the image, but that time will come.

Regrowth: In my art practice, I am most interested in the fundamental rejection of the apparent by photographs, in the idea that pictures hold their meaning in abeyance, the way the unconscious, to a trained and curious mind, is clearly visible in our actions but otherwise elusive. As I continue to play with affecting the surface of prints, different processes strike me as a cogent way to interfere with what is seen. In the case of *Regrowth*, the digital print eclipses a large area of the print made with precious metals. I burned the digital print just at the level where I thought the image would be most significantly devastated. Then I laid it over the same image made in platinum/palladium on Japanese washi.

I think it is a realistic view of this reproducible medium to hold a consistent disdain for the surface of a photograph. While damaging or altering the surface of a photograph brings my attention to it, I also hope that the result strikes an aesthetically convincing note.

Consciousness and the Sublime: When I visit a gallery or a museum and see a picture in whatever genre, what moves me most is when I am overwhelmed by the sheer unknowability of the image – too much to take in at once and also the sense that something is lurking there. It's the sublime. Yet being that my attitude was not to destroy anything, I tried out ways to put the picture, the landscape, the world back together using pushpins, darts, tape, staples, glue and also thread. I liked the feel and the motion of the needle piercing the image surface, so I settled on sewing with cotton thread. It's a game in some ways, an approximation of how I would guess my own consciousness works to make a complete picture of an object. And of course I cannot escape the relationship to my grandmother's stitching – quilting, crocheting, and the whole history of domestic duties and quiet fidelity. To most of us, the world is not whole. It's broken, and we each put it together as we need it to be for us.

Dafna Talmor

Sellotape, a scalpel and strategic overexposure figure prominently in the *Constructed Landscapes* series by London-based visual artist Dafna Talmor. Influenced by the Pictorialist practice of combination printing, Talmor splices together negatives carrying images of very different landscapes – Britain, Israel, Venezuela, the USA – taken in different seasons, in order to generate new, imaginary locations. 'In each case, I wanted to create a space that doesn't exist in the world but that remains rooted in reality,' she explains. Her working method is entirely analogue. 'What's really important to me about the process is its irreversibility,' says Talmor. 'When working digitally you can always undo an action and maintain a master file, whereas here once I've physically cut into a negative there's no turning back. I find that element of risk, and doing it blindly, exhilarating.'

The Problem of Landscape: Originally the images that make up the *Constructed Landscapes* series weren't taken specifically to make the work. For a few years, whenever I travelled I found myself taking photographs of landscapes, alongside working on another series of photographs taken in interior spaces. I didn't really know what to do with the photographs of landscapes I had taken, as I found photographing outside quite problematic. I liked (and seemed to need) the clear limitations that interior spaces provide.

I was always interested in the *suggestion* of what was outside, rather than the specific location. Place is so loaded politically and the genre of landscape is so loaded in terms of its history: whether it's through painting or photography, there's so much to contend with. I didn't know how to go about addressing those areas and so I accumulated countless negatives and contact sheets in boxes. In themselves, the landscapes didn't feel like enough; I was frustrated with them but kept taking them compulsively.

It then dawned on me that by merging negatives of different locations, I could create a new, imaginary space. The process was quite intuitive. I started to remove any interruptions: man-made elements such as cars, roads, paths, lamp-posts and,

on very rare occasions, people. It was an attempt to reclaim the so-called purity of nature, but also to remove any clues that might bring the sort of specificity I was interested in negating. The places in the individual negatives have personal meaning for me but, in combining them, they become more universal. I like mixing landscapes that could never coexist and the impossibility of the time frames that are created. I now shoot landscapes specifically for this series every time I travel, expanding the personal archive that feeds *Constructed Landscapes*.

Manual Matching and Materiality: The process is quite violent. I make them in a rudimentary way by cutting into the negative with a scalpel and putting negatives together with Sellotape; the resulting object itself is quite fragile. Printing the combined negatives is an intrinsic part of the process, as it's the only way to see whether the intersection of the two locations is believable and merges successfully. Sometimes the match is immediate, whereas other times it takes a few attempts and is more laborious. The black void burnt on to the photographic paper – a result of the overexposure where only one layer of negative remains – plays a key role in the image and has to be finely balanced pictorially. The black space creates

a new interruption, pointing to what lurks beneath the surface, hidden from view. It's meant to raise questions and provide a space for rumination but also points to the manual intervention and the materiality of the negative, a core element of the work.

Staged Landscapes: I'm interested in the Pictorialist practice of combination printing and seaming negatives to create a 'perfect' image, as well as more experimental Modernist processes like collage, montage, scratching and defacing, and interventions with the materiality of film. Photographs have always been manipulated; it just used to be a much more complex and time-consuming process. You had to be very technically able, whereas now it has become more accessible through digital technology and there's less at stake. I also like the idea of combining a documentary approach with a staged approach – I see these as staged landscapes.

Dafna Talmor
Untitled (1212-2), 2013
Untitled (1112-3), 2013
from *Constructed Landscapes*

Dafna Talmor
Untitled (0811-1), 2012
from *Constructed Landscapes*

Jorma Puranen

Finnish photographer Jorma Puranen's large body of work draws heavily on archival material, renegotiating the documentary tradition in a dialogue between past and present. Puranen often employs unconventional working methods: painting bits of wood black and then photographing the reflected landscape on their surfaces, or shooting museum portraits of historical figures with deliberate surface glare to create a kind of veil – a physical trace of the passage of time – between the contemporary viewer and the long-dead subject of the painting. He says: 'While photographing these painted portraits I felt as if I were knocking on the frame of a painting and asking: Is there anyone there? Wake up, I know you are in there!'

Reflected Light: I am not interested in effects. I try to create a living frame of reference in which the people depicted, and their fates, can be reconsidered. In *Shadows, Reflections and All That Sort of Thing* I was exploring how reflected light acts as a mediator of images, masking or obscuring our access to them, adding layers of uncertainty to specific historical realities. Some might say that reflection – or reflected light – is the very subject matter of this work. In another project, *Icy Prospects*, I used reflected light as an agent, method and metaphor rather than as a subject. In these pictures actual arctic landscapes are reflected as mirror-images on the surface of bits of black-gloss-painted board.

The Museum Portrait: *Shadows* has its origin in my experiences in different art museums. I have always been keen on portrait painting and it almost makes me sad to see how careless museum visitors are about portraits. People being portrayed many hundred years ago must have had a life very similar to ours with all their hopes, passions and desires. In the withered flesh of each work I wanted to show a person. They are portraits, consisting not of flesh, blood and bones, but of congealed oil, pigments, canvas and wood. Those portrayed are long dead and their likenesses too are perishing.

Archival Resources: As zooming into the past is not yet possible, we try to find other ways to deal with experiences of it. In my case, by dislocating archival and museum material, fragments of the past, from its original purpose and intention, I suggest a fictive historical world. I want to generate narrative possibilities, to point to the twilight zone of what might have happened. By using a plethora of visual historical pickings, I seek to create a fabric of encounters and connections, a field of fantasy and imaginings.

Time: The dialogue between past and present lies at the heart of my work. Indeed, most of the projects I have carried out from the early 1990s on have all had their starting point in visual imagery drawn from museums and archives. Archive pictures can act as a trigger to memories, true or false, and sharply evoke a sense of time or conjure fantasies of history. Such museum pictures can act as a powerful stimulus to the memory. Film is perhaps a much better medium to deal with issues of time, as is literature. Painting, in turn, is about *now* as it is very much about the present tense – duration of time can be seen in every brushstroke. In photography every 'click' is about now. But then you could ask 'how long is now?', as in my work the exposure time for a single image may be five minutes or more. Time – ontologically – is a basic component of photography. In many ways a photograph denies history. It is a fragment of time and space, being dislocated from the flow of time from which it was extracted. While it is of the past, it is also of the present in that the past is transported to the present. In Roland Barthes's famous phrase – the 'there–then' becomes the 'here–now'.

Jorma Puranen
Icy Prospects 17, 2005

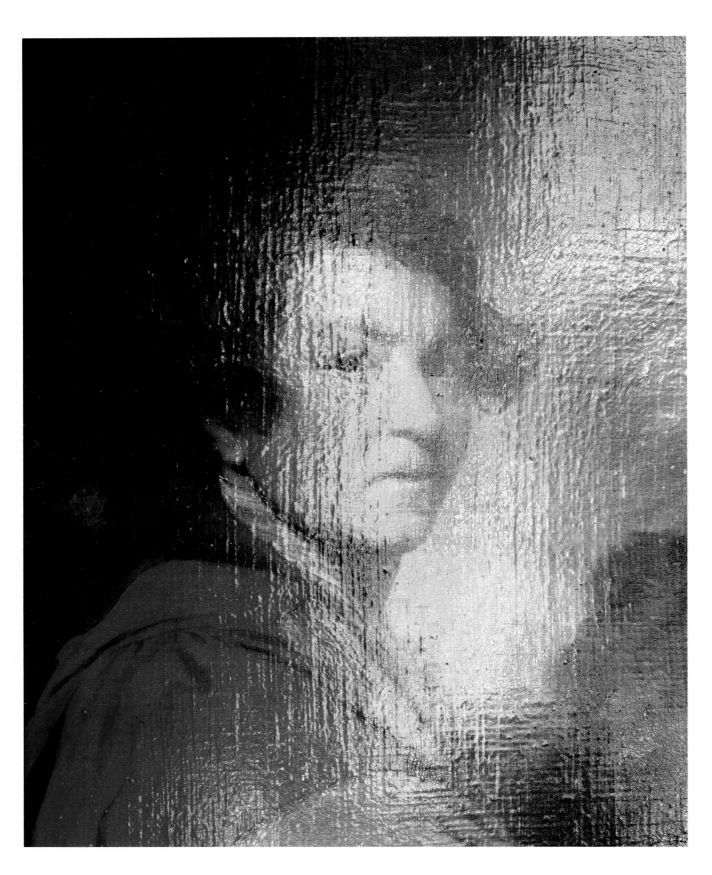

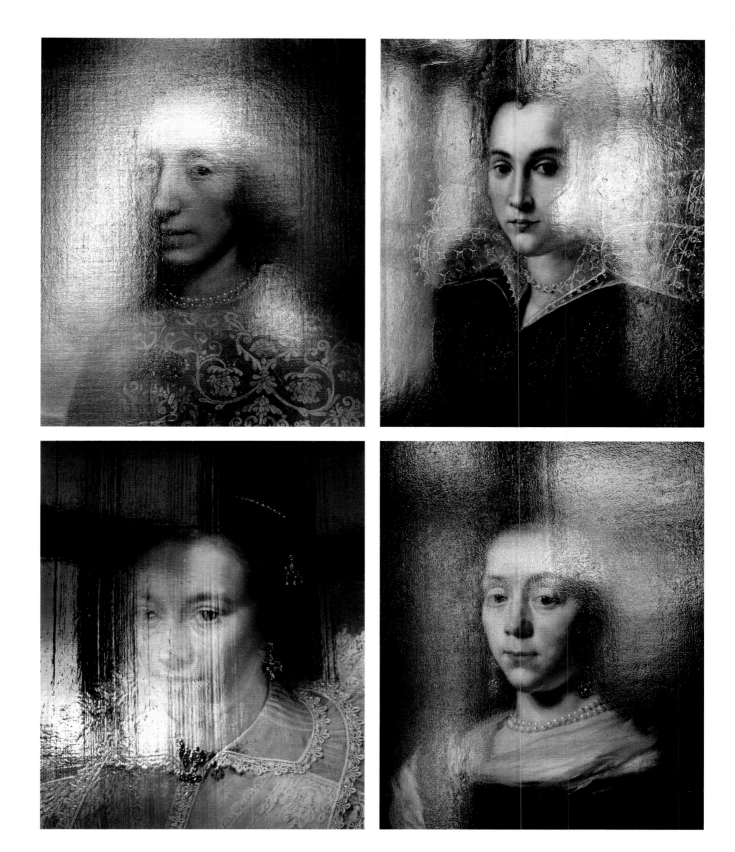

Julie Cockburn

In her Cubism-inflected, collage-based practice, British artist Julie Cockburn is drawn to found imagery of what she describes as an 'almost archetypal ordinariness'. She submits these disarmingly bland pictures – sourced on eBay or at car boot sales – to a labour-intensive process of defacement and transformation. The materials Cockburn adds range from embroidery silks to marbles, producing highly crafted final works of uncanny, abstracted fascination. 'The original images I work on are often discarded, creased and dog-eared, and there is an element of repair, mending and caressing that goes on,' she says. 'People often say my work is aggressive, but I think it is the opposite. I think it is a loving practice. I am a perfectionist.'

Layering Narratives: Initially I was very interested in the notion of the untreasured, forgotten images that are revived, rescued from obscurity. But as my practice has developed, I realize I am more concerned with an authentic, almost archetypal ordinariness, which invites connection/identification with the everyman/woman. I work with found images and objects of all sorts – photographs, paintings, magazine pulls, bookplates – and I have learnt over the years to buy the things that catch my eye, whatever they may be. It is the ones I didn't get that tend to haunt me. The Internet is my main source, though car boot fairs and charity shops are great for the spontaneous find. I am drawn to very static images: studio portraits, studies rather than storytelling images. These lend themselves to the layering of a narrative through manipulation, added materials and titles.

An Instinctual Conversation: I have chosen the initial objects for a reason, though it's not always clear what that is. It's usually just a matter of time. I like to call it having a conversation with the images – a spontaneous response to them. It's less about thinking and more about instinct, perhaps adding what seems to be hidden there or missing, unspoken. I often feel that the original images were somehow waiting for me to complete them in this

way. I think this is what makes a work successful. The first thing I do is scan or photograph the image so that I have a facsimile that I can work on. They are precious, these found images, and so initially I don't work directly on them when I'm planning a piece. I do a lot of preparation work on the computer, especially with the embroidery and collaged works – they need to be pricked and cut very accurately, so I make templates and acetates to aid me. I get a rush of adrenalin when I start a piece – it's an exciting moment when the intervention starts and I commit to the defacement.

The Ethics of Appropriation: The photos are dusty, creased objects, sold in a job lot by a chance eBayer for a few pence. They are history-less in the sense of family lineage, unloved and forgotten, and sold not as an image of a person, but as a collectable object. The photo itself has currency as an object, rather than as a homage to the person or place they depict. So I feel in some ways that I am reinventing them, giving them a second chance – almost collaborating in hindsight with the original photographer, creating another opportunity for exposure. The altered image then goes back out into the world to be looked at, scrutinized, loved (or objected to), and the process starts all over again. A woman recognized

her grandmother as the basis of one piece of work. She was delighted that I had found it (in a lot on eBay, as far as I remember) as she did not have an image of her granny herself. It was so battered and broken when I received it. She bought the work.

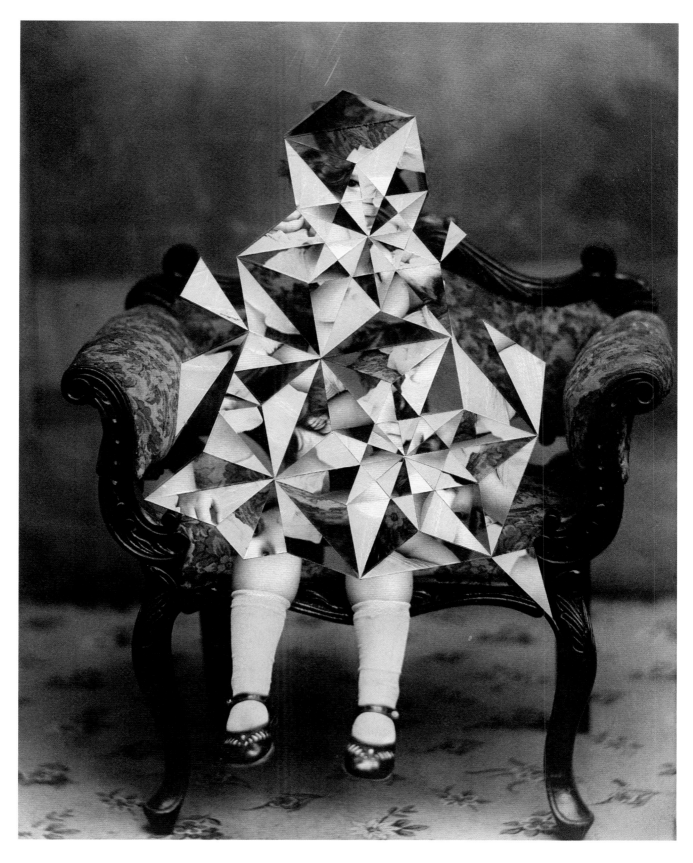

Torsten Warmuth

Berlin-based artist Torsten Warmuth's resonantly Impressionistic images are the fruits of a long and complex 'birth process' that only begins with the clicking of his camera's shutter. 'What I had in mind when creating the concept of the "Silver Paintings" [such as *Giant Steps (Version 1)*, opposite] were freer constructions and more creative possibilities of composition,' he explains. 'I wanted to generate images from my ideas. Ideally, the motif in front of the camera would no longer define the subsequent image. Instead, I wanted to decide what the final image would look like through my interventions on the negatives and the working processes in the darkroom. I did not want reality to anticipate the result; I wanted to show my very own idea of reality; my memory of it; a reflection.'

Experimentation and Chance: Experiments belong to art that works with photography; it might sound ambiguous, but I do want to control my photographs [as well]. Thus, for instance, I do a number of tests with Polaroids before shooting material for a 'real' picture. However, the moment you put in the film, you never know what is really going on in the camera, especially if you 'abuse' the camera the way I do in order to create something that was not intended by the people who built the camera. It's a little bit like John Cage's 'prepared piano' – he prepared all the keys intentionally, he even established an archive containing all the screws and things he would install under the strings. But in concert a lot of tones and melodies result by chance. It's similar with my art: I am led by things that happen; I have to react to outer input or my inner one, to a certain artistic need.

A lot of things result by chance yet are somehow intended. For everything I do, in order to be able to express my artistic idea in the way that comes closest to its conception, it is essential to master the technical aspects with precision and (almost) perfection. If you see an experimental aspect in my work, it most likely relates to darkroom processes. For example, in order to be able to understand how toners work, and how they interact with each other, comprehensive experiments and observations were needed.

Photographic Ambiguity: Photography has, for a long period of time and for many people, been understood as showing a three-dimensional reality in a two-dimensional picture. One can feel free to believe that the camera-inbuilt 'program' – whether it is an analogue or digital one doesn't matter – will capture reality (or what we perceive as 'reality'), and the result is what we call a photograph. I have been discussing these questions with a friend of mine, the author Ralf Hanselle. We ended up with the *Manifesto of Elusionism* (www.elusionism.com). To give you an example: the first photograph with a person in it was, to our knowledge, taken in Paris. The boulevard depicted seems empty; only the shoeshine man and his client are visible in the photograph. When I was a teenager, I would look at this picture in an encyclopaedia hundreds of times, fascinated by how a camera could 'empty' a boulevard crowded with people and maybe carriages, just because of a long exposure time.

Mastering the Machine: To me, one interesting aspect about contemporary art working with photography is the ability to outmanoeuvre the machine using the machine itself for that intention, with a certain idea in mind. It is about pictures that are possible in my or the observer's imagination; ideally, pictures that lead to very individual associations for each observer – and which, on a very personal and emotional level, touch them.

Torsten Warmuth
Giant Steps (Version 1), 2011

Chloe Sells

An air of mystery hangs over Chloe Sells's darkroom technique. For her *Senescence* series, the Colorado-born artist employs the traditional still-life form, making luscious assemblages – plants, food, skulls – which she then shoots in colour. Afterwards, Sells disappears into the darkroom, where she manipulates shades of cyan, magenta and yellow to create her unique, analogue C-type prints. 'I live in Botswana, but the body of work is not an expression solely of Botswana,' she explains. 'It incorporates many places. Travel has always informed my work. Some of the works have an African feel, but more than that they are meant to discuss the non-urban wilds that I encounter where I live.'

Training: I was always artistic, but began taking photographs in 1993. I studied at Rhode Island School of Design for my undergraduate degree, where I was classically trained in photography. I received a Masters in Fine Art from Central Saint Martins.

The Still-life Tradition and *Senescence*: The body of work was conceived as a study of place and provenance through objects. It was the formulated tableau, which would provide a frame to assemble and construct a scene, that brought me to the still-life aesthetic. Naturally, the tradition lends itself to photography with its use of atmospheric light and the assemblage of luscious arrangements. I thought the use of plants, foodstuffs and collected objects was appropriate to explore the ways in which culture is woven from webs of activity that cut across unexpected social spheres to create a bundling of relations and identities.

I am exploiting what Dave Hickey calls our 'residual pagan penchant for investing objects with power'. Using the articles within the prescribed artifice as symbolic surrogates, embedded with references to exploration and movement, I was able to heighten the tactile nature of both the objects within the photograph and the object itself, which is the photograph.

Peacock with Skull follows closely the tradition of the still life, both visually and conceptually. Botswana is a cattle-farming country and the cow skull within the image was found at the side of the road. In Ngamiland, where I live, the cows graze freely, across the countryside and also the roads. The skull, long used in still-life paintings to represent vanitas, is the very embodiment and result of senescence [growing old]. A collection of feathers, dried plants, a horn and a claw are arranged in a bouquet to the right of the cow skull, all of which have been collected near my home.

Virtue and Vice is a fragment from a larger image, a moment within a moment. The uncontrolled, smaller darkroom pieces, or test strips, are quite beautiful and I often collect them to use later, as I did with this piece. The delicious monster plant [*Monstera deliciosa*], which fills the frame, is a plant found in my garden, although it is exotic to Botswana and native to Mexico. The exchange of plants, goods, even humans is fascinating to me and I use these trade routes to make subtle, deviant maps within the images.

Distance and Proximity: The images traverse embellished landscapes, ignore borders and create routes that are physically impossible to follow. While some objects are entirely of and from Botswana, they convey more about exoticism and foreignness than the specifics of the country. They discuss distance and therefore proximity, whether it be from nature or mortality.

Chloe Sells
Virtue and Vice, 2013
from *Senescence*

Chloe Sells
Peacock with Skull, 2013
from *Senescence*

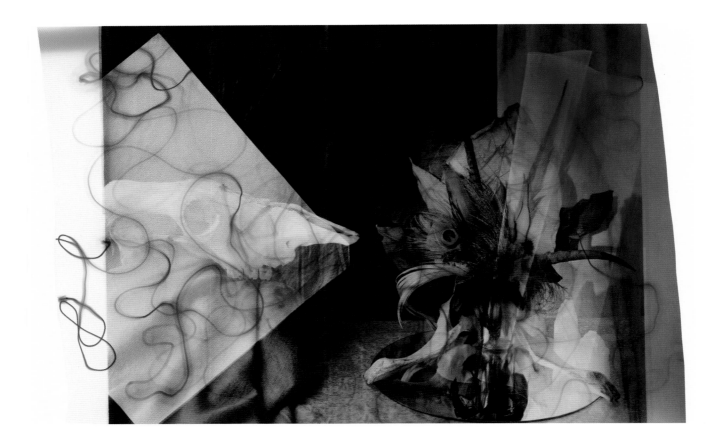

Chloe Sells
Delicious Monster with Juju Hat, 2013
Olympia, 2012
from *Senescence*

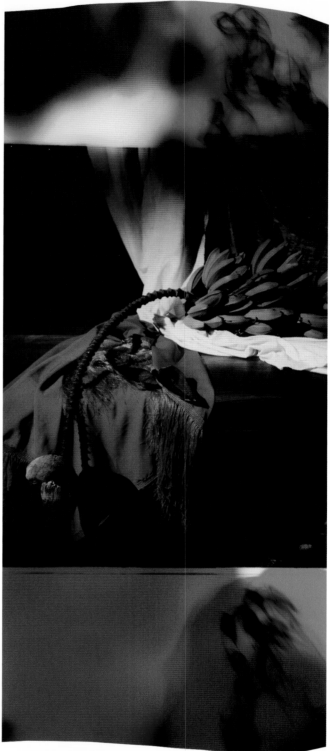

Steffi Klenz

London-based German photographer Steffi Klenz's *Hewitt's Heap* is the result of a series of controlled chance encounters between highly volatile chemicals and carefully but precariously arranged 'furniture mountains'. This ghostly series of domestic portraiture is far removed from traditional architectural photography. 'My sister and her partner are trained architects and we have often discussed the discipline of architecture,' says Klenz. 'Whereas they regard it as functional, rational and grounded, my photographic practice is fundamentally concerned with challenging these conventional conceptions of the built environment. My work aims to uncover unexpected narratives and traces of history embedded in particular spaces.' In the case of *Hewitt's Heap*, 'I wanted to make work that would break with the literal translation of the domestic interiors and the furniture.'

The World of Interiors: I approached the representation of the domestic interior by engaging with the space as a location for transition and transformation. For the Surrealist poet Louis Aragon, buildings were 'thresholds to a kingdom of the marvellous', and the works in my series *Caster*, *Ariadne's Thread* and *Hewitt's Heap* all present the house as more than a 'machine for living' as such spaces were described by Le Corbusier. All of the images in these series were taken in my own house in London. When I moved in in 2010, it appeared to be inhabited, not by the former occupants in their physical form but by their ghosts. I started thinking about my house as a mysterious space, embodied in strangely animated furniture, convulsive forms and unruly guests. I wanted to use the carpets, the attic and the furniture and make work suggesting that the representation of the domestic interior environment is derived from a psychological investment. All the work conceived in my house aims to explore the psychological move towards the affective, whereby internal experiences clash with the external world.

Construction and Destruction as Processes: The former occupants of the house I live in, the Hewitt family, left all their furniture behind. I stacked the chairs, wardrobes and cabinets in the various rooms of my house in such a way that they were on the verge of collapsing. I took photographs of them, which were then transformed and abstracted by the application of acidic chemicals to the surface of the negatives. The chemicals literally inscribe themselves into the photographic negative, determining the final appearance of the image. Each scene was photographed ten times so that each negative could be exposed to the acidic chemicals in different ways. This destructive action was employed in an attempt to discover the domestic space anew. I then used the technique of combination printing to achieve the final image of each scene. This technique was suggested first by Hippolyte Bayard and mainly used by Henry Peach Robinson in the nineteenth century. I often think of my images as collaged constructions achieved in the darkroom.

The Role of Chance: When you work with a 'volatile' process involving acids, you allow unpredictability to become a part of the creation of the image. The Dadaists embraced chance as an avenue to expression in their works but eventually they merged random occurrence with conscious creation, attaining a form of balance. I regard my image-making in similar terms in that different techniques of applying the chemicals, different spray guns and nozzle sizes were used in each image – the parameters were therefore not random but rather were controllable. The intensity of the chemicals and the time the negative was exposed to them in each case played a huge part in the final appearance of the image.

Brendan Fowler

US artist Brendan Fowler's 'Crash Pieces' – three-dimensional works consisting of up to four framed snapshots of friends, flower arrangements and a variety of other scenarios 'crashed' together in complex autobiographical narratives – were among the most striking inclusions in the 2013 'New Photography' show at the Museum of Modern Art in New York. 'They are super-, super-, *super*-fake. They look like a fight but are made more like surgery; they take a very long time,' says Fowler, who worked as a performer/musician before turning to image-making and who brings a sure sense of rhythm to his work. 'They are sculptures that involve photographs. The photographs are metabolized into these objects. The physical frames are just as important to me as the images or files that I printed and put into them.'

From Performance to Pictures: In 2001 I was 23 and trying to figure out how to make political art. I grew up with punk and DIY and was still on that planet, but learning about performance art. I wasn't at the point of wanting to make objects so I created this performance, or this persona or context: BARR. It was like a deconstructed pop-singer identity and was overtly political, but more *personal-political*. Through it I began processing ideas about personal narrative. I was fortunate to get to tour and put out records of the BARR stuff. Through music economies you can perform every day, whereas in art contexts there are fewer venues, just on a numbers basis. Every city might not have a great museum or gallery or non-profit, but it does have kids who want to put on music shows. And records were another thing: I felt like I got to make some work within that format that I felt good about, but for the most part BARR was about the performance, about being in the room, what could happen right then. The project was really predicated on me being there.

So after a while, I guess around 2006, I was starting to get curious about making objects that would function in my absence, and which could maybe even function better in my absence than the performance could function. BARR was so much about words, storytelling with words,

so with the first objects I made in that time I worked with text, but this was just like formalized, or re-presented, transcriptions of the song lyrics. I realized that pictures could do something that me standing there, talk–singing... that I couldn't do. Pictures were the beginning of what objects could do that I couldn't do.

The Autobiographical Impulse: I think the work is totally autobiographical. When I was doing the song/performance work, it was because experiences I had as a kid with that kind of work – seeing, hearing, experiencing it – totally saved my life in the classic sense. I was living in rural Maryland and I felt like that stuff was my way out. My way 'in', too. When I started making work I hoped that my stories could be useful for other people as other people's stories had been useful for me. I'm into entertainment, and I'm into sublimity, and I'm into intellectual rigour, but I'm also into sharing because I think there can be a value in that, and I don't think that any of those things have to preclude one another, but rather can help to support one another.

'Crash Pieces': In my mind the 'Crash Pieces' come from the same personal narrative as the text for BARR (and my new project And Martin, which I started in 2012, although I may change the

name again). In truth, though, these tend to be a little bit more open, which is something that I think the object viewing is good for. The titles are very specific, though, and so I feel like two (at least) different ways of reading them are readily available: the less directed, more vague, more questioning – how did this thing happen? – immediate view, when you just see the thing there; and then when you see the titles, which is the more directed view that involves specifics, the who/what/where/when.

Brendan Fowler
Spring 2011 (Photographing Mirrors 1, Photographing Mirrors 2,
Mirror Reflecting White Flat 1, Photographing Mirrors 1,
Photographing Mirrors 2, Mirror Reflecting White Flat 2), 2012

Brendan Fowler
Spring 2011–Fall 2012 (Mirror in Miami, Texting and Driving It Can Wait, Coronado Ter Towels, Mirror Reflecting Black Flat 2), 2013

Brendan Fowler
*Fall 2009–Summer 2011 (Joel's Phone on Lauro Table,
Andrea on the Way to Anxiety of Photography Opening,
½ x 2½" Clear Pine Molding Sticking Out of the Car,
Flowers Outside of the Silk Flowers Show in LA 2)*, 2011

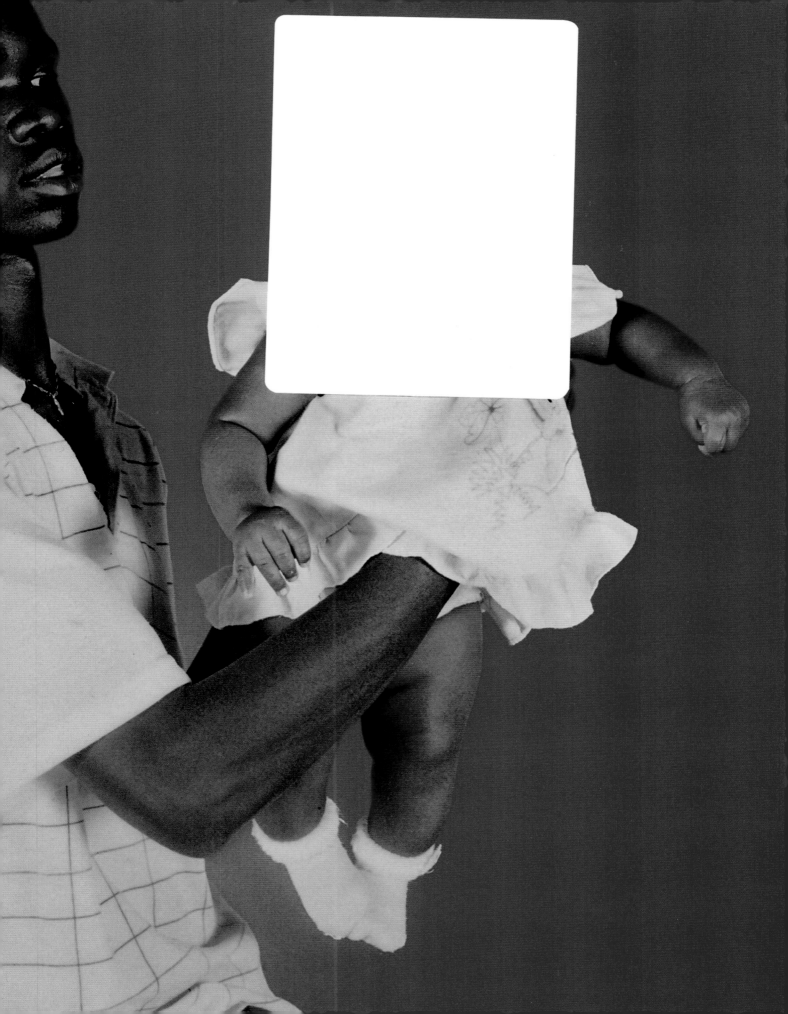

Post-Photojournalism

Found imagery isn't the traditional domain of the photojournalist. Remember Magnum founder Robert Capa's macho dictum: 'If your photographs aren't good enough, you're not close enough.' Physical proximity to the action – particularly if it involves danger to yourself – is what secures the best, most telling shot, not sitting back and reframing someone else's work, runs the logic. But when prize-winning Italian photojournalist Martina Bacigalupo was working on an assignment for Human Rights Watch in war-torn northern Uganda, she made an unusual and entirely unsought discovery that made her think afresh about her approach: a series of discarded studio portraits from which the sitters' heads had been removed. Bacigalupo's *Gulu Real Art Studio* demonstrates the documentary value of a good, old-fashioned Surrealist accident, and is one of a clutch of projects that have helped to redefine twenty-first-century photojournalism, not least in relation to Africa.

Another key work in this regard is Cristina De Middel's *The Afronauts*, which employs playful and entirely faked visual reconstructions to examine the largely forgotten 1960s Zambian space mission. No 'authentic' contemporary photographic documentation of the programme survives, so in choosing to make a work about it, experienced photojournalist De Middel had no choice but to create her own fictional images – to controversial effect. The project gave rise to heated debate about the means photojournalists could legitimately employ to tell their stories.

Artist duo Adam Broomberg and Oliver Chanarin have innovated unorthodox means to document conflict, for instance, producing abstract work while embedded in Iraq in order to challenge the clichés of conflict-based photojournalism. As Broomberg has said: 'I think that now is the most interesting time for documentary photography.'

That said, traditional photojournalism has never been under greater financial pressure. Magazines and newspapers are adopting swingeing cost-cutting measures, making large sections of their photography departments redundant, and turning increasingly to citizen journalists and crowdsourcing techniques to provide more and more of their visual material. Photojournalism is also facing a huge imaginative challenge as it tries to compete with the visual overload of the Internet. In order to make sure that their images command attention, the photographers featured in this section have all adopted unconventional approaches to portray their subjects. Yang Yi faked underwater shots documenting an event that hadn't yet happened (but that has since); Richard Mosse's *Infra* offers an arrestingly psychedelic vision of armed conflict in the Congo, and David Birkin deliberately exploits dysfunctional technology in his attempt 'to find a way to articulate loss and the effects of war without recourse to spectacle'. Benjamin Lowy, meanwhile, became the first photojournalist to have an image taken with an iPhone featured on the cover of *Time* magazine. 'With the cornucopia of work produced today,' he says, 'you have to innovate and create and think in order to produce work that stands out from the fray.'

Martina Bacigalupo
from *Gulu Real Art Studio*, 2011–12

Michael Wolf

For the first part of his career, prolific German artist Michael Wolf worked as a photojournalist, spending eight years in Hong Kong for *Stern* magazine before dedicating himself to his own projects. Over the course of the past decade his work has moved forward the limits of both traditional fine-art photography and photojournalism. *A Series of Unfortunate Events*, consisting of pictures of images taken from Google Street View, received an honourable mention at the 2010 World Press Photo awards. Wolf's great subject is city life, particularly in the Far East, ranging from his remarkable close-ups of Japanese commuters in *Tokyo Compression* to his abstracted visions of Hong Kong's high-rise buildings in *Architecture of Density*.

Post-photojournalism: I worked as a photojournalist from 1976 until 2003. After 9/11 and the bursting of the tech bubble, magazines cut their budgets drastically. Instead of spending three months working in-depth on a story, the time allotted to an assignment was often only two to five days, and consequently the work became much more shallow. Also, I was getting more demanding in what I wanted to do with my life. I had many ideas that would never have been possible to realize for a magazine: the *Bastard Chairs* or the *Real Toy Story* projects, for instance. So I decided to strike out on my own and work only on projects that interested me, and see if I could make a living in the art and publishing worlds. The great thing about working as an artist is that I am free to go in any direction my instinct and/or interests take me. It can be an installation, large-format prints or a more photojournalistic style (such as in *Tokyo Compression*). I am thinking of doing a series of still lifes, or even combining my images with ones I have bought on eBay or collected at flea markets.

Photography and the City: My photographic approach is not all that different from that of photographers 50 years ago, except that my work is more concept-based and, starting in 2006, I switched to digital technology.

For instance, Lewis Hine (immigrant ghettos), Walker Evans (New York subway portraits) and Eugène Atget (Paris architecture) all photographed aspects of life in cities – and all three influenced me. The big difference is that there was only a tiny market for 'art' photography then, and also no one made 180 x 220-centimetre (71 x 87-inch) prints. Digital photography has not influenced the content of my photographs at all. The reason I switched was that it shortened the time between taking a photograph and being able to see the result. It's much faster. Also, digital equipment weighs less and is more compact, so it's easier to carry around.

Causing Controversy: Art has always embraced and commented on developments in science and technology. Within a year of Street View being launched, a handful of photographers had used the platform as a launching point for their own projects. I was fascinated by the 100 per cent coverage of our world by the 'objective eye' of the Google camera, and tried to undermine it with my own subjective interpretation in *A Series of Unfortunate Events*.

Obsessiveness: Photography is the ideal medium for me, as it rewards obsessiveness. Many of my projects are topology-based, so it's necessary to 'collect' a large number of images so that one can compare within the genre: three photographs of bastard chairs could be a fluke, but 100 photos of bastard chairs create a genre.

Michael Wolf
Tokyo Compression 5, 2010
Tokyo Compression 17, 2010

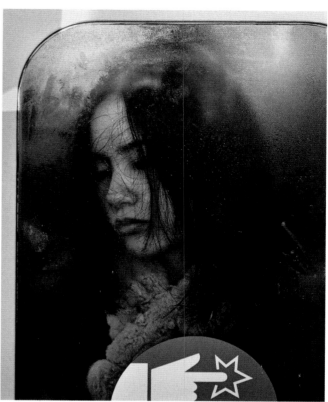

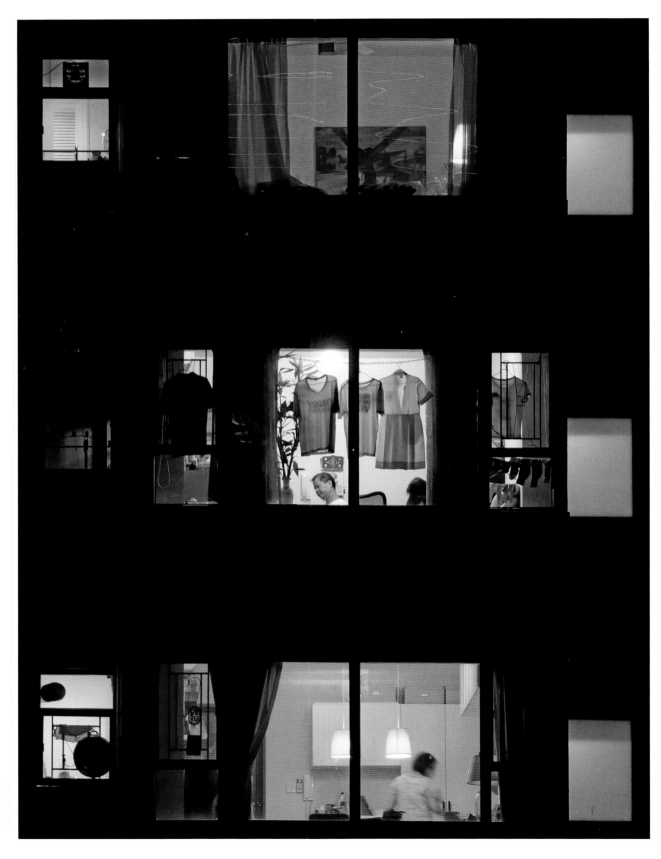

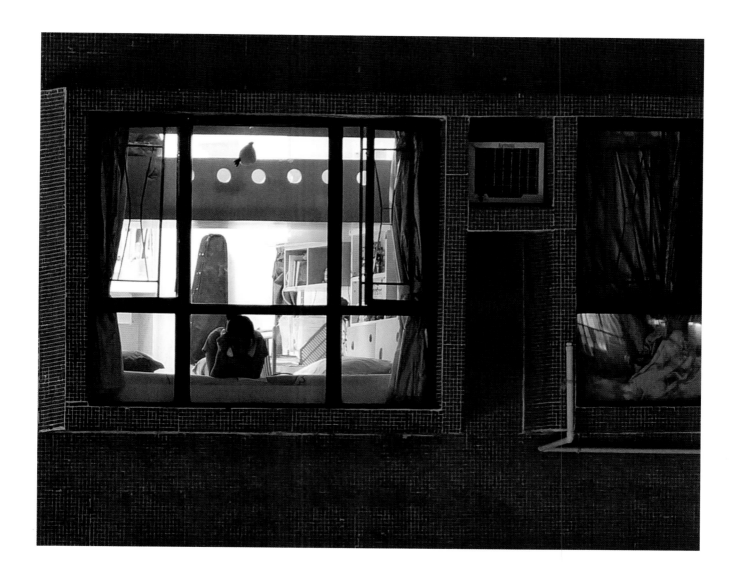

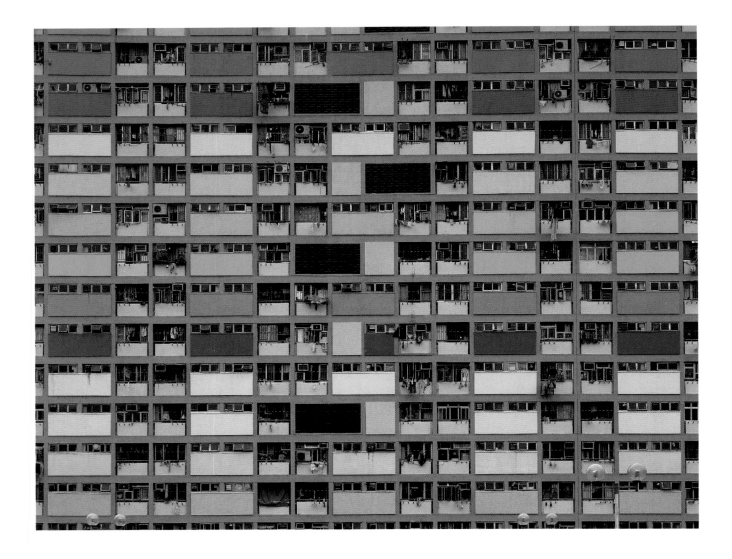

Michael Wolf
Architecture of Density 102, 2007

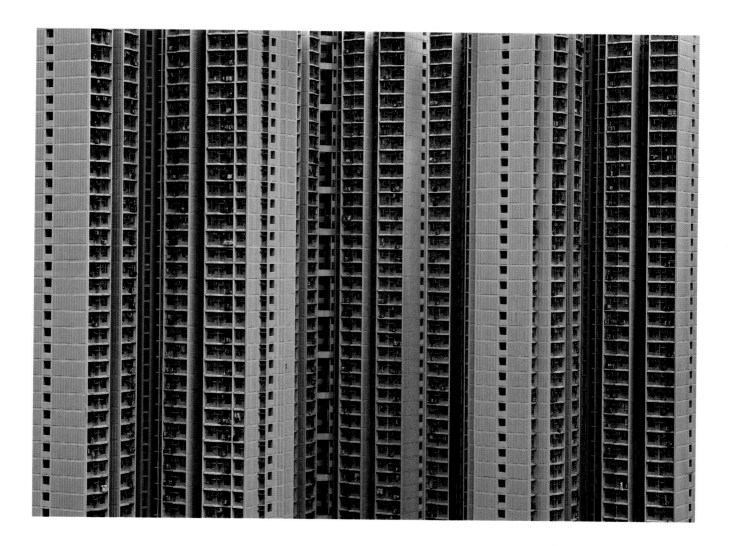

Michael Wolf
Night 14, 2005

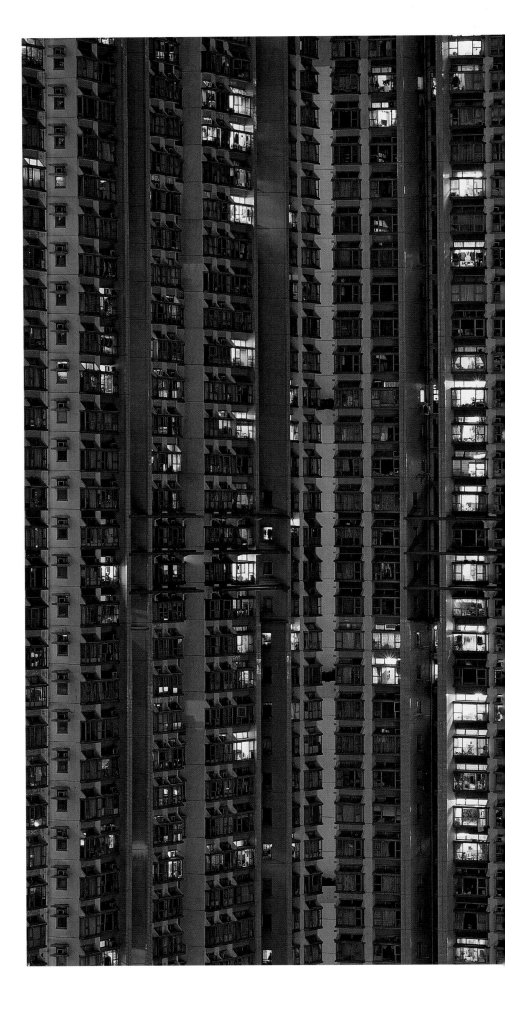

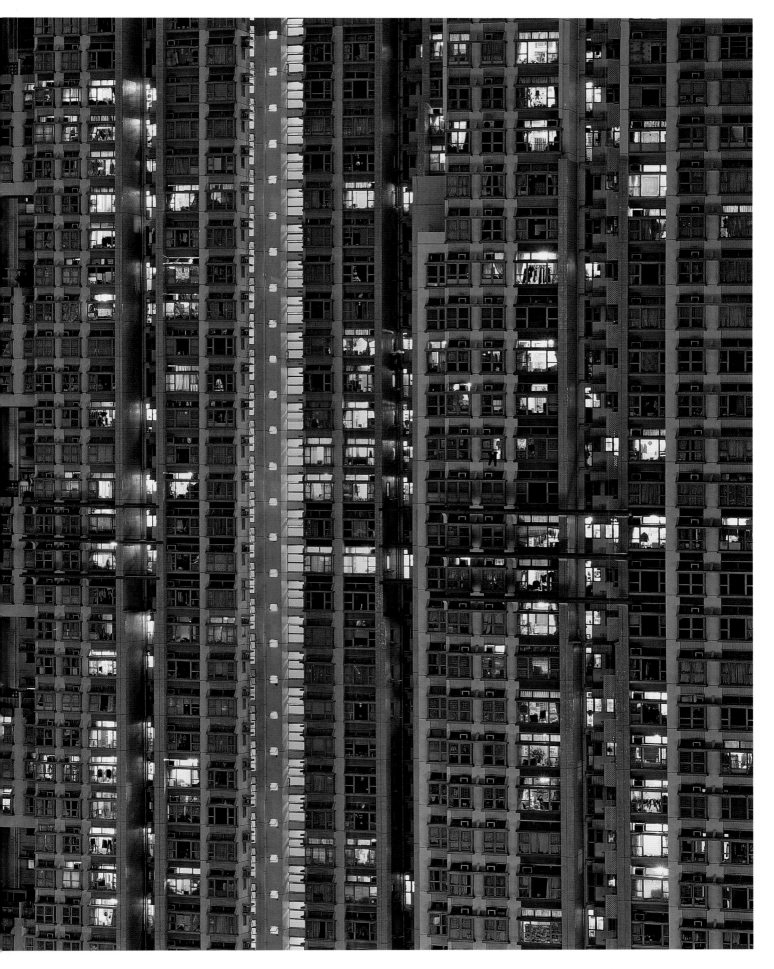

Yang Yi

Yang Yi's eerie faux-underwater images document a tragedy that affected the lives of a million and more people – before it actually happened. The Chinese government's controversial Three Gorges Dam Project, a huge feat of engineering and construction along the Yangtze River, was designed to transform the country's energy-generating capabilities, but in the process consigned whole towns and cities to history by submerging them under water. It has drawn responses from many artists, including Canadian photographer Edward Burtynsky and fellow Chinese artist Chen Nong (see page 188). Inspired by the approaching flooding of his hometown of Kaixian, Yang Yi's contribution, *Uprooted*, has a distinctly nostalgic, and even otherworldly, quality. The photographer's subjects wore diving goggles but he shot the various aqueous effects separately in a water tank, before marrying the two in Photoshop.

Artistic Encouragement: I suppose my family was instrumental in cultivating an early interest in art. My grandfather learnt oil painting, and in his later years he practised Chinese painting diligently. Both my mother and brother also studied painting at some point. As a child, I didn't seriously consider pursuing an artistic career, although I did sketch and paint quite frequently. My parents never attempted to dissuade us from taking our creative development further. Instead, they encouraged us and allowed us the freedom to do whatever we wished. This was considered rather unorthodox for a Chinese family in the 1970s, as most parents were adamant that their children should go to university or land themselves respectable jobs.

Later on, I studied graphic design at university, and not long after I graduated I set up my own advertising agency. A few years later, I became disheartened with the prosaic nature and banal constraints of commercial design work. In 2006, I abandoned my career temporarily and enrolled myself on a photography course at the Beijing Central Academy of Fine Arts for a year. Prior to taking this course, I had barely even used a camera. I wasn't aware that it could be such a powerful tool in stimulating the senses. Acquiring a more profound and complex understanding of photography also benefited my artistic vision and practice.

The Three Gorges Dam Project: The Yangtze River occupies a very unique geographical position in China, and it is also a very potent symbol of the development of the nation through the ages. Chinese people undergo intensive lessons in heritage and culture from a young age, and it is the norm for children to take poetry, calligraphy and painting classes. The Yangtze River is a recurring motif in all these forms of creative expression. That's why changes to the Yangtze River are sure to provoke a strong response from Chinese artists. The Three Gorges Dam Project caused the rapid destruction of many historic towns that had existed for thousands of years, and millions were forced from their homes. It's also quite evident that the social fabric of the region has been irrevocably ruined. My hometown, in Chongqing County, was one of the last to be torn down and completely submerged. I believe that laws that lie beyond mortal comprehension govern the natural world. When people forcibly or recklessly alter the natural landscape, there will be unfathomable consequences.

A Variety of Techniques: I started on the *Uprooted* series in 2006, although most of the work was done between 2007 and 2008. It took slightly more than a year to finish the project. I don't emulate particular trends or styles, I just try to work with a variety of techniques. I instructed the models to wear diving goggles, and shot the scenes in medium format. Then I shot the river water, light and air bubbles in a transparent fish tank with a digital camera. Later I used Photoshop to combine both elements.

Motivation: To leave vivid, deeply intimate impressions of my hometown: this was the original motivation behind my work. I love my hometown! This is perhaps the only objective of the project. I hadn't expected so many people to empathize with me or applaud my efforts. Naturally, I am very pleased and gratified by the warm response.

Yang Yi
from *Uprooted*, 2006–08

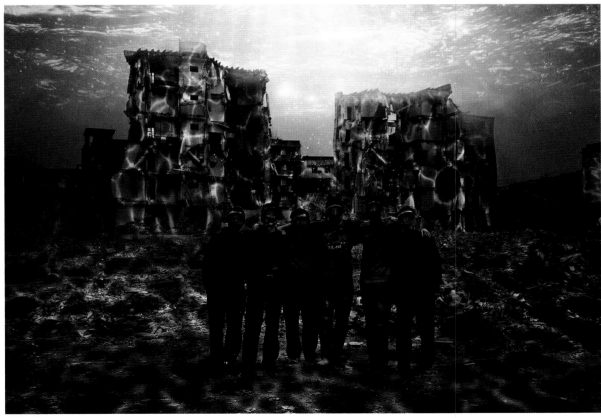

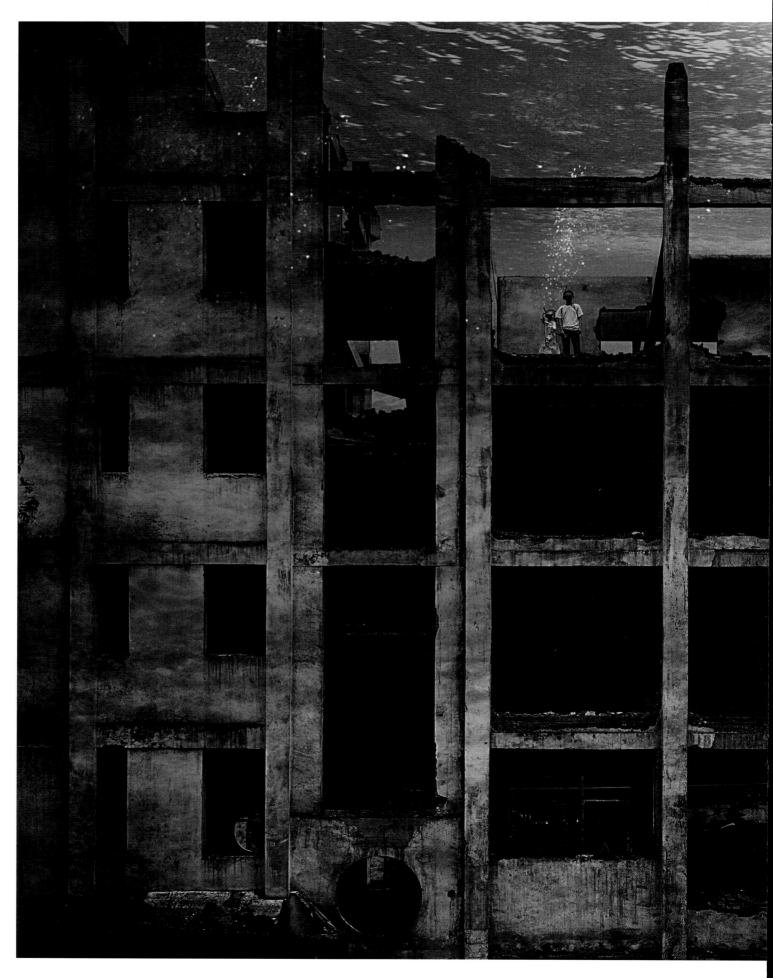

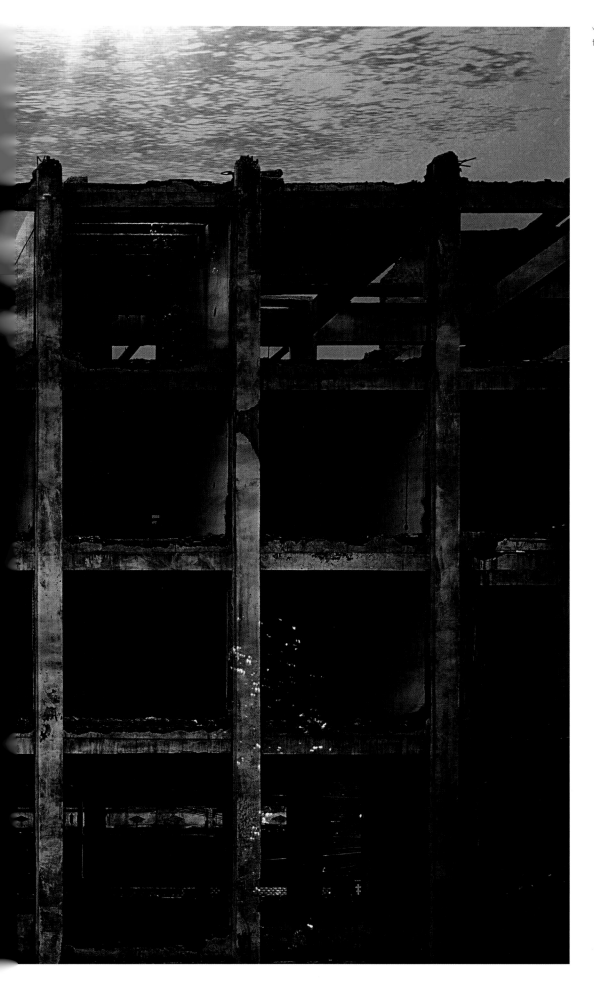

Yang Yi
from *Uprooted*, 2006–08

Martina Bacigalupo

A chance discovery of discarded headless portraits carried traditional photojournalist Martina Bacigalupo beyond the normal parameters of documentary realism. *Gulu Real Art Studio* presents a cross section of Gulu society – children, soldiers, farmers – at a moment of transition. The ravages of war are evident, not least in the fact that the portraits are mutilated leftovers, but they nonetheless manage to tell a bigger, more rounded story of lifes lived. As Bacigalupo points out, they also serve as surreal prompts to the viewer to dream a little. 'You see whatever you want to in them,' she says, and mentions what a friend wrote to her after seeing the images. 'I can't stop thinking about these characters without their heads,' he said. 'To me they are fabulous gods who accompany us.'

A Surreal Discovery: While waiting for some prints to be made in a small studio in Gulu in northern Uganda, I noticed an unusual object on the desk – an ordinary 10 x 15-centimetre (6 x 4-inch) photograph of someone posing for a studio portrait, but with the face strangely missing, leaving a square hole where the head had been. I asked what this was, and the woman at the counter said she had forgotten it there and proceeded to discard it. When I told her I would like to see her trash bin, people around us laughed, but a man [named Obal] who was part of that crowd, amused like the others and yet, I think, more curious, told me that if I was interested he would be happy to show me more.

The portraits were well composed, with subjects seated on a chair or on a bench, with a blue, white, or red curtain behind them, in various poses and modes of dress. Obal, who was running the oldest photography studio in town with his father, told me the secret behind those pictures: he only had a machine that would make four ID photos at a time, and since most of his clients didn't need four pictures, he therefore preferred to take an ordinary photograph and cut an ID photo out of it. This was common practice in most of the studios in Gulu. Captivated by the eerie result, I asked Obal if he wouldn't mind putting aside all the leftovers he was going to produce that day. When I went back in the evening he gave me a little box.

The Photographer as Editor: I love these pictures because they're not mine. I'm an editor basically. During the editing process I went over hundreds of leftovers, where small details – a hidden sign, a comic posture, a bitter aspect – were revealing different stories. I remember the clumsy pose of the man wearing a too-large jacket – a jacket lent by the studio to those sitters who didn't have one (I would find a whole series afterward): he was holding the jacket closed with his hands while still wearing his muddy boots. I was always struck by the ravishing traditional robes of the Acholi women, who would wear their best clothes even though their dresses would not show in the final print. I knew these photographs carried burdensome stories, and yet those details were portraying something else, something about the daily life we all share, besides time and space, with its common worries and hopes.

Transcending the Documentary: You see journalists coming in and out of Africa, looking for tragic news. But by reporting events in that way, we are perpetuating a way of looking at it as a continent of misery. This project has been a way of talking about things – including the war in northern Uganda – in a more everyday way. The child who is sleeping on the lap of his mother while the picture is taken – it's something we can all relate to. It's lighter. The pictures are funny at times. There's a descriptive part in the portraits, which ties them to journalism, but then there's the hole, which is a window to something completely different. That is, the questioning of photography itself. Photography is about framing, choosing. This work is about what has not been chosen, what has been left out of the frame, and that for a series of coincidences has survived. The question that these photos raise is: is there more truth in what is inside or in what is outside the frame?

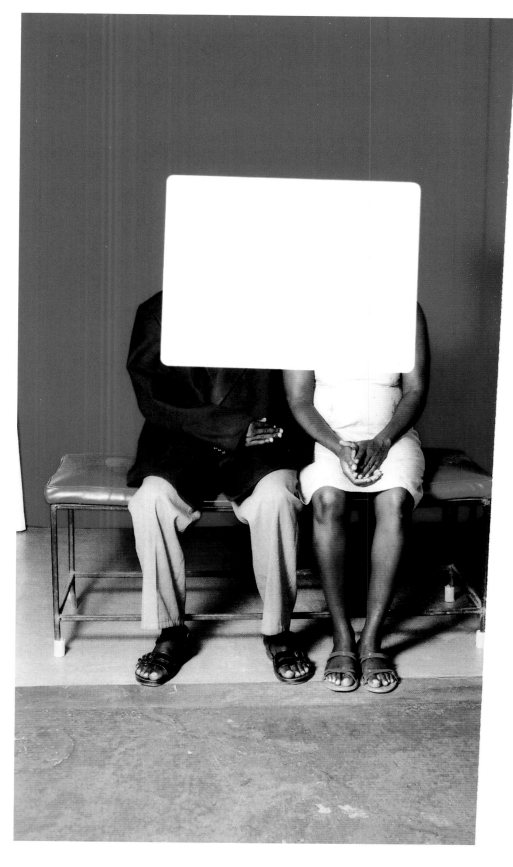

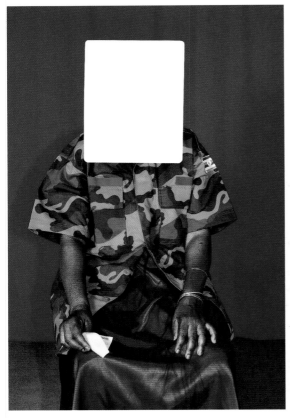
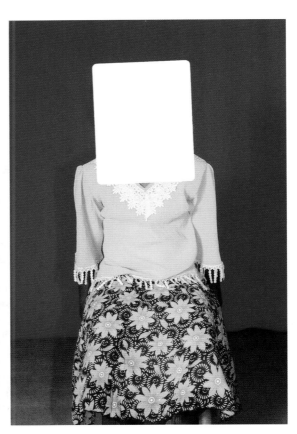
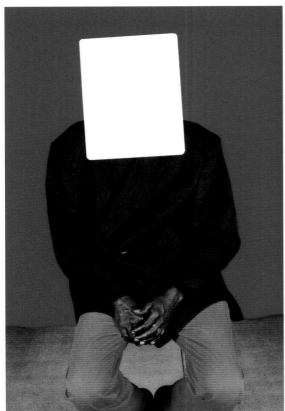
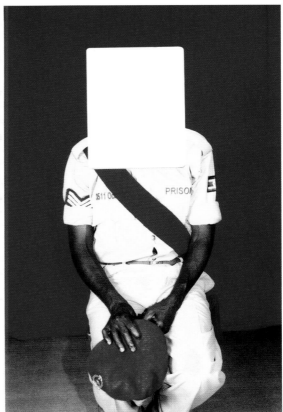

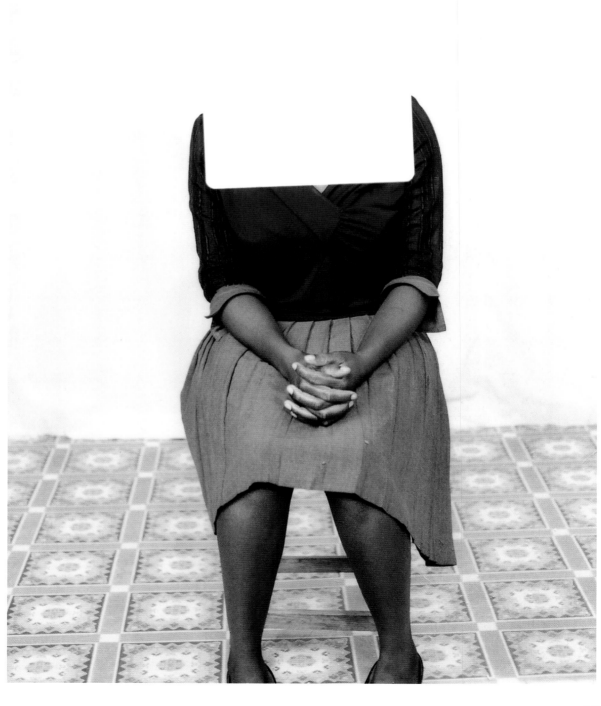

Cristina De Middel

In the 1960s Zambia planned to send astronauts to the Moon. Seeking to challenge the clichéd Western media view of Africa as a continent of war and misery, former photojournalist Cristina De Middel caused quite a stir – not to mention being nominated for the Deutsche Börse Prize and scooping an ICP Infinity Award – when she chose to document the fact of the Zambian space mission via fictive means in her series *The Afronauts*. The pictures were taken in Alicante (Spain), Majorca, Italy, the US and elsewhere. 'If you go back to the definition of photojournalism,' she has argued, 'it's all about telling a story with images, and in this case I'm telling a story that happened in the 1960s. There were no images so I had to create these images.'

Photojournalistic Beginnings: I studied Fine Arts but I went into photojournalism because I wanted to use what I knew how to do – take photographs – in a useful way and to change things. But local newspapers weren't really fulfilling my aspirations so I started working with NGOs (Médecins Sans Frontières, the International Red Cross and Red Crescent Movement, UNICEF) in Beirut, Haiti, Lebanon, India. I spent ten years as a staff photographer on newspapers and on humanitarian projects for NGOs. Then at the end of 2011 I realized that this wasn't what I wanted to do. I had stopped believing in the value of photojournalism: it made no difference, brought about no change, I stopped believing in the platform of the media as a means of raising awareness at all. I thought I could use photography in a different way, convey my message in a more efficient way. So instead of complaining I decided to give myself a year to prove that there were other ways of telling stories.

Photographic Veracity: I did an exhibition in which I took spam mails and made portraits of how I imagined the senders looked (*Polyspam*). This was the first time I had done something that played with fact and fiction and where I wasn't documenting things in a classical way. Because I was a photojournalist, a lot of people asked me how I had gained access and got permission to take portraits of these people. Of course, it was all completely faked and staged! That made me realize that there was a lot to be done in relation to how people consume photography and how they tend to assume that everything in a photograph has to be true. So I started playing with that. After that, I was doing research on 'incredible stories' – stories that seemed unbelievable but that I could document with photography to create a tension between the veracity-load of photography and what it actually showed.

The Afronauts: I was mainly focusing on weird experiments in the US in the 1940s, '50s and '60s. But then I found a list of the ten craziest experiments in history, and the first one on the list was the Zambian space programme. There was a link to an interview with the project leader. When I saw it I thought to myself: This is fake. But no, it was true. So I was myself a victim of the game that I wanted to play with my own work about fact and fiction. But also it gave a different point of view on Africa – the image of Africa has been really damaged by the approach of the classical media to the continent. Since colonialism Africa has been the victim of a terrible marketing campaign.

There is no good news about Africa. That's why a story like *The Afronauts* is so striking, because it talks about the dreams that Africans have. In a way it was a kind of photojournalistic scoop. The good thing about this series for me – and which allows me to say I'm not an artist – is that a lot of normal newspapers who haven't done a review of my work as such have used it instead to illustrate what happened in Zambia – they use my images to illustrate that. In strictly photojournalistic terms, it's been my most successful project because a lot of people have learnt about the Zambian space programme through it.

Cristina De Middel
Iko Iko
from *The Afronauts*, 2011

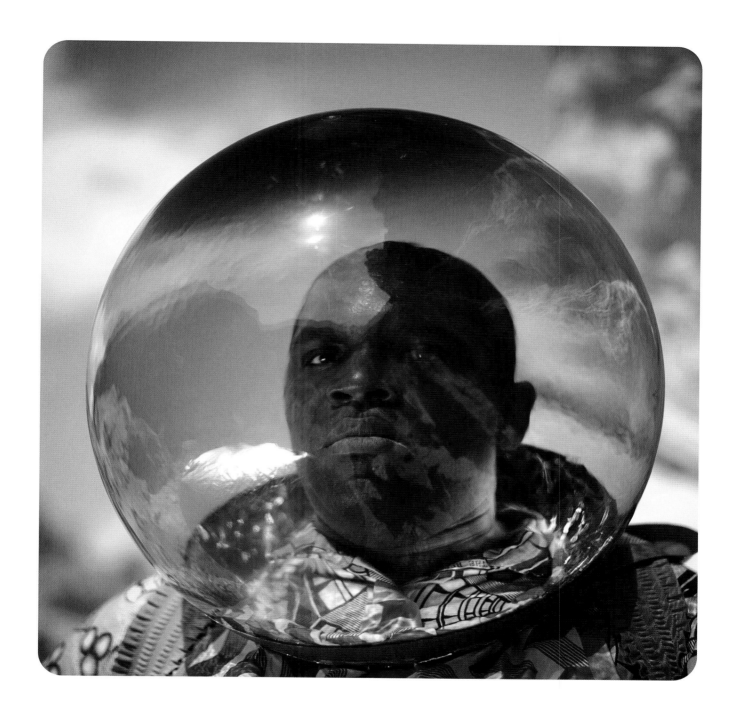

Cristina De Middel
Bongo; Ifulegi; Umeko; Butungatana
from *The Afronauts*, 2011

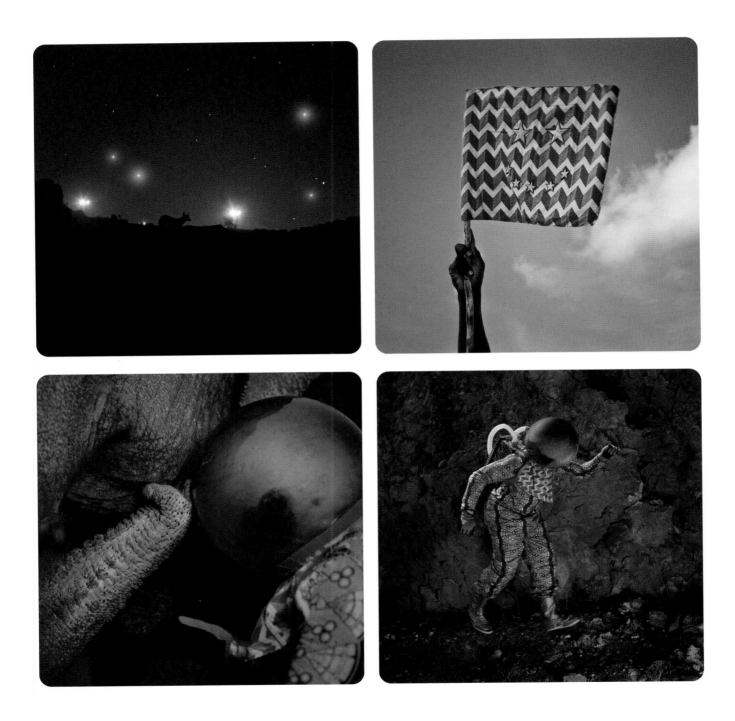

Cristina De Middel
Kulunguele; Ubutongo; Isimema; Inselele
from *The Afronauts*, 2011

Richard Mosse

New York-based Irish photographer Richard Mosse was the toast of the 2013 Venice Biennale for his unique work using Aerochrome, Kodak's newly discontinued colour infrared film. 'I felt Aerochrome would provide me with a unique window through which to survey the battlefield of eastern Congo. Realism described in infrared becomes shrouded by the exotic, shifting the gears of Orientalism,' he writes in his book *Infra*. 'The film gave me a way of thinking through my role as a white male photographing Congo with a big wooden camera. By extension, it allowed me to begin to evaluate the rules of photojournalism, which always seem to be thrust upon me in my task of representing conflict, and which I wished to challenge in my own peculiar way.'

The Limits of Representation: I originally chose the Congo because I wished to find a place in the world, and in my own imagination, where every step I took I would be reminded of the limits of my own articulation, of my own inadequate capacity for representation. I wished for this to happen in a place of hard realities whose narratives urgently need telling but cannot be easily described. Congo is just such a place. Its war seems essentially intangible. It is a protracted, complex and convoluted conflict, fought by rebels with constantly switching allegiance. These narratives, though brutal and tragic, are not tales that are easily told. I was pursuing something essentially ineffable, something so trenchantly real that it verges on the abstract, at the very limits of description. I needed to find an appropriate form to better describe this sinister resonance.

In December 2009, Kodak officially discontinued their colour infrared film, Aerochrome. This film was developed during the Cold War, in collaboration with the US military, in order to read the landscape, detecting enemy infrastructure. It quickly found civilian uses among cartographers, agronomists, foresters, hydrologists, glaciologists and archaeologists – namely, anyone wishing to study landscape. In the late 1960s, the medium was appropriated in the cover art of albums by rock musicians like Jimi Hendrix and the Grateful Dead, trickling into the popular imagination as the palette of psychedelic (from the Greek for 'soul-manifesting') experience, eventually accumulating a kitsch aesthetic.

Rethinking the Rules of Photojournalism: I have always been drawn to working in places of conflict – sites more commonly the concern of journalists. While my work is documentary in spirit, I have struggled with the idea that documentary photography, regardless of the photographer's concerns, arrives pre-loaded with an implicit assumption of advocacy. My work is not a performance of the ethical. I'm concerned less with conscience than with consciousness. And so I became enthralled by Aerochrome's inflation of the documentary, mediating a tragic landscape through an invisible spectrum, disorienting me into a place of reflexivity and scepticism, into a place in consonance with my impenetrable, ghost-like subject.

Articulating the Inexpressible: Art has the potential to reflect our difficult world, shifting the way we see, the way we understand, and can have a cumulative and profound effect on consciousness. It can help us begin to describe, and thereby account for, what exists at the limits of human articulation. According to German art historian Hans Belting, art offers 'a last refuge for the inexpressible, the unsayable, concepts borrowed for the West by nineteenth-century Romanticism from much older civilizations'. On my travels in eastern Congo I encountered a beautiful landscape touched by appalling human tragedy, a people locked in an endlessly recurring nightmare. Their situation lies well beyond my powers of communication, yet I felt compelled to attempt to describe it. My photography there was a personal struggle with the disparity between my own limited powers of representation and the unspeakable world that confronted me.

Richard Mosse
Come Out
from *Infra*, 2012

Richard Mosse
Colonel Soleil's Boys
from *Infra*, 2012

Richard Mosse
Men of Good Fortune
from *Infra*, 2012

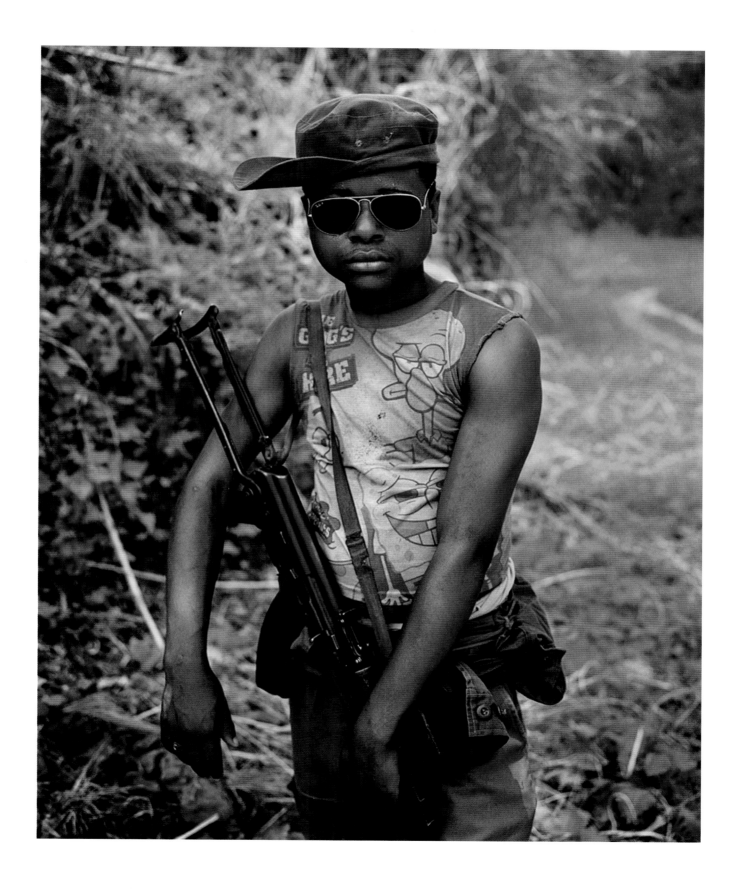

Benjamin Lowy

Renowned 'conflict photographer' Benjamin Lowy hit the headlines in 2012 when august US publication *Time* magazine put one of his images on the cover of its print edition. What was so surprising about that? The picture had been taken with an iPhone. 'I think the only people who cared that much were other photographers and media industry folks,' says the American artist matter-of-factly now. But he has also acknowledged in interview the importance of photojournalists innovating technically and aesthetically: 'There is so much information out there these days, and it's very hard to capture the attention of a – for the most part – apathetic public. By showing important images of a war or social issue to people using a unique aesthetic, I believe I can capture their attention and shine a light on some of these stories.'

Photojournalism and the Need to Innovate: The business aspect of photojournalism is taking a beating. Making a living wage and supporting a family is tough. But photojournalism as a form of expression and documentation is stronger than ever. With the cornucopia of work produced today, you have to innovate and create and think in order to produce work that stands out from the fray.

Iraq. Perspectives I (Windows) and II (Nightvision): During my embeds I was able to use US military-issue night-vision goggles, firmly attached to my camera by means of duct tape, dental floss and, occasionally, chewing gum, to make images that reveal a more menacing nocturnal version of Iraq's abandoned streets, cowering civilians and anxious soldiers. With these two series, I aimed to create an 'aesthetic bridge' that circumvented the usual depiction of the war, and surmounted public apathy to conventional news imagery. I hope that viewers are compelled to question the meaning of these devastating events and their long-lasting effects on Americans and Iraqis.

#Sandy: As the wrath of Hurricane Sandy descended on the East Coast of the United States, I found myself tasked with documenting its destructive and violent visitation while using social media platforms for *Time* magazine and Tumblr to update the public instantly. In fact, web statistics show that there were ten images uploaded every second to Instagram with the #sandy marker. These images were made over the two weeks I spent photographing Sandy from New York City to Atlantic City.

Shooting Sandy with Instagram: I think that as a child of the digital age, with technology constantly changing, I am more open to adapting to new tech and ideas. The visual nature of a hurricane and the rise of Instagram's popularity came together at the perfect time.

The Pros and Cons of the iPhone: I don't have total manual control. There is little to no depth of field, there is one wide-angle lens, and it's not great with low light and fast-moving subjects. But the phone is the darkroom in your pants. It's always there and it can be used for every type of occasion, from news to the birth of a child. The fact that 50 per cent of images last year were made on an iPhone, and more images were made last year than in all the other years of photography's existence, is evidence of its advantages.

Art versus Photojournalism: 'Art' is about self-expression as much as communication. That is not always a place the photojournalist should inhabit. I don't want my images of the dead to transcend to art. It minimizes the sacrifice of the people I've photographed.

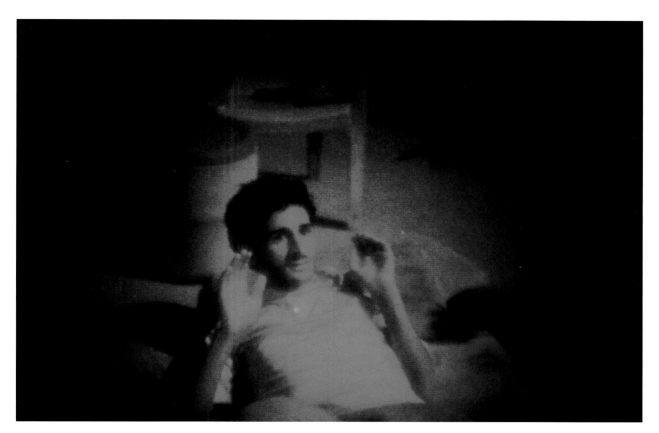

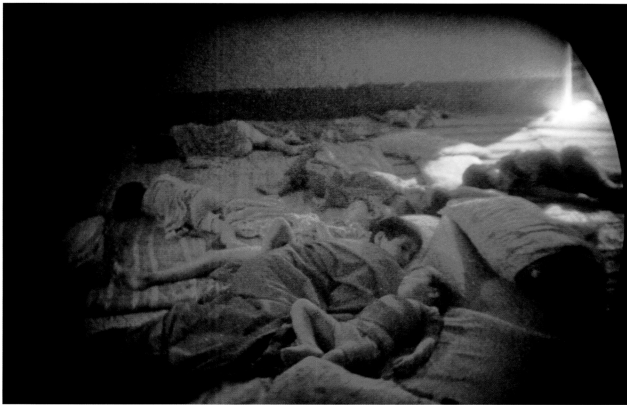

Benjamin Lowy
from *Iraq.*
Perspectives II:
Nightvision, 2003–08

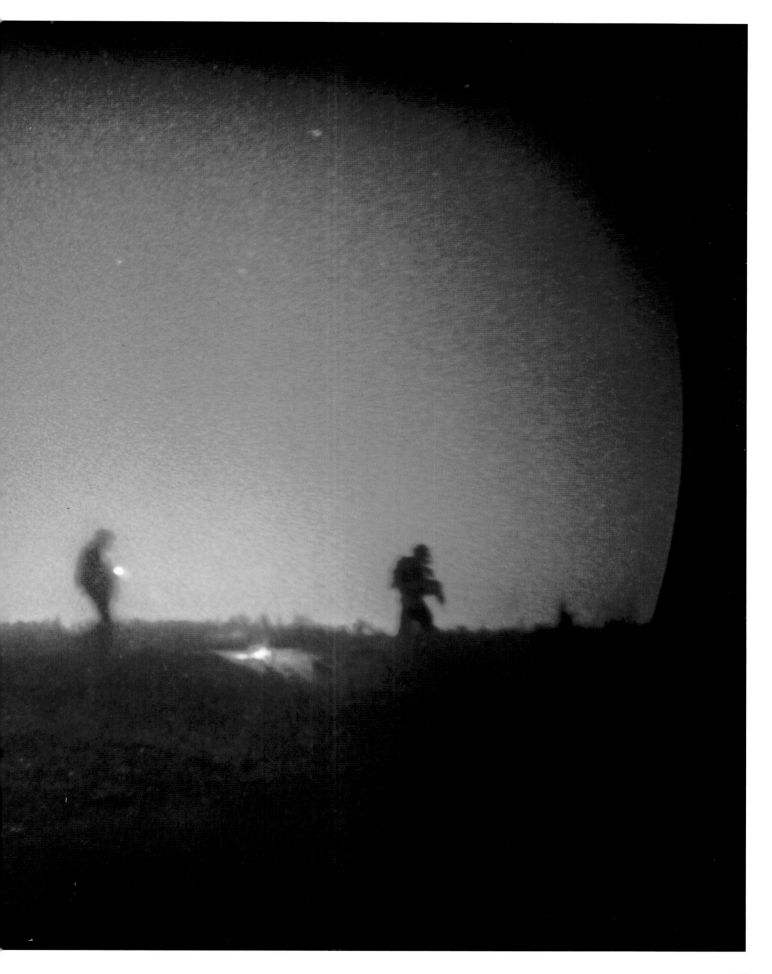

Benjamin Lowy
from #sandy, 2012

David Birkin

Loss is one of the major themes of British photographer David Birkin, as is the awkward relationship between ethics and aesthetics. Perhaps it's no surprise that he has found himself regularly drawn to the subject of war in his work, although not in the manner of traditional reportage. 'I was inspired by the work of war photographers like Don McCullin and Philip Jones Griffiths, but I didn't want to be a photojournalist,' he says. 'Yet something about the distortion that arises from freezing time, and the complicity that the photographer and viewer share in that process, intrigued me.' Many of his most eloquent projects are an attempt, as he describes it, 'to find a way to articulate loss and the effects of war without recourse to spectacle'.

Not Showing: I'm more interested in what doesn't get shown than what is depicted. The gaps are what often tell us the most. Judith Butler talks about the public sphere being partially constituted 'by what cannot be said and cannot be shown'. A lot of my work is about the failure of images. Precisely because it's such a fundamentally representational medium, I try to use photography to picture a void – which may then reveal something about the way we consume spectacle or, conversely, about what gets left out. *Pietà* is a good example. It comprises a wire-photo from 1992 of an Afghan woman at the funeral for her infant child in Kabul. The image is overlaid with lapis lazuli sourced from mines in Badakhshan, north-east of where the photograph was taken. Owing to its scarcity during the Renaissance, lapis was reserved for painting the robes of the Virgin Mary. The piece touches on the way certain Christian iconographic tropes have been recycled throughout Western photojournalism. But it can also be read in light of the Islamic prohibition on anthropomorphic imagery, as well as the kinds of photographs that have been absent in more recent wars.

Analogue vs Digital: The film versus digital debate is normally framed in terms of which is a 'better' process, with respect to either its fetishistic value or its technical efficacy. I'm interested in when cameras become *ineffective*, and the point at which the image-making process breaks down. In the case of *Profiles*, I was looking for a way to portray casualties from the Iraq War for whom no photographic record exists. The process entailed inserting identification numbers from the civilian casualty database into a digital colour space to generate a chromatic 'value' for each individual. This unique colour was then exposed onto a single 10 x 8-inch photographic transparency, with the person's name, age, occupation and cause of death contained within the filename and inscribed along the film's rebate. They're a series of non-photographs, representing blanks in the photographic record. As Baudrillard says, 'The non-will to know is part of the non-war.' Similarly, for the series *Embedded*, I wrote names into the JPEG code which corrupted the file and fractured the image, so that each casualty was denoted by a digital glitch. By contrast, *Midnight Blue* uses an archaic and outmoded photographic process to reflect on the death penalty in the United States. Prussian Blue, the dye that gives cyanotypes their distinctive hue, is a chemical by-product of hydrogen cyanide or 'Prussic acid': a residue of which was found on the walls of the Nazi gas chambers at Majdanek. The same poison gas was used for many years on Death Row, and the state of Missouri has threatened to resume its use if European pharmacies continue to block the export of drugs for the lethal injection. One minute past midnight is also the traditional time set for executions in the US, hence the title.

Appropriating Materials: There's been a lot of rhetoric about image saturation since the advent of camera phones. On the one hand, the proliferation of internet imagery has transformed the way political events unfold in profound ways – from Tahrir Square to Abu Ghraib – and the new technology has proved itself an effective tool for challenging state power. On the other hand, we've reached a point where there are so many images already out there that I feel like I need a good reason to actually take a photograph and add it to the pile. I also think that found images and objects carry a charge that can be very compelling. The discarded hospital light boxes I displayed the *Profiles* transparencies on each has its own history. They were used to illuminate patients' X-rays up until the point when medical imagery, like the rest of photography, became digital. That kind of fluorescent tube technology is now defunct in Britain and the US, but is still current in countries across the developing world, including Iraq. It's as much about teasing out what's already there as adding something new.

David Birkin
Detail from *Profiles*, 2012

aswan_ahmed_lutfallah_cameraman__age_36__killed_by_gunfire__iraq_body_count_number_d1760__=__HEX_colour_value_#df0760__=__RGB_equivalent_223_7_96___.jpg

David Birkin
Untitled
from *Embedded*,
2011

David Birkin
Midnight Blue, 2014

David Birkin
Pietà, 2012

(ISL-1)KABUL,Afghanistan, July 9--FUNERAL--An Afghan woman burst into tears Wednesday during the funeral for her infant child who was killed by rocket attacks fired by rebel Mujahedeen from mountains surrounding Kabul city. More than 50 civilians were killed in rocket attacks from Hezb-e-Islami bases. (AP PHOTO)c(bk5.1600str/Caroline Cremo)1992. \\lib

AP LEAFDESK

AP LEAFDESK

Adam Broomberg and Oliver Chanarin

The London-based duo of Adam Broomberg and Oliver Chanarin won the prestigious Deutsche Börse Photography Prize in 2013 for *War Primer 2*, a photobook that reworked Bertolt Brecht's 1955 publication *War Primer*, in which the German Socialist playwright added four-line captions to images taken from mass-circulation magazines. For their *War Primer 2*, Broomberg and Chanarin added screengrabs and smartphone snaps to reflect on the role of photography in the 'War on Terror'. Among their other projects are *Afterlife*, which deconstructs a famously 'anonymous' Pulitzer Prize-winning image showing the execution by firing squad of 11 Kurdish prisoners in Iran in 1979, and *Holy Bible*, which again takes inspiration from Brecht and draws on imagery found in the Archive of Modern Conflict.

Relationship to the Photojournalistic Tradition: Some of our projects have partly been an interrogation of the ecosystem of photojournalism; its economy, its vocabulary, its limitations and its strengths. In the 16-odd years we've been working together we've seen the photojournalistic world change remarkably. Beginning with the way images are gathered (Associated Press now have more people scouring social media than they have operative cameramen and -women on the ground), to the way they are controlled (the embedding process was an ingenious and very stealthy way of controlling how both the wars in Afghanistan and Iraq were imaged) to their dissemination (editors are now more then ever accountable to art buyers at advertising agencies – a picture of a dead body doesn't help get you a Hermès ad). We've also seen a subconscious shift in which the poor image, a low-resolution image, commands more authority of truth than a sharp one, the assumption being that the photographer has compromised quality for speed of transfer. These are some of the issues we try to examine.

***Holy Bible* and Bertolt Brecht:** [Brecht] said that images have as much ability to lie as the typewriter does. He also went as far as calling them hieroglyphics in need of decoding, deciphering and sometimes complicating. The *Holy Bible* project was actually inspired by one of our visits to the Brecht archive, where we held Brecht's personal copy of the Bible, which had an image of a racing car stuck on the cover and various other images pasted over the pages inside. Our *War Primer 2* project was more a meditation on Brecht's scepticism towards press images; *Holy Bible* is more concerned with how the Bible is a parable for the growth of the modern state and how power and photography are so tied in with each other.

Adi Ophir, a remarkable philosopher with whom we worked, published an essay called 'Divine Violence' in our version of the Bible, in which he argues that God's main mode of utterance is catastrophe and punishment. Replace God with the State and we're all born into a silent contract that ties us into so many laws – some of which are still punishable by death! Not many of those laws are determined by us, the citizens. Then there is photography's obsession or preoccupation with catastrophe.

We mined one archive for months on end: the Archive of Modern Conflict, which is solely concerned with images of conflict, from the Crimean War to today. It's a remarkable place, full of let's call it the unofficial photographic history of conflict; from private Nazi soldiers' albums showing tender moments between young soldiers to bourgeois dinners in the Jewish ghettos moments before deportation to the death camps... essentially an archive full of narratives of war we're not meant to have seen.

Afterlife: [It began with a] chance encounter in Rome with the aunt of a remarkable young journalist called Joshua Prager who noticed when paging through the book of Pulitzer Prize-winning images that only one in its entire history was marked 'anonymous'. He made it his mission to track down the photographer and he kindly introduced us to [Jahangir] Razmi, who was then in his mid-sixties and working as a wedding photographer in the suburbs of Tehran. Razmi in turn generously shared the other 26 images he had taken of the execution. We learnt a lot about the history of the Iranian Revolution, about how a photojournalist navigates a moment like that, how history coagulates around a single image instead of really analyzing an incident with all the tools available. We got to know the story of one man who was so profoundly affected by that moment and the subsequent war in Iraq that he spent years taking photographs. It was a remarkable experience. Maybe some of that comes through in the work?

Adam Broomberg and Oliver Chanarin
*'The earth opened her mouth, and swallowed
them up together'* – Numbers 26:10
from *Holy Bible*, 2013

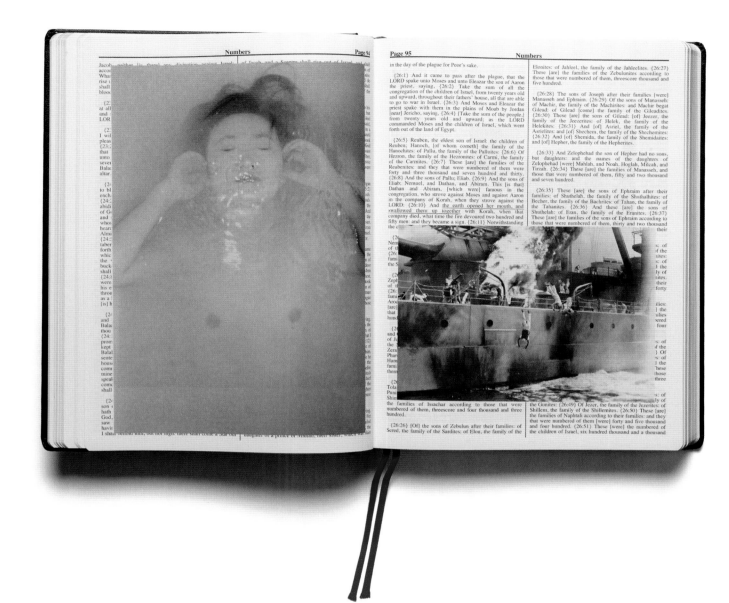

Adam Broomberg and Oliver Chanarin
'Life for life, {21:24} Eye for eye, tooth for tooth, hand for hand,
foot for foot, {21:25} Burning for burning, wound for wound,
stripe for stripe' – Exodus 21:23
from Holy Bible, 2013

Adam Broomberg and Oliver Chanarin
'Cursed [be] the man that maketh [any] graven or molten image' – Deuteronomy 27:15
from *Holy Bible*, 2013

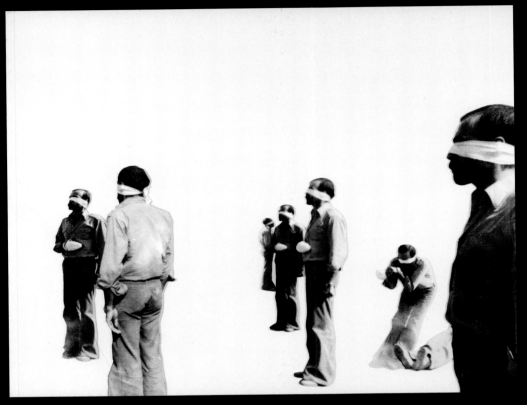
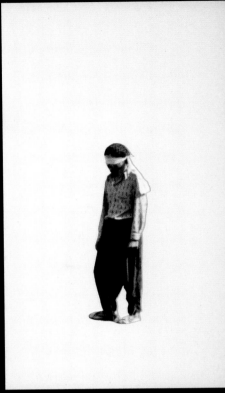

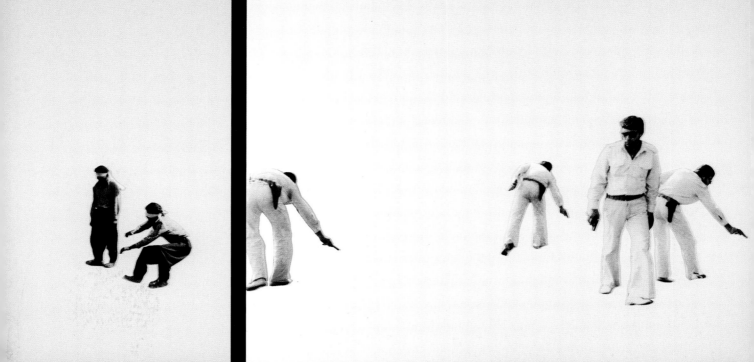

Credits

Some artist interviews are taken in part or whole from material that first appeared in *Elephant* magazine. Martina Bacigalupo: text in part derived from the artist's essay 'Leftovers' in Martina Bacigalupo, *Gulu Real Art Studio* (Steidl, 2013). Richard Mosse: text derived from the artist's essay in *Infra: Photographs* (Aperture, 2012). Quoted with permission.

p. 2 David Thomas Smith, *Three Gorges Dam, Sandouping, Yiling, Hubei, People's Republic of China*, 2010–11, from *Anthropocene*.

p. 6 Mishka Henner, from *Photography Is*, 2010, 13.97 x 21.59 cm.

p. 9 Julia Borissova, from *DOM (Document Object Model)*, 2013, 60 x 90 cm, 40 x 60 cm, editions of 7, 10.

p. 10 Aliki Braine, *Masterpiece in 10 Coloured Dots (after Velázquez)*, 2013, mixed media, 15 x 10 cm

p. 12 Eva Stenram, *Drape (Cavalcade VI)*, 2012.

p. 15 Mishka Henner, *Mauritskazerne, Ede*, from *Dutch Landscapes*, 2011, archival pigment print.

p. 16 Mishka Henner, *Unknown Site, Noordwijk aan Zee*, from *Dutch Landscapes*, 2011, archival pigment print.

p. 17 Mishka Henner, *Staphorst Ammunition Depot*, from *Dutch Landscapes*, 2011, archival pigment print.

p. 18 Mishka Henner, clockwise from top left: *Abu Alwan Oil Field (28°33'46"N, 18°43'8"E)*; *Jebel Oil Field (28°37'55"N, 19°53'11"E)*; *Haram Oil Field (28°50'0"N, 18°50'35"E)*; *Al Kotlah Oil Field (28°36'10"N, 18°54'46"E)*, all from *Libyan Oil Fields*, 2011, archival pigment prints.

p. 19 Mishka Henner, *Nafura Oil & Gas Facility (29°14'24"N, 21°33'28"E)*, from *Libyan Oil Fields*, 2011, archival pigment print.

p. 20 Mishka Henner, *Hollywood No. 1*, from *Less Américains*, 2012, silver gelatin print.

p. 21 Mishka Henner, *Rassemblement Politique No. 1*, from *Less Américains*, 2012, silver gelatin print.
http://www.mishkahenner.com/

p. 23 Joachim Schmid, *Statics (Women's Fashion Catalogue)*, from *Photogenic Drafts*, 1999.

pp. 24–25 Joachim Schmid, from left to right: *No. 140, Belo Horizonte, August 1992*; *No. 217, Los Angeles, March 1994*; *No. 414, Paris, July 1996*; *No. 961, Belo Horizonte, March 2010*; all from *Bilder von der Straße (Pictures from the Street)*, 1982–2012, courtesy P420 Arte Contemporanea, Bologna.

pp. 26–27 Joachim Schmid, from *Estrelas Amadas (Beloved Stars)*, 2013.
http://schmid.wordpress.com/

p. 29 Eva Stenram, *Birds in Flight I–III*, 2006–08.

p. 30 Eva Stenram, *Drape (Centrefold II)*, 2012.

p. 31 Eva Stenram, *Drape (Centrefold I)*, 2012.

pp. 32–33 Eva Stenram, *Parted (Trio)*, 2010.
http://www.evastenram.co.uk/.

p. 35 Nicole Belle, *Untitled*, from *Rev Sanchez*, 2008, inkjet print.

p. 36 Nicole Belle, *Untitled*, from *Rev Sanchez*, 2008, inkjet print.

p. 37 Nicole Belle, *Untitled*, from *Rev Sanchez*, 2008, inkjet print.
http://nicolebelle.com/

p. 39 David Thomas Smith, from top: *Burj Dubai, Dubai, United Arab Emirates* (detail); *Las Vegas, NV, United States of America* (detail); both 2009–10, from *Anthropocene*.

p. 40 David Thomas Smith, *Fimiston Open Pit, Kalgoorlie-Boulder, Western Australia, Australia*, 2009–10, from *Anthropocene*.

p. 41 David Thomas Smith, *Burj Dubai, Dubai, United Arab Emirates*, 2009–10, from *Anthropocene*.
http://www.david-thomas-smith.com

p. 43 Jonny Briggs, *Un-seeing*, 2012, C-type Lambda print, 115 x 180 cm.

p. 44 Jonny Briggs, *Envisionaries No. 1*, 2013, photomontage, 45 x 69 cm.

p. 45 Jonny Briggs, *Into the Black*, 2011, C-type Lambda print, 121 x 126 cm.
http://www.jonnybriggs.com/

p. 47 Noé Sendas, *Crystal Girl N78*, 2011, black-and-white inkjet print, 30 x 22.5 cm, edition of 2 + 1 AP.

p. 48 Noé Sendas, *Crystal Girl N51*, 2011, black-and-white inkjet print, 21.5 x 21.5 cm, edition of 2 + 1 AP.

p. 49 Noé Sendas, *Crystal Girl N79*, 2013, black-and-white inkjet print, 30 x 24 cm, edition of 3 + 2 AP.

All images courtesy of Michael Hoppen Contemporary.
http://www.noesendas.com/

p. 51 Julia Borissova, from *Running to the Edge*, 2012, inkjet print on Baryta Hahnemühle 315 gsm, 40 x 50 cm, 30 x 40 cm, editions of 10, 12.

p. 52 Julia Borissova, from *Running to the Edge*, 2012, inkjet print on Baryta Hahnemühle 315 gsm, 60 x 90 cm, 40 x 60 cm, 30 x 40 cm, editions of 7, 10, 12.

p. 53 Julia Borissova, from *Running to the Edge*, 2012, inkjet print on Baryta Hahnemühle 315 gsm, 60 x 75 cm, 40 x 50 cm, editions of 7, 10.

All images courtesy the artist.
http://juliaborissova.ru/

pp. 55–59 Roman Pyatkovka, from *Soviet Photo*, 2012.

All images courtesy the artist.
http://cargocollective.com/pyatkovka

p. 61 Brandon Juhasz, *Followers*, from *I Can't Promise to Try*, 2012, archival inkjet print, 91 x 61 cm.

p. 62 Brandon Juhasz, *Oh Shit*, from *American Bigfoot Is Monkey Suit*, 2011, chromogenic print mounted on sintra, 61 x 91 cm.

p. 63 Brandon Juhasz, *A Return to Nature*, from *American Bigfoot Is Monkey Suit*, 2011, chromogenic print mounted on sintra, 61 x 91 cm.
http://brandonjuhasz.com/

p. 65 Andreas Schmidt, clockwise from top left: *Gerhard Richter 3*; *John Currin*; *Edward Hopper 2*; *Francis Bacon*; all from *Fake Fake Art*, 2012, digital C-type print, 25 x 30 cm.

pp. 66–67 Andreas Schmidt, *Porn*, 2011, dimensions variable, giclee print on Hahnemühle.
http://www.andreasschmidt.co.uk/

p. 69 Clement Valla, from top: *Postcard from Google Earth (40°26'29.66"N, 79°59'32.91"W)*; *Postcard from Google Earth (34°1'45.70"N, 118°13'32.98"W)*; both 2010–12, archival pigment inkjet on paper, 101.6 x 58.4 cm, edition of 5 + 1 AP.

p. 70 Clement Valla, from top: *Postcard from Google Earth (48°24'31.45"N, 122°38'45.52"W)*; *Postcard from Google Earth (46°42'3.50"N, 120°26'28.59"W)*; both 2010–12, archival pigment inkjet on paper, 101.6 x 58.4 cm, edition of 5 + 1 AP.

p. 71 Clement Valla, from top: *Postcard from Google Earth (46°32'23.37"N, 6°38'28.25"E)*; *Postcard from Google Earth (39°46'30.47"N, 105° 8'39.34"W)*; both 2010–12, archival pigment inkjet on paper, 101.6 x 58.4 cm, edition of 5 + 1 AP.
http://clementvalla.com/

p. 72 Dan Holdsworth, *Forms, cg 01*, 2013 (detail). C-type print, 75 x 95 cm (each panel).

p. 75 Valérie Belin, *Crowned Head #1*, 2009, silkscreen, 188 x 146 cm.

p. 76 Valérie Belin, *Bride_Fiat 124 Spider*, 2012, from *Brides*, archival pigment print, 186 x 140 cm.

p. 77 Valérie Belin, *Painted Daisy (Carmine Blush Chrysanths)*, 2010, from *Black-Eyed Susan*, archival pigment print, 163 x 130 cm.
http://valeriebelin.com/

p. 79 Jae Yong Rhee, from top: *Self-Analysis I, II*, 2008, both digital pigment print, 80 x 120 cm, edition of 5.

p. 80 Jae Yong Rhee, from top: *Memories of the Gaze, Gilsan Rice Mill*; *Memories of the Gaze, Gunsan Rice Mill*; both 2012, archival pigment print, 107 x 160 cm (frame size), 102 x 155 cm (image size), edition of 3.

p. 81 Jae Yong Rhee, from top: *Memories of the Gaze, Gungsan Rice Mill*; *Memories of the Gaze, Gyerim Rice Mill*; both 2012, archival pigment print, 107 x 160 cm (frame size), 102 x 155 cm (image size), edition of 3.

All images courtesy Gallery EM. Copyright Jae Yong Rhee.
http://www.galleryem.co.kr/artist/jae-yong-rhee

p. 83 Jonathan Lewis, from top: *Ermanno Scervino*; *Sonia Rykiel*; both from *Designer Labels*, 2009, archival pigment print, 102 x 135 cm.

pp. 84–85 Jonathan Lewis, *Krizia*, from *Designer Labels*, 2009, archival pigment print, 102 x 135 cm.
http://www.jgdlewis.com/

p. 87 Sohei Nishino, *i-Land* (detail), 2007–08, from *Diorama Maps*, light jet print on Kodak Endura.

p. 88 Sohei Nishino, *Rio de Janeiro*, March–June 2011, from *Diorama Maps*, light jet print, 150 x 174.5 cm.

p. 89 Sohei Nishino, *Rio de Janeiro* (detail), March–June 2011, from *Diorama Maps*, light jet print, 150 x 174.5 cm.

All images © Sohei Nishino, courtesy of Michael Hoppen Contemporary.

http://www.soheinishino.com/

p. 91 Olivo Barbieri, *site specific_LONDON 12*, 2012. Courtesy Ronchini Gallery, London.

p. 92 Olivo Barbieri, *site specific_HOUSTON 12*, 2012. Courtesy Yancey Richardson Gallery, New York.

p. 93 Olivo Barbieri, *site specific_MEMPHIS 12*, 2012. Courtesy Yancey Richardson Gallery, New York.
http://www.olivobarbieri.it/

p. 95 Yang Yongliang, *Untitled 3*, 2008, from *Heavenly City*, 128 x 76 cm, inkjet print on Epson fine art paper

p. 96 Yang Yongliang, *A Bowl of Taipei – 3*, 2012, 150 x 150 cm, Epson ultragiclee print on Hahnemühle traditional photo paper.

p. 97 Yang Yongliang, *Phantom Landscape III – Page 01*, 2007, 45 x 45 cm, inkjet print on Epson fine art paper.
http://www.yangyongliang.com/

p. 99 Dan Holdsworth, *Megalith 01*, 2000, C-type print, 92.5 x 114.5 cm.

p. 100 Dan Holdsworth, *Blackout 22*, 2010, C-type print, 226 x 177 cm.

p. 101 Dan Holdsworth, *Blackout 08*, 2010, C-type print, 226 x 177 cm.

p. 102 Dan Holdsworth, from top: *Mount Shasta, D9*; *Grand Canyon B3*; both 2012, from *Transmission: New Remote Earth Views*, C-type print, 46 x 34 cm.

p. 103 Dan Holdsworth, from top: *Yosemite C2*; *Grand Canyon B5*; both 2012, from *Transmission: New Remote Earth Views*, C-type print, 46 x 34 cm.
http://www.danholdsworth.com/

p. 104 Rune Guneriussen, *It's Common Knowledge*, 2009, digital C-print/aluminium/laminate, 187 x 150 cm, edition of 5 + 1 AP.

p. 107 Laurence Demaison, *Si j'avais su n° 1 (If Only I Had Known No. 1)*, 2010.

p. 108 Laurence Demaison, *Bulle n° 1 (Bubble No. 1)*, 1998.

p. 109 Laurence Demaison, *Bulle n° 5 (Bubble No. 5)*, 1998.

pp. 110–11 Laurence Demaison, *Saute d'humeur (Mood Jump)*, 2004. All images courtesy Gallery Esther Woerdehoff, Paris.
http://www.laurencedemaison.com/.

p. 113 Hisaji Hara, *A Study of 'The Street'*, 2009, digital archival print.

p. 114 Hisaji Hara, *A Study of 'The Victim'*, 2009, digital archival print.

p. 115 Hisaji Hara, *A Study of 'Because Cathy Taught Him What She Learnt'*, 2010, digital archival print. All images © Hisaji Hara, courtesy Michael Hoppen Contemporary, London and MEM, Tokyo.
http://hisajihara.com/

p. 117 Shadi Ghadirian, *West by East 10*, 2004, C-type print, 60 x 90 cm, edition of 10.

p. 118 Shadi Ghadirian, *Ctrl+Alt+Del 1*, 2006, C-type print, 40 x 60 cm, edition of 10.

p. 119 Shadi Ghadirian, *Like EveryDay 16*, 2000, C-type print, 50 x 50 cm, edition of 10.
http://shadighadirian.com/

p. 121 Leonce Raphael Agbodjelou, *Untitled*, 2012, from *Demoiselles de Porto-Novo*.

p. 122 Leonce Raphael Agbodjelou, *Untitled*, 2011, from *Egungun*.

p. 123 Leonce Raphael Agbodjelou, *Untitled*, 2011, from *Egungun*.

All images courtesy Jack Bell Gallery, London.
http://www.jackbellgallery.com/

p. 125 Christy Lee Rogers, from top: *Birth of a Star*, from *Of Smoke and Gold*, 2013; *Upon the Cheek of Night*, from *Odyssey*, 2011.

p. 126 Christy Lee Rogers, *Reckless Unbound*, from *Reckless Unbound*, 2012.

p. 127 Christy Lee Rogers, *The Heart Is a Lonely Hunter*, from *Reckless Unbound*, 2012.
http://www.christyrogers.com/

p. 129 Angelo Musco, *Iride*, 2013, printed on metallic photo paper, encased in a round white wood frame, 173 cm diameter.

pp. 130–31 Angelo Musco, *Xylem*, 2011, printed on metallic photo paper, Plexiglas face mounted, 6.1 x 2.4 m.
http://www.angelomusco.com/

p. 133 Olaf Breuning, *Pattern People*, 2013, C-print, 120 x 150 cm, edition of 6.

pp. 134–35 Olaf Breuning, from left: *Damien*; *Andy*; *Edvard*; *Frida*, all 2011, from *Art Freaks*, colour print, 193 x 90.5 cm (frame size), 188.9 x 86.7 cm (image size), edition of 3 (MP# P-85, P-83, P-86, P-88).

p. 136 Olaf Breuning, *Complaining Forest*, 2010, C-print, 150 x 190 cm, edition of 6.

p. 137 Olaf Breuning, *Smoke Bombs 2*, 2011, mounted C-print on 6mm sintra, framed, 123.2 x 154.3 cm (image size), 124.8 x 154.9 cm (frame size), edition of 6 (MP# P-110).

All images courtesy the artist and Metro Pictures, New York.
http://www.metropicturesgallery.com/

p. 139 Scarlett Hooft Graafland, from top: *Harvest Time*, 2006, from *Soft Horizons*; *Windmill I*, 2010, hand-made analogue C-type print with red thread embroidery, 40 x 50 cm.

pp. 140–41 Scarlett Hooft Graafland, from top: *Baguette*, 2012, from *Madagascar*, C-type print, 70 x 210 cm; *Mothers of the Forest*, 2012, from *Madagascar*.

All images courtesy of Michael Hoppen Contemporary.
http://www.scarletthooftgraafland.nl/

p. 143 Rune Guneriussen, *Abnormal Growth of Gluttony*, 2009, digital C-print/aluminium/laminate, 190 x 150 cm, edition of 5 + 1 AP.

p. 144 Rune Guneriussen, *Second System of Ethics*, 2012, digital C-print/aluminium/laminate, 115 x 156 cm, edition of 5 + 2 AP.

p. 145 Rune Guneriussen, *A Grid of Physical Entities*, 2012, digital C-print/aluminium/laminate, 150cm x 208 cm, edition of 5 + 2 AP.

http://www.runeguneriussen.no/

p. 147 Erik Johansson, *Go Your Own Road*, 2008.

pp. 148–49 Erik Johansson, *Common Sense Crossing*, 2010.
http://erikjohanssonphoto.com/

p. 151 João Castilho, from *Vacant Plot*, 2007, C-type print, 40 x 60 cm each, edition of 5.

pp. 152–53 João Castilho, *Veiled Movie*, 2012, inkjet print, edition of 4.

pp. 154–55 João Castilho, from *Vade Retro*, 2012–13, inkjet print, edition of 5.
http://www.joaocastilho.net/

p. 157 John Chervinsky, *Flowers, Painting on Door*, 2011, from *Studio Physics*.

p. 158 John Chervinsky, *Clock, Outlet and Painting on Wall*, 2011, from *Studio Physics*.

p. 159 John Chervinsky, *Balloon, Rock on Table with Painting*, 2010, from *Studio Physics*.
http://www.chervinsky.org/

p. 161 Caleb Charland, *Silhouette with Matches*, 2009, from *Fathom and Fray*.

p. 162 Caleb Charland, *Breakbeat with Sparkler and Metronome (When the Levee Breaks)*, 2012.

p. 163 Caleb Charland, from left: *Four Spheres with Compass, Penlight and Drill*, 2007; *Kettle with Ping Pong Ball*, 2010; both from *Demonstrations*.
http://calebcharland.com/

p. 165 Alejandro Guijarro, $\Theta_3 = K$, 2011, from *Momentum*, C-type print, 100 x 101.6 cm, edition of 5.

pp. 166–67 Alejandro Guijarro, *Untitled VI*, 2012, from *Momentum*, C-type print, 236 x 118 cm, edition of 5
http://www.alejandroguijarro.com/

p. 169 Daniel Eskenazi, *Untitled VII*, from *Pictures of You*, 2013.

pp. 170–71 Daniel Eskenazi, from left: *Untitled III*; *Untitled II*; *Untitled V*; *Untitled VI*; all from *Pictures of You*, 2013.

All images courtesy of Michael Hoppen Contemporary.
http://www.michaelhoppengallery.com/

p. 173 Berndnaut Smilde, from top: *Nimbus Cukurcuma Hamam I*, 2012; *Nimbus Green Room*, 2013; both digital C-type prints.

pp. 174–75 Berndnaut Smilde, *Nimbus NP3*, 2012, digital C-type print.

All images courtesy of the artist and Ronchini Gallery.
http://www.berndnaut.nl/

p. 176 Jorma Puranen, *Shadows, Reflections and All That Sort of Thing 53*, 2012, digital C-print, Diasec, 125 x 100 cm.

p. 179 Aliki Braine, *Draw Me a Tree: White Out 2*, 2006, black-and-white photograph with inked negative, 95 x 117 cm.

pp. 180–81 Aliki Braine, *The Hunt*, 2009, black-and-white photograph with hole-punched negative, 85 x 224 cm.

p. 182 Aliki Braine, *14 Ugly Spots (After Carracci)*, 2012, black-and-white photograph with hole-punched negative, 20 x 25 cm.

p. 183 Aliki Braine, *Circle/Square (Hommage à Wals)*, 2011, colour photograph with stickered negative, 33 x 33 cm.
http://www.alikibraine.com/

p. 185 Chen Nong, *Fly Series #2*, 2002–05, silver gelatin print, colour painted, 100 x 120 / 50 x 60 cm.

pp. 186–87 Chen Nong, from top: *Three Gorges Series #1*, 2005–06; *Three Gorges Series #2*, n.d.; *Yellow River Sketch*, n.d.; *Yellow River*, 2007–08.

p. 188 Chen Nong, *Climbing to the Moon*, 2012, silver gelatin print, colour painted, 120 x 100 / 60 x 50 cm.

p. 189 Chen Nong, Water Lily Series #3. 2006–07.

All images courtesy Galerie Alex Daniels – Reflex Amsterdam and Chen Nong.
www.reflexamsterdam.com

p. 191 Charles Grogg, from top: *Ascension 1*, 2010, toned gsp, mud, pigment, alkyd, 61 x 50.8 cm, edition of 10; *Intravenous*, 2010, toned gsp, brown cotton thread, 61 x 50.8 cm, edition of 10.

pp. 192–93 Charles Grogg, *Regrowth*, 2013, burned digital print on rag over platinum/palladium on washi, soot, 198.1 x 66 cm, edition of 3.
www.charlesgroggphotography.net/

p. 195 Dafna Talmor, from top: *Untitled (1212-2)*; *Untitled (1112-3)*; both 2013, from *Constructed Landscapes*, C-type print.

pp. 196–97 Dafna Talmor, *Untitled (0811-1)*, 2012, from *Constructed Landscapes*, C-type print.
http://www.dafnatalmor.co.uk/

p. 199 Jorma Puranen, *Sixteen Steps to Paradise 18*, 2008, digital C-print, Diasec, 125 x 100 cm.

p. 200 Jorma Puranen, *Icy Prospects 17*, 2005, digital C-print, Diasec, 160 x 198 cm.

p. 201 Jorma Puranen, *Icy Prospects 5*, 2005, digital C-print, Diasec, 154 x 189 cm.

p. 202 Jorma Puranen, *Shadows, Reflections and All That Sort of Thing 47*, 2009, digital C-print, Diasec, 125 x 100 cm.

p. 203 Jorma Puranen, clockwise from top left: *Shadows, Reflections and All That Sort of Thing 50*, 2009; *Shadows, Reflections and All That Sort of Thing 63*, 2010; *Shadows, Reflections and All That Sort of Thing 78*, 2011; *Shadows, Reflections and All That Sort of Thing 68*, 2010; all digital C-print, Diasec, 125 x 100 cm.
http://www.purdyhicks.com/

p. 205 Julie Cockburn, *Idyll*, 2012, hand embroidery on found photograph, 23.3 x 18.1 cm.

p. 206 Julie Cockburn, *Green Dress*, 2012, altered found photograph, 25 x 20.3 cm.

p. 207 Julie Cockburn, *Tantrum 3*, 2012, altered found photograph, 25.3 x 20.2 cm.
http://www.juliecockburn.com/

p. 209 Torsten Warmuth, *Giant Steps (Version 1)*, 2011, silver painting, gelatin silver paper, TW 283, 80.7 x 99 cm, unique work.

pp. 210–11 Torsten Warmuth, *On Fire I*, 2013, mixed photographic media, pigment print on fibre-based paper, TW 320, 86.5 x 180 cm (edtion of 3) / 14 x 29.2 cm (edition of 3).
http://www.torsten-warmuth.com/

p. 213 Chloe Sells, *Virtue and Vice*, 2013, from *Senescence*, unique analogue C-type print on Fujicolor crystal archive paper.

p. 214 Chloe Sells, *Peacock with Skull*, 2013, unique analogue C-type print on Fujicolor crystal archive paper.

p. 215 Chloe Sells, from left: *Delicious Monster with Juju Hat*, 2013; *Olympia*, 2012; unique analogue C-type print on Fujicolor crystal archive paper.

All images © Chloe Sells, courtesy of Michael Hoppen Contemporary.
http://chloesells.com/

pp. 217–19 Steffi Klenz, *Hewitt's Heap*, 2012–13, C-type prints.
http://www.steffiklenz.co.uk/

p. 221 Brendan Fowler, *Spring 2011 (Photographing Mirrors 1, Photographing Mirrors 2, Mirror Reflecting White Flat 1, Photographing Mirrors 1, Photographing Mirrors 2, Mirror Reflecting White Flat 2)*, 2012, archival inkjet prints, frames, plexi, 180.3 x 128.3 x 13.3 cm (Inv# BF301.12).

p. 222 Brendan Fowler, *Spring 2011–Fall 2012 (Mirror in Miami, Texting and Driving It Can Wait, Coronado Ter Towels, Mirror Reflecting Black Flat 2)*, 2013, inkjet prints, frames, plexi, 119.4 x 118.1 x 12.7 cm (Inv# BF373.13).

p. 223 Brendan Fowler, *Fall 2009–Summer 2011 (Joel's Phone on Lauro Table, Andrea on the Way to Anxiety of Photography Opening, ½ x 2½" Clear Pine Molding Sticking Out of the Car, Flowers Outside of the Silk Flowers Show in LA 2)*, 2011, archival inkjet prints, frames, plexi, 128.3 x 124.5 x 12.7 cm (Inv# BF258.11).
http://www.brendanfowler.com/

p. 224 Martina Bacigalupo, from *Gulu Real Art Studio*, 2011–12. Courtesy the artist, The Walther Collection and Agence VU.

p. 227 Michael Wolf, from left: *Tokyo Compression 5, 17*, 2010.

p. 228 Michael Wolf, *Watching Windows 1*, 2012.

p. 229 Michael Wolf, *Watching Windows 2*, 2012.

p. 230 Michael Wolf, *Architecture of Density 8b*, 2005.

p. 231 Michael Wolf, *Architecture of Density 102*, 2007.

pp. 232–33 Michael Wolf, *Night 14*, 2005.
http://photomichaelwolf.com/

p. 235 Yang Yi, from *Uprooted*, 2006–08.

pp. 236–37 Yang Yi, from *Uprooted*, 2006–08.

All images courtesy of M97 Gallery, Shanghai.
http://www.m97gallery.com/

pp. 239–41 Martina Bacigalupo, from *Gulu Real Art Studio*, 2011–12. Courtesy the artist, The Walther Collection and Agence VU.
http://www.martinabacigalupo.com/

p. 243 Cristina De Middel, *Iko Iko*, from *The Afronauts*, 2011.

p. 244 Cristina De Middel, clockwise from top left: *Bongo*; *Ifulegi*; *Umeko*; *Butungatana*; all from *The Afronauts*, 2011.

p. 245 Cristina De Middel, clockwise from top left: *Kulunguele*; *Ubutongo*; *Isimema*; *Inselele*; all from *The Afronauts*, 2011.
http://www.lademiddel.com/

p. 247 Richard Mosse, *Come Out*, from *Infra*, 2012.

p. 248 Richard Mosse, *Colonel Soleil's Boys*, from *Infra*, 2012.

p. 249 Richard Mosse, *Men of Good Fortune*, from *Infra*, 2012.

p. 250 Richard Mosse, from top: *Vintage Violence*; *Even Better Than the Real Thing*; both from *Infra*, 2012.

p. 251 Richard Mosse, *Rebel Rebel*, from *Infra*, 2012.

All images courtesy of the artist and Jack Shainman Gallery, New York.
http://www.richardmosse.com/

p. 253 Benjamin Lowy, from *Iraq. Perspectives II: Nightvision*, 2003–08.

pp. 254–55 Benjamin Lowy, from *Iraq. Perspectives II: Nightvision*, 2003–08.

p. 256 Benjamin Lowy, from *#sandy*, 2012.

p. 257 Benjamin Lowy, from *#sandy*, 2012.
http://www.benlowy.com/

p. 259 David Birkin, detail from *Profiles*, 2012, photographic transparencies displayed on hospital X-ray lightboxes, 25.4 x 20.3 cm.

pp. 260–61 David Birkin, *Untitled*, from *Embedded*, 2011, digital inkjet prints, 85 x 185 cm.

p. 262 David Birkin, *Untitled*, from *Midnight Blue*, 2014, cyanotype print, 30 x 38 cm.

p. 263 David Birkin, *Pietà*, 2012, Associated Press wire-photo overlaid with Afghan lapis lazuli, 18 x 21 cm.
http://www.davidbirkin.net/

p. 265 Adam Broomberg and Oliver Chanarin, 'The earth opened her mouth, and swallowed them up together' – Numbers 26:10, from *Holy Bible*, 2013, MACK/AMC.

p. 266 Adam Broomberg and Oliver Chanarin, 'Life for life, {21:24} Eye for eye, tooth for tooth, hand for hand, foot for foot, {21:25} Burning for burning, wound for wound, stripe for stripe' – Exodus 21:23, from *Holy Bible*, 2013, MACK/AMC.

p. 267 Adam Broomberg and Oliver Chanarin, 'Cursed [be] the man that maketh [any] graven or molten image' – Deuteronomy 27:15, from *Holy Bible*, 2013, MACK/AMC.

pp. 268–69 Adam Broomberg and Oliver Chanarin, from left: *Afterlife 1*; *Afterlife 5*; *Afterlife 11*; all 2009, collage, glass, lead, C-type print, 50.8 x 40.6 cm.

All images © Adam Broomberg and Oliver Chanarin
http://www.choppedliver.info/

UNIVERSITY H.S. LIBRARY

Robert Shore is the editor of the visual-arts quarterly *Elephant* and was previously deputy editor at *Art Review* magazine. As an arts journalist he has contributed to the *Sunday Times*, the *Guardian* and *Metro*. He is also the author of *10 Principles of Advertising* and *Bang in the Middle*.

Acknowledgements My gratitude goes to all of the artists and galleries who have contributed to the book; in particular I would like to thank Daisy Hoppen and the Michael Hoppen Gallery and Averil Curci at Camilla Grimaldi for facilitating the project. Marc Valli, editor-in-chief of *Elephant* magazine, provided the title and so much else. Melissa Danny at Laurence King Publishing saw it all through the press.

LAURENCE KING

Published in 2014
by Laurence King Publishing Ltd
361–373 City Road
London EC1V 1LR
tel +44 20 7841 6900
fax +44 20 7841 6910
e-mail enquiries@laurenceking.com
www.laurenceking.com

© Text 2014 Robert Shore

Robert Shore has asserted his right under the Copyright, Designs, and Patent Act 1988, to be identified as the Author of this Work.

All rights reserved. No part of this publication may be reproduced or transmitted in any form or by any means, electronic or mechanical, including photocopy, recording or any information storage and retrieval system, without prior permission in writing from the publisher.

A catalogue record for this book is available from the British Library.

ISBN 978-1-78067-228-1

Designed by Struktur Design Limited
Printed in China

Cover credits
Front: Cristina De Middel, *Hamba*, from *The Afronauts*, 2011.
Back: Christy Lee Rogers, *The Innocents* (detail), from *Reckless Unbound*, 2012.

2/25/2015

UNIVERSITY H.S. LIBRARY